THE BODY

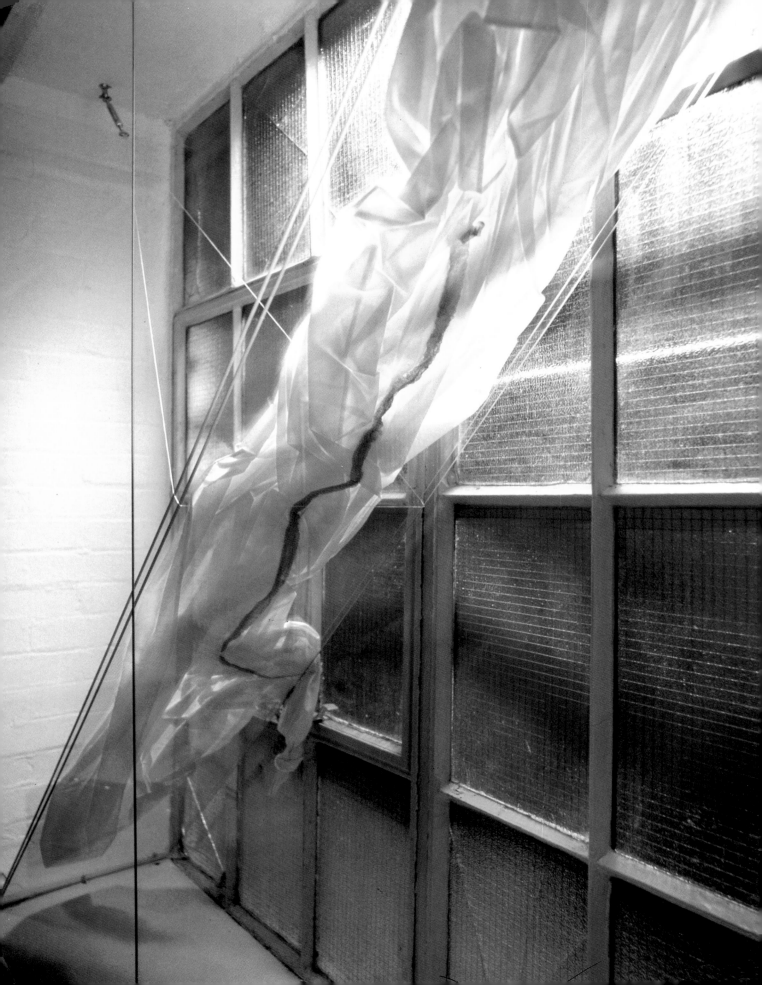

Journal of Philosophy and the Visual Arts

THE BODY

ACADEMY EDITIONS • **ERNST & SOHN**

ACKNOWLEDGEMENTS

Visual material is reproduced courtesy of the following: p 8 (above): Hirshhorn Museum and Sculpture Garden, Smithsonian Institute (transferred from the Hirshhorn Museum and Smithsonian Archives, 1983), photograph Lee Stalsworth; (below): Amon Carter Museum, Fort Worth and Warwick University; p 22: The Trustees, the National Gallery, London; p 26: Metropolitan Museum of Art, bequest of Mrs HO Havemeyer, 1929, The HO Havemeyer Collection; p 30 (left): Frau Eva-Maria Rössner, Backnang, Germany; (right): Anthony Reynolds Gallery, London; p 39: Courtesy of the artist; p 40 (above): Marlborough Fine Art, London; (below): Musée d'Unterlinden, Colmar France, photograph O Zimmermann; p 51 (left): Marlborough Fine Art, London; p 52: Marlborough Fine Art, London; pp 56-57: Tate Gallery, London; p 59: Marlborough Fine Art, London; p 60 (above): Friedrich Barth, *Insects and Flowers: The Biology of a Partnership,* trans MA Biederman-Thorson, Princeton University Press, 1991; (below): Courtesy of artist and Max Protech Gallery, New York City; p 64 (from above, L to R): Georges Bataille, *Visions of Excess* (see Notes); R & M Buchsbaum, J & V Pearse, *Animals without Backbones,* University of Chicago Press, 1987; Berlin, Neue Museum; F McKinney & JB Jackson, *Bryozoan Evolution,* (see Notes); Y Osada & SB Ross-Murphy, 'Intelligent Gels' (see Notes); F Dagognet, *A Passion for the Trace: Etienne-Jules Marey* (see Notes); p 69 (right): Courtesy of artist and Max Protech Gallery, New York; pp 70-79: All photographs by Karant and Associates, except the bench photographs by Jim Duignan; pp 80, 83: Courtesy of the artist, photographs Ed Woodman, to be featured in the exhibition 'Elective Affinities', Tate Gallery, Liverpool, 8 Sept-7 Nov 1993; pp 84-89: Text translated by K and A Rüthi-Davis; pp 84, 87: From 'Brief Window [Refrain]' installation at Museum of Installation, London, photographs Ed Woodman, courtesy of the artist; p 90: Stuart Regen Gallery; p 92 (below): Anthony d'Offay Gallery, London; p 95: Courtesy of the artist, photographs Ed Woodman.

Front Cover: Francis Bacon, Head VI, *1949, oil on canvas, 65x80.5cm (Marlborough Gallery, London); p 2: Louise Sudell,* Personal Memory Intervention, *1993, glass sheets, bed sheet, snakeskin (Museum of Installation, London)*

First published in Great Britain in 1993 by
Journal of Philosophy and the Visual Arts an imprint of the
ACADEMY GROUP LTD, 42 LEINSTER GARDENS, LONDON W2 3AN
ERNST & SOHN, HOHENZOLLERNDAMM 170, 1000 BERLIN 31
Members of the VCH Publishing Group
ISBN: 1 85490 212 1

Distributed to the trade in the United States of America by
ST MARTIN'S PRESS, 175 FIFTH AVENUE, NEW YORK, NY 10010

Printed and bound in Singapore

Journal of Philosophy and the Visual Arts
THE BODY
Edited by Andrew Benjamin

CONTENTS

ANDREW BENJAMIN
BRINGING BACK THE BODY

Initially, the body's position will have been given by tradition. Its site will be present therefore in its opposition to mind. In this way the body takes the form of the other possibility. And yet the force of this positioning of the body is only derived from its being the mind's other. From within such a purview all that will have taken place in bringing the body to the fore is a switch in which, instead of one location being central, another comes to hold sway. The centrality of the body would only arise because of this distancing of the mind. The direct consequence of this potential oscillation is that any sustained rethinking of the body must start from the recognition that its traditional and thus founding location will be within this nihilistic trap. It is nihilistic because all that it can set in play is an oscillation between the opposition's constitutive parts. Furthermore it is a trap that betrays the body. More will emerge here however than simple boundaries – the bounded opposition – since what this recognition will bring with it cannot be restricted to the traditional opposition between mind and body. The particularity of the distinction will be generalised such that what will also be implicated is the actual tradition of oppositional thinking itself.

The twofold nature of this recognition brings the body into the range of metaphysics (the place of traditional philosophical thinking) while also allowing a possible reopening of the body in which the metaphysical hold of oppositional thinking loses its hold. The body will be allowed another possibility and thus can come to be held in different ways.[1] What must be remembered in the move from one hold to another is the reciprocity between the traditional specificity of the body and its place – a place to be displaced – in the founding opposition of mind and body and the structure of oppositional thinking. It is precisely this thinking that sustains the oppositions and which is in turn therefore sustained by them. The opening of one will necessitate the opening of the other. While a task, be it interpretive, philosophical or artistic, is identified here, it is because of the self-sustaining interdependence at work in framing and therefore reframing the body that the specific consequences of these openings cannot themselves be simply given. In addition what this means is that the task in itself resisting a specific determination will enjoin a necessary plurality. It will be a plurality beyond the simple divisions of interpretation, philosophy and art.

What is being brought into play by the recognition of this reciprocity are therefore specific critical tasks. What is demanded and thus that which emerges as the task taken in its most general sense, and thereby as what defines its critical specificity, is the twofold movement in which the position of the body within the mind/body opposition is displaced at the same time as the oppositional thinking which gives and sustains the distinction is itself also being displaced. Rather than this entailing the absence and thus impossibility of any identity, what it will demand is a rethinking of identity itself. It will be in terms of this demand that the body – its being reopened – will come to figure. An integral part of that figuring will be the displacing of any neutrality – the neutral body – and thus the affirmation of the effective presence of gender. Following from this affirmation will be the necessity to work with the always already-present question of gender. Furthermore what this affirmation will entail here is a positioning (a repositioning) of the centrality and insistence of the question of gender beyond the standard oppositions of male/female and heterosexual/homosexual. It will only be in freeing these terms from their traditional positions – positions with their necessarily positioned standards – that their constitutive components will then be able to be reclaimed. Reclaiming will involve bringing back the body and with it repositioning the locus and nature of identity.

Reclaiming as an interpretive act however must be understood as working in relation to tradition. Any attempt to avoid this relation would only be possible and thus only sanctioned by a forgetting – what amounted to an active and systematic forgetting – that eschewed critical engagement. While working with the ineliminability of relation what should still be recognised is that relation, rather than being the mark of a simple connection, is itself marked by a complex set of determinations. In terms of activity what this recognition will demand is the necessary reworking and reading of works (be they texts or painting) that comprise the locus of tradition's work. (The denial of this necessity will be another form of forgetting.) The straightforward consequence of this reworking is that in being repeated the work's reworking means that tradition's hold and its enforced and enforcing continuity will have been sundered. It will be with the abeyance of tradition's determinations that the body is repositioned.

The result of this division and thus what in the end will have to amount to a relation of non-relation is that the works come to be given again. In being reworked and therefore in their repetition the forced continuity of the tradition in which they were trapped is, as has been indicated, broken up. This possibility can be activated in a number of different ways. Two of the most constructive involve working with the understanding that what is displayed in either text or painting also displays a series of determinations that enact the necessarily present dimension of power and position within tradition. The other is the use of the frame to reframe the actual categories in which the interpretive act has already framed the work. In using the work against its already present reception the work comes to be given again.

Moving from the place of either interpretation or philosophy to the site of artistic activity will bring further considerations to bear. While it should not be thought, as was suggested, that these divisions are absolute, it remains the case that there is an important difference. The latter form of activity is comprised of undertakings that are given to be understood. When what is given is itself working with a distancing of dominance, then the demands made upon the categories of understanding will entail that what is conventionally present in order to understand will no longer be apposite. As such what arises is that state of affairs in which works of art force interpretation, and thus philosophy to think through their own initial inability to take up what has been given. It is precisely this particular encounter between artistic activity and the practice of understanding that is also being staged here.

Finally, where this leaves the body is not as a site that could be substituted for another – such a possibility is precluded by the body's own tradition – but as a locus in which gender, philosophy and the insistence of interpretation interweave to create other possibilities for thinking. These others however are not futural projections with a utopian hue but active engagements which via the process of repetition and reworking work to create an intense present.

Note

1 Rather than offering a running commentary on the texts and work presented here these introductory comments are meant to provide an interpretive overview of the journal's specific project in relation to the body. It will of course be a project that allows for generality.

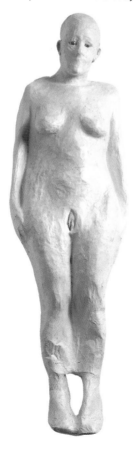

Kiki Smith, Virgin, *1993, paper, glass, plastic and metho-cellulose, 155x47x23cm*

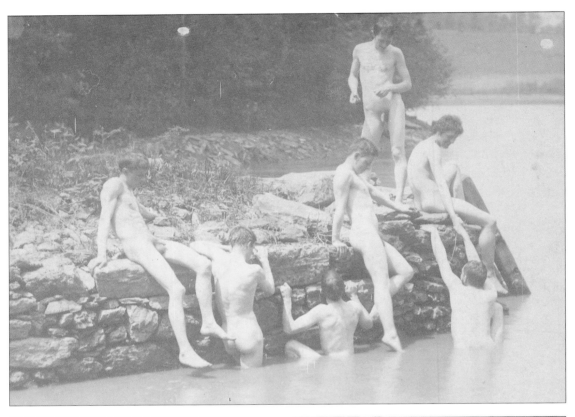

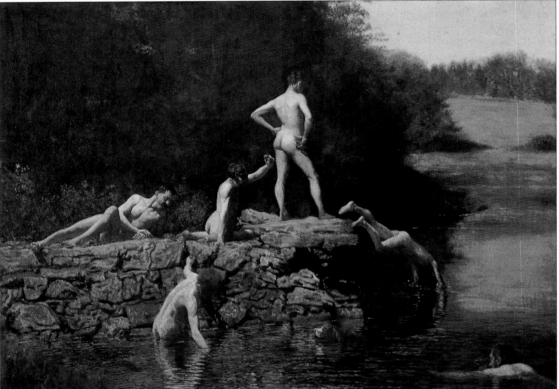

FROM ABOVE: Thomas Eakins, Eakins' Students at the Site of *The Swimming Hole*, 1883, *albumin print on paper 15.4x19.8cm; Thomas Eakins, The Swimming Hole, 1883, 68.5x91.5cm*

MICHAEL HATT

THE MALE BODY IN ANOTHER FRAME
Thomas Eakins' The Swimming Hole as a Homoerotic Image

Thomas Eakins' painting *The Swimming Hole* presents us with a problematic history. The patron, Edward Coates, the director of the Pennsylvania Academy of Fine Arts, first demanded changes to the picture (painted on commission in 1884-85), and then, on its completion, rejected it in favour of another canvas by Eakins, *The Pathetic Song*. This latter work, a portrait, was deemed by Coates to be 'more representative' of Eakins' work[1], although at this stage in his career Eakins was by no means established as a portraitist. *The Swimming Hole* seems to have been ignored for the rest of the artist's lifetime, being exhibited only once, at the Pennsylvania Academy's annual show in 1885, and apparently attracting no critical reaction. The evidence that suggests that the picture may have been controversial coupled with the absence of any documentation is tantalising and frustrating. Art historians have assumed that the painting and its subject strained the limits of acceptability in late 19th-century Philadelphia, and that the use of the male nude in the representation of the homosocial is, at base, what consigned *The Swimming Hole* to a basement for so many years. In exploring the painting, it is this subsequent history – the history of the image in recent cultural and art historical work – with which I want to begin. Not only do I want to deal with the silences of the late 19th-century, but I also want to challenge the views of the image that have become commonplace in recent publications.

Responses to the painting in recent scholarship reiterate the sense of its being problematic. While accounts of the painting place it centrally in Eakins' output, and, indeed, in the canon of 19th-century American painting, art historians have not engaged with the image in the same way that they have with other works by Eakins.[2] Gordon Hendricks, for example, in his monograph on the artist, declares that *The Swimming Hole* is 'a major work from Eakins' Academy years'[3] but then spends only two brief paragraphs discussing it. In part, of course, this paucity of analysis is due to the lack of documentation. For both more traditional art historians interested in authorial intention and social historians of art seeking audience responses, the primary material of letters, contracts, reviews, and reports is missing. Significantly, though, attempts to fill this absence, to speculate or to find alternative methodological approaches

that might allow something to be said about the painting, have not been made.

In addition to the silence that surrounds this specific image, there is another silence to contend with but one, I hope, that may be made to yield a history: the critical silence around Eakins himself in the 1880s and 1890s. Much of the secondary literature on 19th-century American painting offers us an extremely distorted view of the contemporary art world. Whilst art historians have tended to characterise the end of the century in terms of the ascendancy and triumph of realism, represented by the triumvirate of Eakins, Winslow Homer and Albert Pinkham Ryder, of these only Homer received any acclaim at the time.[4] Art history has reinstated Eakins at the pinnacle of 19th-century art, but has overlooked the fact that his contemporaries often viewed his work very differently. In discussing the work Eakins produced at the nadir of his career – the last 15 or 20 years of the century – it is important to remember that the American art world was far more interested in mainstream academic painters such as Gerome, landscapists like Millet, and sentimental genre painting.[5]

Given these limitations in the literature, what *has* been said about *The Swimming Hole*? Principally, there are four major kinds of response, but all of them have as an intentional or unintentional focus the issue of male sexuality. The first response, which is the most extreme and the most inaccurate, is that represented by Edward Lucie-Smith who, in his book *The Body: Images of the Nude*, describes the painting as an autobiographical image which, while overdetermined, is the outcome of 'the matter of Eakins' own suppressed homosexuality'.[6] Eakins, for Lucie-Smith, is beyond doubt homosexual, and this image is a manifestation of his desire for other male bodies. There are numerous problems with this suggestion, not least that it pays no attention to the historical viability of our modern notion of 'the homosexual'.[7] It ignores the enormous difficulties presented by trying to find evidence for this assertion, and seems to rest on the argument that if a male painter chooses to paint the male nude then that choice must be sexually motivated in a completely straightforward manner. The use of the word 'suppressed' rather suggests a vulgar Freudianism that fails to take account of the dynamic and economic relations between the

systems of the conscious and the unconscious.[8]

In a far more sophisticated argument, Michael Fried also raises the issue of repressed homosexual desire. In his long and brilliant essay on *The Gross Clinic* [9], Fried only refers to *The Swimming Hole* in a footnote, but it is an instructive aside. The footnote appears in the context of a discussion about Freud's Schreber case study and 'the "paranoiac" scenario based on the homosexual wish-fantasy of being sexually possessed by another man.'[10] Casually, at the margin, Fried adds that 'another major painting by Eakins in which homoerotic fantasy would appear to be in play is of course *The Swimming Hole*.'[11] There is an awkward tension between the assertive-ness of the statement – 'major painting', 'of course' – and Fried's uncertainty in saying that fantasy 'would appear' to be 'in play'. Moreover, there is a very telling switch from homosexual to homoerotic. Without explaining the difference between the terms, or why he applies one to Gross and one to the bathers, Fried exacerbates the sense of uncertainty.

In spite of the enormous differences between Lucie-Smith and Fried, both point to the repressed homosexuality of the artist as central to the image and, therefore, suggest that finding a meaning for the painting depends upon tracing the relation between the artist's sexuality and his work. In the other three responses I want to describe, this notion is not challenged, but is diluted or qualified in various ways.

A number of commentators have presented the image as imbued with a broadly homosexual spirit, particularly by linking it to the poetry of Walt Whitman. William Gerdts offers the clearest exposition of this kind of discussion:

> There is . . . something very sexual about this work, as indeed there is about Eakins' other depictions of male nudity. . . . Such sexuality is lacking in Eakins' few treatments of the female figure. Whether conscious or not, homosexuality may have contributed to a sympa-thy with Walt Whitman, whose great portrait Eakins painted, and whose poem 'Twenty-eight Young Men Bathe by the Shore' bears literary analogy to Eakins' *Swimming Hole*.[12]

In effect, this amounts to little more than a more circumspect version of the Lucie-Smith thesis, but bearing an apparent historical credibility through the reference to Whitman. The same poem is cited as an analogue by Evan H Turner[13], while Donelson Hoopes merely refers to the painting's 'Whitmanesque abandon'.[14] The painting is also used as the front cover illustration of the Penguin edition of Whitman's poetry, and one of the associated photographs Eakins made of his students bathing at the site of the painting is used by Guy Hocquenghem to illustrate a discussion of Whitman in a book about homosexuality.[15] It is almost as if Whitman's homo-sexuality – and this, of course, is never problematised – can simply be used to bear witness to Eakins' homosexuality.

Thirdly come a number of writers who write with a more sophisticated model of homosexuality.[16] Emmanuel Cooper, for instance, makes it clear that 'none of [Whitman, Eakins, and Tuke] can be seen as homosexual in the modern sense of the word,' although 'all expressed at some time powerful homoerotic qualities in their work.'[17] This shift in terminology – from homosexual to homoerotic – ultimately seems to make little difference. In discussing *The Swimming Hole*, Cooper veers back to the orthodoxy of the examples above. The picture is a 'physical and symbolic demonstration of Eakins' own homoerotic interests' and relates to the themes of Whitman's *Song of Myself*.[18]

Finally, there are those writers who deny the fact that Eakins was homosexual. It may seem as if their inclusion here is misplaced, but what is particularly interesting about these historians is that they feel the need to reject explicitly a charge of homosexuality without actually citing the accusa-tion they refute. Sexuality continues to be the focus of the image even when it is being disavowed. The spectre of deviance is, it seems, immediately raised by the sight of the male nude in *The Swimming Hole*, and the ensuing anxiety is only too apparent. Consider, for instance, Gordon Hendricks, who also mounts his argument via the photographs:

> Some have considered such photographs as evidence that Eakins, if not homosexual or bisexual, was at least homoerotic. But the artist would undoubtedly have done the same thing with his women students if such a thing had been possible.[19]

That's all right then. Indeed, it's very revealing that Hendricks is so eager to recuperate Eakins for heterosexuality.[20]

Together, these diverse responses, manoeuvring around the notion of homosexual desire, consolidate the image as problematic. It is addressed as an articulation of desire, with little historical attention paid to the possibility of such a transparent articulation and, more to the point, what it might have meant for a 19th-century American. A reference to Walt Whitman is simply not sufficient as a means of covering this ground, and what are supposed to be historical connections are little more than a veneer on a psychobiography, founded on essentialist notions of gender and sexuality.

Here, I want to do two things in response to this use of the painting. Firstly, I want to challenge the categorisation of the image as homosexual. Indeed, I want to challenge the very ways these suggestions are framed and ask instead, as Thomas E Yingling does, 'How may homosexuality be organ-ised as a system of inquiry that moves beyond the question of thematics to the problem of representation?'[21]

In order to move beyond thematics, I want to interrogate the image in such a way that we can shake off apparently straightforward speculation about the artist's sexuality. In-stead I shall address a series of specific questions: does *The*

Swimming Hole express desire? If so, can this desire be described as homosexual? Is such an explanation of the painting compatible with the history of its circumstances of production and its social location? In attempting to pose, if not answer, these questions, I shall begin with the idea of the homoerotic, a term frequently used in relation to the picture. In doing this I shall engage with a second task, which is to ask how the homoerotic might be defined; how it might be used to conduct or to intervene in an analysis of an image, and whether it can be a more useful tool, as a discrete theoretical category, than a model based on a speculative reconstruction of Eakins' unconscious.

Towards a Definition of Homoeroticism

> As we stood around the flickering blaze that night I caught myself admiring the splendid bodily vigor of Capron and Fish – the captain and the sergeant. Their frames seemed of steel, to withstand all fatigue; they were flushed with health: in their eyes shone high resolve and fiery desire.[22]

This quotation from Theodore Roosevelt's account of his experiences in the American-Spanish War of 1898 typifies an important element of the late 19th-century discourse around war and soldiering. The homosocial world of the army camp is a place where the male body is a spectacle, an object of scrutiny for a male gaze. In *The Swimming Hole*, a different environment, also homosocial, appears to operate a comparable visual economy. The naked male body is displayed for a male audience. The bathers might also catch themselves admiring the frames of their comrades.

It seems clear that in this visual economy, in this all-male world, something is going on that we might label 'homoerotic'. In the commonsense apprehension of that term there seems to be little to explain or theorise. The homoerotic unproblematically marks a particular desire of one man for another, an expression of homosexual desire framed in a particular, perhaps subtle or covert manner. However I want to question the apparent ease with which the term 'homoerotic' is used, and to ask what it means to apply it as a description to a text or a painting. What are its implications? What is the status of the homoerotic as an historical category or object?

We need to begin with a definition of the word 'erotic'. Again, this is a word that seems self-evident, but is in fact far from the straightforward term that its dictionary definition ('pertaining to the passions of love'[23]) suggests: as a definition merely seems to beg the question. The erotic is a representation of the sexual. When applied to, say, an image, it provides a legitimation of the sexual nature or the sexual content of that image. To deploy the term is to engage in a complex negotiation of the thorny area of representation and sexuality. First of all, 'erotic' marks a move away from the

corporeal to an ostensibly intellectual or spiritual realm. Without denying the sexual, it predicates the possibility of disembodied desire, a desire that somehow goes beyond mere lust.

'Erotic' therefore represents the body or the sexual as an aesthetic object. Desire is reconstituted as an aesthetic response. The gaze is construed as being concerned not simply with its own desire, but with a disinterested sense of beauty. A particular image of sexuality, then, is validated, or valorised, by its representation as being something which is beyond desire.

Importantly, though, while the 'erotic' aestheticises the sexual, desire is not completely effaced or ignored. Aestheticised desire does not seek to deny pleasure, but, instead, makes a division between good and bad pleasure, good and bad desire, good and bad sexuality that supposedly subsists apart from the interests of the individual. This description of the sexual in aesthetic, that is, non-sexual terms provides the obvious point of entry for a deconstruction of this notion of eroticism and its deployment.

This definition of the erotic also works to create a hierarchy of cultural products; for example, a painted nude is erotic, while a Page Three pin-up is merely titillating. The erotic becomes a way of consolidating cultural categories, such as the opposition between the aesthetic and the pornographic. The ways in which eroticism is defined in relation to diverse areas of social practice is also a clue to the question of how these definitions are produced and circulated. It would, of course, be ridiculous to suggest that there is some authoritative agency that is empowered to construct the erotic and dictate the manner in which it functions. The power to define is not simply inherited by or given to specific individuals or institutions, but is embedded in numerous practices and structures; the determination of the erotic is constantly negotiated in diverse sites. So one might point to cultural critics and historians, audiences, judicial bodies, and so on as participants in the process of definition. This is an extremely complex issue and I do not want to suggest that such a brief analysis is more than an indication of how one might explore the questions of agency and power at stake here, but the central point should be clear: the definition of the erotic is not bounded by a fixed meaning that can be found in the dictionary, but is the product of an overdetermined social process.

What, then, of 'homoerotic'? At first glance it may seem that it is simply the same strategy applied to a homosocial realm. To call *The Swimming Hole* homoerotic is to permit the possibility it presents of male pleasure in the male body. But there are significant differences which present a particular set of difficulties in using the term and in analysing the kind of rhetoric or image it represents; not least because of the

problems created by desire in a homosocial context. The *Oxford English Dictionary* defines the word as 'pertaining to or characterised by a tendency for erotic emotions to be centred on a person of the same sex.'[24] For the *OED* the term is clearly more complex than 'erotic', and the inclusion of the words 'tendency' and 'emotions' suggest that the dictionary is keeping something hidden, or is containing a threat. Interestingly, one of the references given in the *OED* is from Ferenczi's *Sex in Psychoanalysis* which distinguishes between the homoerotic as psychical and the homosexual as biological; and yet the dictionary tells us that the two terms are also frequently used synonymously. We are thus led to believe that the two words, 'homoerotic' and 'homosexual', are both the same and different.

Nonetheless, an analysis of male homoeroticism must begin with male pleasure in a male body; the quotation from Roosevelt's *The Rough Riders* can stand as a paradigmatic instance of this. The most immediate difference from the erotic is that such desire is not validated by its description as homoerotic. Instead, it is validated by strategies that actually refute the possibility of such a label; to legitimate this desire, the erotic has to be denied. This distinction is well-illustrated by male and female nudes. While the description of a female nude as erotic is positive and validating, a male nude has to be validated by a description that refutes any eroticism; for a male viewer to find pleasure in a male body, he has to find a response that effaces desire. The homoerotic functions by concealing itself. Our paradigm, for example, lies on the borders of transgressive sexuality, and requires not only an aestheticisation, but also a disavowal of the sexual. The division is no longer between good and bad, clean and dirty, beautiful and ugly sex, but between the sexual and the asexual or aesthetic. Rather than locating the aesthetic as a potential category within the field of sexuality (a point of contact that we have already identified as the erotic), the aesthetic and the sexual are radically disjoined.

The homoerotic, then, reproduces the erotic inasmuch as it valorises desire, mitigating it by the implicit claim of disinterestedness, but differs from it by actually concealing that desire. It seems to constitute a paradox. This paradox, being central to the issue, is not something to be glossed over, but it has to be separated from a methodological confusion. The argument so far is dealing with two distinct questions: the homoerotic is firstly a rhetorical strategy that effaces the desire that motivates it; but it is also a label the critic or historian might use to name that strategy. It becomes a category that can be imposed on a text or an image to deconstruct it, to reveal the paradox that lies at its centre, thus reinstating desire and reasserting the sexual that is denied. For example, the Roosevelt quotation is homoerotic in that it describes homosocial pleasure as a recognition of

soldierly virtue, an intention for Roosevelt's gaze that apparently bypasses desire. And yet, for the historian actually to declare this to be an instance of homoeroticism is to characterise the quotation as fundamentally concerned with or expressive of desire.

These issues of pleasure and desire cannot be pursued without approaching the relationship between the homoerotic and the homosexual. As alluded to at the beginning, the homoerotic is often taken to mean erotic within a homosexual context; that is, a homosexual version of the erotic, thus validating certain homosexual desire. Indeed, this can be the case – for example, in a certain kind of *apologia* for homosexuality which distinguishes between good, stable gay couples whose desire is founded in love and bad, promiscuous gay sexual partners whose practices are purely sexually motivated. But even so, there is a need to separate homosexual eroticism and homoeroticism. The erotic in the homosocial, where desire must remain unspoken (or spoken as unspoken), is very different from the eroticisation of the homosexual. The homoerotic is not about the validation of homosexual desire but about the articulation of a desire that cannot be validated.

This distinction is the crux of the matter, particularly for the purposes of historical analysis. The danger exists of confusing a generic and necessary homosexual desire with a specific repressed or unformed desire or pleasure; of defining the homoerotic as a representation of homosexual desire *tout court*, rather than as an historically variable subject position. This desire will certainly bear the traces of sexuality but it may not correspond to a modern notion of homosexuality.

How, then, can we characterise the relationship between the homosexual and the homoerotic? In his book *Homosexual Desire*, Guy Hocquenghem says this:

The exclusively homosexual characterisation of desire in its present form is a fallacy of the imaginary; but homosexuality has a specially manifest imagery, and it is possible to undertake a deconstruction of such images. If the homosexual image contains a complex knot of dread and desire, if the homosexual fantasy is more obscene than any other and at the same time more exciting, if it is impossible to appear anywhere as a self-confessed homosexual without upsetting families, causing children to be dragged out of the way and arousing mixed feelings of horror and desire, then the reason must be that for us twentieth-century westerners there is a close connection between desire and homosexuality. Homosexuality expresses something – some aspect of desire – which appears nowhere else, and that something is not merely the accomplishment of the sexual act with a person of the same sex.[25]

Homoeroticism is exactly the mechanism by which the licit and the illicit, the sexually acceptable and the obscene are ostensibly kept apart. It is the discourse or strategy that both articulates that aspect of desire and keeps at bay the threat it poses. However, if we use 'homoerotic' as a category of historical analysis, a concept that we impose on a history from our own position, it becomes something else, something beyond a frame. In his essay 'Parergon'[26], Jacques Derrida, talking about understanding the limits of an object of historical inquiry, says

> This requirement [to distinguish between the internal or proper sense and the circumstances of the object being talked about] presupposes a discourse on the limit between the inside and the outside of the . . . object, here a discourse on the frame. Where is it to be found?[27]

Homoeroticism as an historical tool of analysis is such a discourse on the frame, an interpretive category that traces the border that Hocquenghem has helped us to identify. So, a history of the homoerotic must first pay attention to these two complementary definitions: of homoeroticism in the first sense identified as the frame that separates the homosocial and the homosexual, that is, as a strategy of containment providing a boundary between the two realms; and, in the second sense, the homoerotic as a category of historical analysis, serving as the discourse on the frame, identifying where the frame is and how it operates.

So, the homoerotic marks the visible boundary that divides the homosocial and the homosexual; a steel frame that keeps one out and the other in. But, to identify this frame is to draw attention to, not simply the division, but the dangerous closeness of the social to the sexual.[28] Hocquenghem goes on to call homosexuality 'unnameable'.[29] He is wrong at this point. Homosexuality is only too nameable, even though there may be complex questions of power around the naming process and the deployment of that name (as Hocquenghem himself discusses). Instead, it is the homoerotic that cannot be named, not least because of the way it opens up the field of desire and makes the social/sexual division untenable.

To proceed with an account of the homoerotic as boundary, we must try to grasp how a rhetoric such as Roosevelt's functions; we need to identify the strategies of containment that mitigate desire. Four obvious examples present themselves:

1 By writing self-consciously within a specific discourse, or by participating in a discipline which requires the intention of desire with a different intention such as inquiry. By writing from within, say, sport or medicine, a rationale is offered to explain the insistence of the male gaze on the male body. The rhetoric of desire can thus always be confirmed as absent since desire is understood as being outside the bounds of the discipline.

2 The gaze can be scripted as female. While this is rarely possible in an image, texts can momentarily describe the spectacle of the male body from a female viewpoint. A gaze can be prescribed, even though that gaze be ineligible for the homosocial space in question. In Owen Wister's novel *The Virginian*, for instance, the narrator, on first seeing the eponymous hero in circumstances that a woman could not, remarks that if he were a woman his gaze would be charged with desire:

> Lounging there at ease against the wall was a slim young giant, more beautiful than pictures . . . No dinginess of travel or shabbiness of attire could tarnish the splendour that radiated from his youth and strength . . . Had I been the bride, I should have taken the giant, dust and all.[30]

3 The pretension to a purely aesthetic response. The body can be reduced to a representation; if, for example, it is described as a sculpture. This resembles the second strategy in so far as it denies the necessary agents of the transaction (ie male gaze and male body) but of hypothesising a different corporeal gaze, the object of the gaze is transformed into an object which validates the claim to a disinterested response.

4 Perhaps most importantly, hierarchies are deployed. Categories of otherness are established which turn the gaze into an administrative instrument. Looking is a legitimate function of power. The object might be of a different race, in which case the gaze can become ethnographically superior; it might be a difference of age, or of class; and in Roosevelt's case, of course, it is a question of rank, the colonel reviewing the troops. All these redefine the object as a legitimate spectacle, and the pleasure of viewing as distinct from mere desire.

So far, then, we have a definition of the homoerotic, albeit a split one, and a sense of both what its role might be and how it might function. But one difficult question remains. How can we tell what is homoerotic and what isn't? What are the boundaries of the boundary itself?

Again, perhaps a turn to deconstruction can help address these questions, not so much as a means of providing an ostensibly definitive answer, but to help explore the sense of such questions, to pinpoint what is at stake, and to assess the extent to which these questions might be answered at all. To begin with, this split definition, the difference of homoeroticisms – or perhaps the difference *within* homoeroticism – raises an important issue for history. Whilst such a deconstructive approach may yield results in a purely textual analysis, is there not a problem here of leaving behind or misrepresenting empirical history? Might not the very use of the term be anachronistic to the point of historical invalidity?

The relationship between deconstruction and history is, of course, far from stable. Much deconstructive work, particularly in the field of literary studies, is either unconcerned with historical questions, or works with a reductive or uninformed view of what historians do.[31] Nonetheless, a number of practitioners – and unsurprisingly those who make the claim for a Marxist deconstruction such as Gayatri Spivak[32] – insist on an implicit historicism in Derrida's work. Whilst the arguments are far too complex to be entered into here, I would contend that deconstruction can be a useful tool in the unpicking of certain historical problems; and I certainly believe it can help us in dealing with the homoerotic.

Let us turn for a moment to Derrida's essay 'Le facteur de la verité'.[33] At the beginning of the essay, Derrida makes some brief comments about Freud's deployment of the notion of truth as a hidden object waiting to be unveiled. In *The Interpretation of Dreams*, examining Oedipus, Freud establishes a rule: everything in a text that does not constitute the semantic core of the two 'typical dreams' he has just defined (incest with mother and murder of father), everything that is foreign to the absolute *nudity* of this oneiric content, belongs to the 'secondary revision of the material'.[34]

Thus, according to Freud, says Derrida, any interpretation of Oedipus as something other than this essential semantic core, ie the Oedipus complex, is supplementary, something added to deny this naked content. But, as Derrida's work repeatedly demonstrates, such a notion of an opposition between the essential core and its supplement, between semantic content and its formal covering, between nudity and unveiling, is deceptive. According to the 'logic of the supplement'[35] the core is dependent on or even constituted by its derivatives. So, Freud's idea of a naked truth is produced by or derived from these secondary revisions.

When Freud intends to denude the original *Stoff* beneath the diagnosis of secondary fabrication, he is anticipating the truth of the text.[36]

At the heart of this is the argument from 'Parergon': where is the boundary that delimits the primary and the secondary, the *Stoff* and its revisions, the beginning and end of analysis? 'Where is it to be found?'

One might argue from this that my analysis could be criticised in the same way that Derrida reproaches Freud: that 'homoeroticism' suggests a naked truth, namely the presence of homosexual desire, and that I have anticipated this in my unveiling. But this, in fact, is the criticism I want to make of those readings of *The Swimming Hole* cited at the beginning of this article. It is there that one finds the diagnosis of the secondary fabrication of the painting to anticipate the apparent truth of Eakins' homosexuality. What I want to suggest in opposition to this view is that in, for instance, our examples of Eakins and Roosevelt, it is not that

there is an authentic desire waiting to be unveiled, but that the sense of a boundary between licit and illicit, the frame of regulation, produces the idea of such a naked truth. In other words, I want to reverse the process of unveiling, the process that anticipates a truth, and to try to identify the process of veiling or containment that produces the very possibility of the naked or true. This should make it clear why it is so important to differentiate between the homosexual and the homoerotic as distinct categories; because, if we do not, then the homoerotic comes to stand for or anticipate the homosexual. Deconstructing the term, then, enables us to conceive the homoerotic as the process of finding a place for certain desires between men, not as an already formed desire looking for an object, but as a desire that emerges from or is actually shaped by a disciplinary frame or method of containment.

In all the methods of containment thus far identified, and serving as, at least, a starting point for an analysis that could be used in an historical case study rather than simply standing as a piece of abstruse theory, I want now to suggest that the homoerotic can be identified by a displacement where the nonfunctional becomes functional; where, for example, the gaze of pleasure becomes a legitimate gaze. *The Rough Riders* is full of looks and feelings of fraternal love and soldierly mutual devotion. This shifts from affection and desire to a means of cementing the ranks, of inspiring the men to fight. In questions of race, the pleasure of the black body is obscured by an aspiration to, for instance, an ethnographic or racist purpose;[37] and the gaze directed on the body of the youth comes to be a means of discipline, part of a regime of health, designed to ensure purity.[38] It is not enough to identify a homosocial scrutiny of the body. We have to find the places where such a scrutiny is pulled back from the obscene to the acceptable.

The Swimming Hole: Homoeroticism and the Male Nude in Late 19th-Century America

I now want to turn to Eakins' painting but, before trying to offer a more considered, more theorised account of the extent to which *The Swimming Hole* might be described as homoerotic, I want to mention some general methodological problems arising when dealing with the male nude. First of all, the history of the male nude itself poses a problem. Its rise and fall, and its eclipse by the ascendancy of the female nude as aesthetic prize par excellence in the 19th century, has yet to be explained sufficiently and, consequently, the status of the male nude is uncertain. Secondly, in art history, the female nude is normally defined in terms of desire (albeit as 'erotic' according to the account given above).[39] The insistence on the female nude as the object signifying desire tends to mean that the male nude, in a heterosexual discourse, denies

desire; that is, the homoerotic, the placing of limits on the articulation of desire is already in play in art history. Thus the issues raised here, such as homosexuality and the eroticised homosocial gaze, do not have an easy legitimacy in the art historical field. Thirdly, there is a tradition of the male nude to be taken into account. In analysing a specific nude we must remember that it inevitably stands in a tradition stretching back to classical antiquity, a tradition that was used or invoked repeatedly, and thus any discussion of desire has to be made in or against the context of a convention.

Outside these problems internal to the history of art are further methodological difficulties specific to the history of late 19th-century America. The male nude cannot stand apart from other ideas about the body in circulation when the work was produced, although it has to be recognised as a discrete category. The changes in definitions of normative masculinity, in particular the growing insistence on the body as a physical embodiment of masculine virtue in the last quarter of the century, the conflation of muscles, manners and morals, must be understood as having some bearing on art or representation in a more general sense. Both subject and style are pertinent and raise complex questions of how the body and its representation are related. At what level are links forged? How far can one go in reading social ideas in the image and the art history in which it is located?

There is of course a concrete point of contact between the two histories which is the social history of the nude in 19th-century America. The reception of the nude, and the protocols regarding viewing and use, were different from Europe, principally in the greater prudishness of the American public and art world. From the 1830s, when Horatio Greenough's sculpture of nude cherubs cause a scandal, through the grudging acceptance of Hiram Powers' ideal female nude in marble, *The Greek Slave*, to Eakins' own problems concerning the difficulty of using the nude both in teaching at the Pennsylvania Academy (particularly shocking in female art classes), and in his painting, the nude never had the legitimacy in America that it had in, say, the Paris Salon. Moreover, its use became restricted to certain forms of production. While idealised sculpture could present the nude (as a classically validated object), realist painting could not; while aesthetic painters like Edwin Blashfield and Kenyon Cox could paint allegorical female nudes, the notion of the real body exposed in the studio was potentially scandalous. In 19th-century America, then, more so than in Europe, the nude was already a threat, already on the borders of the obscene, and articulated as such. It could not be recuperated by the idea of the erotic (as in, for example, the valorisation of desire as happens in European Orientalist painting), and more often gained ground by the appeal to antiquity and, therefore, the purity of the ideal and its ostensibly disinterested aesthetic gaze.

The issue, then, is not only a question of the subject of the painting, but of the body and its representation. But to suggest that a simple proscription of the male nude was in force would be both historically inaccurate and theoretically untenable; it would not only deny that the male nude was represented in America in the 1880s and 1890s, but would also understand subject as prior to style rather than in a dialectical relation. Instead, the suggestion that style is a principal parameter for the categorisation of the nude into acceptable and unacceptable should alert us to exactly how unstable a category 'the nude' is. We have to contend with not only the differences of male and female, and of the different bodies that are consolidated by style, such as the body of neoclassical sculpture, but also with the different ways of reading the nude engendered by institutional contexts, and the criteria for licitness or illicitness that arise from the conjunction or disjunction of subject, style and audience. All these divisions make the nude a field of difference rather than the solid, unimpeachable category of the connoisseur.

Furthermore, to destabilise the nude in this way makes it clear how easy it would be to overemphasise opposition to the nude in 19th-century America. Nudes certainly did shock – and Eakins is an obvious reference here – but disapproval depended on what nude was placed in what context. Arguments against the nude were by no means all of a piece. The kind of hostile response to Eakins' *Agnew Clinic*, for instance, which deplored the medical setting, the sense of violation to the body, and the unsuitability of the painting as an object for women to look at, was very different to arguments against Greenhough's *Washington*, which focused on the unsuitability of the pose, the classical costume, and the absence of historical reference in a world depicting the pivotal figure of American history. The problem of the male nude in *The Swimming Hole*, therefore, is sure to be more complex than a straightforward and unproblematic hostility to a generic nudity. Moreover, while many nudes, male and female, were deplored, others were actively promoted. In the same show at the Pennsylvania Academy in which Eakins' canvas was hung in 1885, a plaster model of Rodin's allegorical male nude, *The Age of Bronze*, was presented and acclaimed.

So what exactly is the problem here? I want to argue that Eakins' attempts to contain desire, the strategies he adopted to legitimise his use of the nude, were, for his contemporaries, invalid. He failed in respect of all four strategies outlined above: *The Swimming Hole* resists discursive rationalisation, acceptable modes of spectatorship, aestheticisation, and reading in terms of power.

Eakins' work can be understood as participating in a redefinition of masculinity, not least in his portrayal of

homosocial spaces – the boxing ring, the gymnasium, the clinic, the rowing club – the kinds of site where a new physical ideal of masculinity was constructed. This new ideal was, essentially, a paradigm whereby gender was understood to be literally embodied. Eakins' subjects tend to accord with those disciplines such as sport, war and scouting which regulated the body and the moral values it incorporated; disciplines which work against the threat of the unmasculine, the feminine, the sissy, and so on. *The Swimming Hole* presents a problem in this respect, though. One of Eakins' quirks was a wholehearted belief in naturism, in the beneficial effects of naked activity in the open air. With his male students from the Academy, he would go off for naked romps in the woods outside Philadelphia and, of course, *The Swimming Hole* is based on a series of photographs Eakins made during these jamborees. While the idea of fresh air, physical exercise and the casting off of over-genteel civilisation were all acceptable to contemporary attitudes to male behaviour, Eakins' parties were disapproved of. The problem was that outside a discipline, outside a regulated space where the male body was a legitimate spectacle and where looking was controlled, the possibility of unregulated pleasure arose; that is, the homosocial was threatened with the explicit articulation of desire. Why did these young men remove their clothes, bathe together, wrestle and generally fool around? It may have been something to do with health and exercise, but, if so, why were they not at a gymnasium, at a YMCA or in a sports club? These institutions had, after all, been set up to some extent to prevent actions such as these, and to provide a proper, moral, disciplined framework for such activity.

But if evidence of such a social framework was absent, what of aesthetic traditions surrounding the nude? It is at this juncture that a discussion of style becomes crucial. Almost all discussion around the style of the painting seems to centre on the notion of realism and Eakins' use of photography. The series of photographs taken at the site of *The Swimming Hole* are interpreted as preparatory studies, mechanical reproduction in the service of art. Two points have to be made immediately about the photographs. Firstly, they are all too often invoked as part of an argument which defines realism as a transparent process, one which simply transfers a real event onto canvas. The limits of style, the extent to which aesthetic judgement intervenes, can simply be read from the difference between the photograph and the painting. This, of course, fails to address both the question of photography as production and of the sense of realist painting as no less stylistically constructed than any other kind of image. Secondly, the photographs have an uncertain status as evidence. Few of Eakins' contemporaries would have seen them, so their usefulness in an historical reading of

the reception of the painting may be limited to the point of irrelevance.

Where the photographs *do* help us, though – at least within the methodological framework I have established here – is in tracing the process of re-forming the body as nude in Eakins' practice; that, is, the process of containing the body and, ultimately, of engaging the homoerotic. A comparison of the photographs and the painting are a further illustration too of the need to subdivide the category of the male nude. The photographic nudes are further formalised and idealised in the painting. Bodies are turned to remove the penis from sight, poses are stabilised, and models from the lexicon of the academy are invoked – the clearest example is the figure lying on the rock, based on the famous antique statue of *The Dying Gaul.*

The intervention of academicism between the two regimes of representation, photography and painting, raises the awkward question of the extent to which Eakins and *The Swimming Hole* can or should be described as realist. The problem is that in the canons of art history, styles have been consolidated as self-sufficient terms, whereas in 19th-century America, 'realism' was more a comparative term. Often, art was categorised not according to notions of style, but generically.

The division between landscape and figure painting, for example, was a more obvious one than that between, say, realism and romanticism. More importantly, realism was most frequently deployed in a philosophical, or to be more precise, pseudo-philosophical sense, as the antithesis of idealism. In this definition, realism is less a style and more a precise of artistic production. I do not raise this issue in order to undermine all notion of style, or to suggest that style was not understood as a taxonomic principle in 19th-century America, but, firstly, to point up the historical specificity of these terms,[40] and, secondly, to reconsider the relation between style and the body.

Rather than thinking of this relation in terms of style as something imposed on the body, that is, as if an unproblematic given is represented according to specific stylistic criteria, we need to attend to the ways in which different styles produce different bodies, different nudes. This should make us rethink the importance of style in relation to *The Swimming Hole* as more than a simple formula of realism plus the nude equals unacceptable. Instead, we need to try to understand how Eakins' style failed to complete the nude, failed to fill the absences that would have been all too apparent to contemporary critics: an absence of a moral content to the nude; an absence of allegorical or analogical levels in the picture; an absence of a narrative justification for the body. The nude as genre fails to compensate for the absence of the disciplinary framing.

Indeed, the issue largely depends on the very definition of the nude and the corresponding notion of the limits of decency of the unclothed body. Too many accounts of nudes have been confounded by a reliance on Kenneth Clark's distinction between naked and nude,[41] which, while an important difference, fails to take into consideration how that difference is made. Clark's book stabilises the fluid category of the nude, and my argument here is that in 19th-century America the artistic styles in which the nude is permissible are those which, in the same way, stabilise the nude and allow 'nude' to function as a pure, undifferentiated sign.[42]

This is often, crucially, a question of tradition, of the aetiology of the nude. In ideal sculpture, the nude is, of course, legitimised by a centuries-old tradition, by the classical paradigm, and so a statue by Harriet Hosmer or William Wetmore Story is not merely permissible, but actually desirable;[43] it is actually the display of the body which, in part, accounts for the huge success of the work of sculptors like Hosmer and Story. The ideal, the neoclassical, contains the body, submits it to a regime which solidifies the body both literally, in transforming it into a statue, hard and three-dimensional, and metaphorically, as something clearly defined, outlined, and taking on a moral impenetrability from its material existence. This, I would venture, is the basic meaning of the trait that Clark refers to as *cuirasse esthétique*.

Beyond this, though, is the question of the very impetus of that tradition. Consider these two quotations: first, Harriet Hosmer writing in 1894, arguing for neoclassicism in sculpture over the modern school of realism:

> Deprived of these magnificent monuments of human genius [ie antique statuary], we could form no conception of the beauty of which human form is capable.[44]

And now, fellow sculptor William Wetmore Story, from his book *Conversations in a Studio*:

> The Greek artist in his ideal works never suffered himself to be seduced by any accidents of the model from principles established by long study of the varying forms of nature . . . All the ancient sculpture has a style of its own: whether the individual work be good or bad in execution, it is founded upon a distinct and scientific distribution of parts . . . Modern sculpture, on the contrary, is full of accident. It is domineered over by the model . . . Part by part it is worked out, but without any understanding of the whole and without any style. Imitation is its base, because imitation is carried out without principles and without selection, and what is seen in the model is copied and taken as absolute.[45]

For Story, the starting point of the representation of the body is another representation: a body that has already been measured and purified. Similarly for Hosmer, the beauty of the human form is evident not in real bodies, but in classical representations.

These statues become the starting point for a sculptural or aesthetic tradition, a representation that *precedes* the flesh-and-blood bodies of models. This argument removes the body from the tradition entirely; it is art itself that is both model and representation. The process of sculpture, of the transformation of flesh into plaster, marble or bronze, is a process of repetition; the repetition of the erasing of the model's body from the tradition of the nude.

In another of the dialogues that make up *Conversations in a Studio*, one of Story's speakers says

> The Greeks always had the nude before them, and felt no sham modesty in exposing their person. In the annual festival of Neptune, the most beautiful girls in Athens went nude along the shore and bathed in the sea while all the assembled world looked on. There was no idea of immodesty in this. It was a religious rite. On these occasions Phryne, in the perfection of her beauty, showed herself to the admiring eyes of all, looking like Aphrodite as she rose from the sea.[46]

In this bathing picture, Story's tone emphasises the aesthetic gaze. Modest, religious, perfect, transcendental, the naked female body – or nude, as Story chooses to describe it – and the gaze of the viewer are complements in an aesthetic economy. Again the flesh is displaced, and touch is denied, as is, indeed, the radical connection between touching and looking.

A number of factors, then, to which we might add the materials of sculpture, and anatomical schematisation – the solid outline sub-divided into clearly defined interlocking areas allowing no leakage – combine to render the sculpted body a sign that effaces its referent; and this is true of both male and female nudes. Idealisation was largely a process of imposing a system of proportion (such as the one Story himself formulated, in emulation of conjectured Greek treatises[47]), of muscular formations, and of physical completeness on the model. It is exactly such a metamorphosis of anatomy through the medium of taste that allows neoclassical sculpture in 19th-century America to stabilise the nude, and make it useable.

Realist painting, as Eakins practised it, on the other hand, works in exactly the opposite direction. Compare Hosmer and Story with this quotation from Eakin:

> I don't like the long study of casts, even of the sculptors of the best Greek period. At best they are only imitations, and an imitation of imitations cannot have so much life as an imitation of nature itself. The Greeks did not study the antique: the *Theseus* and *Illyssius* and the draped figures in the Parthenon pediment were modelled from life, undoubtedly.[48]

The emphasis here is very much on flesh, on the primacy of

the body even in the classical tradition. The body is defined as the origin rather than the supplement of art. An interesting visual analogue is provided by an oil sketch Eakins made for a projected painting of *Phidias Studying for the Parthenon Frieze* (undated, but likely to be *c*1885-90), in which the Greek sculptor is shown drawing two naked horsemen from life. Since this is only a sketch, arguments about style are unlikely to hold water, but I think one can still gain some insight from the very fluid nature of the brushwork which emphasises the body as flesh and minimises outline. In a sense, this is what one would expect from an oil sketch, but a preparatory study by, say, Gerome, would be by no means as unfettered in its approach to either paint or corporeality.

Moreover, Eakins insisted on the impossibility of disconnecting touching and looking, which would have been both theoretically and practically unacceptable to much of the late 19th-century art world:

> Feel the model. A sculptor when he is finishing has his hand almost continually on the model.[49]

Such attitudes, and their stylistic consequences, immediately destabilise the nude as defined by Story and Hosmer. While ideal sculpture demonstrates that style can purify the body by its treatment of the physical and by the motivation it offers the gaze in terms of a specific moralising narrative or of a generic appeal to tradition, realism does neither.

Eakins' approach to the body, then, is sufficiently different from that of many of his contemporaries to mark him out aesthetically, stylistically, and morally. So what exactly *is* the 'realism' of the style of *The Swimming Hole*? What does it mean? And how is it constitutive or symptomatic of the distinctions between the homoerotic, the homosocial and the homosexual?

Firstly, let's return to the photographs that Eakins made of his students bathing at the site of the swimming hole. As I have already pointed out, these photographs are frequently offered as some kind of concrete evidence of Eakins' realism; here, after all, is the 'real' event that the painting describes, an event, moreover, that is empirically proven by the testimony of the objective camera. This is, of course, an untenable position. It is all too easy to find fault with such an argument, and one can attack it on many fronts: it conflates an apparently unmediated view of reality with photographic and painted representations of the world; it pays no attention to the diversity of definitions of realism; it gives the photographs undue importance as evidence; and, perhaps most problematic of all, it fails to understand realism as a style or set of aesthetic conventions. To counter this omission, and to try to tease out some of the connections between style and the homoerotic, we need to look at the painting in a very specific way. Clearly, the photograph and its revision on the canvas offer an image of unacceptable behaviour. As the

examination of the nude has shown, art could render the unacceptable acceptable for the contemporary audience, but Eakins' art fails to fulfil this function. There must, then, be something particular about the painting that was unpalatable to Eakins' contemporaries, that goes beyond the issue of what is represented.

Before leaving subject matter behind altogether, though, what kind of location might we find for this painting in traditions? More than anything, in terms of 19th-century categorisations, *The Swimming Hole* is a kind of genre painting. The history of art is littered with bathing beauties of one sort or another, and while most of these might be female, there are important exceptions such as the Michelangelo *Battle of Cascina* cartoon, or John Singer Sargent's successful canvas *Boys Bathing*. Moreover, in America at this time, the subject of boys at a swimming hole was a popular subject that formed an important part of the myth of the barefoot boy, the picturesque and innocent rural child.[50] As I hope I have already demonstrated, the distance of Eakins' picture from both these precedents made it potentially transgressive; it was too 'realist' to conform to Michelangelesque high art, and too unsettling in terms of its content to be just another outdoor life painting. More important than the specific history of these images, however, is the general mode of signification of genre painting. To raise the trivial to the level of art is to suggest that the image represents something beyond its ostensibly banal content. For the art audience of late 19th-century America this did not necessarily mean that every genre painting was imbued with an allegorical meaning, but that such work at least confirmed a view of the world that was true to the bourgeois, Christian, sentimental and nationalistic ideals of America. While a picture of boys bathing might be less than profound, it endorsed the notion that America was untainted, innocent, that there was a place for everything and everything was in its place. Eakins' painting not only fails to do this, but rather offers an alternative: it draws attention to the disjunction of scene and participants, and describes the relocation of mature male homosociality in the unregulated and unspecific landscape. *The Swimming Hole*, then, resists discursive rationalisation. It cannot be explained in terms of either an assumed real event, or in terms of generic protocols. Rather than confirming social order, it shows the displacement of the social framework.

There is also more to be said about the realist nude here. We seem to be at a point where Eakins' nudes are somewhat paradoxical; on the one hand, I described them as subject to some of the conventions of academicism – the removal of the penis from sight, the reference to *The Dying Gaul* – and yet, on the other, Eakins seems to have challenged attitudes to the nude. The point is that in spite of the academic gestures, the description of the flesh in *The Swimming Hole* is such that

the body appears as unstable. The poses are formal, but are arranged in a string almost like a photograph by Muybridge. Indeed, that comparison is quite telling; Eakins worked with Muybridge, and made photographs himself which detailed movement, showing the various positions of the body in motion in a single image.[51] This kind of presentation undercuts the formality of the pose. While the academic nude captures the perfect moment, a gesture which receives its significance from having been frozen, Eakins' suggestion of the transitory nature of the pose, not to mention its instrumentality – that is, pose as always a functional part of a movement – disturbs this orthodoxy.

There is another sense in which Eakins' interest in motility unsettles the tradition of the nude. The nude body here is insufficiently schematised, and presents instead a shifting surface. These nudes are not contained by regular surfaces but are made up of areas of tension and relaxation, of hardness and softness, of muscle and flesh that signify contingency, beyond the safety of the classical pose. Moreover, through their poses, the way that light emphasises specific areas such as the buttocks, and specific movements, and the mobile finish, these nudes represent in too straightforward a way the injunction to feel the model. This is particularly evident in the standing figure whose buttocks are presented to the viewer as the very fulcrum of the painting. The formality of the composition, of any of the poses, actually draws attention to the tactility and fluidity of Eakins' technique, and so both confirm the materiality of the body and the strategies of art to contain the corporeal. What I am suggesting is that these nudes make the operation of the homoerotic too clear.

While it may seem that to read the instruction 'Feel the model' into this painting is methodologically unsound, the economy of gazes in and around the painting appears to support such an analysis. Within the frame of the painting the visual economy does not seem to relate to any established economy of power. There is no hierarchy to determine who can look at whom and with what authority. Instead, looks can be exchanged freely, and no single gaze need defer to any other. It is as if the relations between men, which so often depend upon a strict codification of visual exchange, are opened up to the scrutiny of a gaze that is casual and desiring. This is not to say that desire can be specifically located or identified in the picture, but that it exists as a field of possibilities; looking is determined by wish rather than any more overtly functional structure. There is no obvious answer here to the question of why a man would look at another naked man. Eakins' inclusion of himself, as the figure in the bottom right of the canvas, underlines this uncertainty. Swimming towards the men on the shore, his gaze is the one that is directed; artist and viewer, he simply looks, and in

doing so problematises the homosocial gaze. The arrangement of the bodies emphasises that they are there to be looked at. The poses emphasise display, variety, motion, and invite pleasure more than anything else.

Outside the picture, the viewer bears the consequences of this problematisation. The male viewer is in a difficult position here. The implications of an unregulated visual economy structured by desire make us only too aware of the ways in which homosocial looking is normally controlled. That is, the body, uncontained by style or by protocols of looking, performs the function of the 'discourse on the frame': in offering no functional reason for spectatorship, and thus making the viewer aware of its difference from other representations, it declares the operation of the homoerotic.

In Europe, the presence of vestiges of academicism may have sufficed as a strategy of containment, the classical allusion and academic composition mitigating the threat of unregulated pleasure. The image in Europe may well have been homoerotic in the sense that the Roosevelt quotation is homoerotic, using an index of propriety (in this case, artistic tradition) to mitigate the intrusion of desire into the homosocial. This is not to suggest that the male nude was never a problem in 19th-century Europe – it quite clearly was. But in European academicism, the non-functional gaze upon the male body is more easily assimilated as a conventional element in the construction of the image and is granted an aesthetic function in the appeal to the nude as the basic motif of academic painting. In America, though, the nude is too unstable a category. It is still contested within debates about aesthetics. Permissible in sculpture and classicising discourses, within certain conditions, realism, understood as transparent representation, cannot use it. Eakins' strategy of containment is disallowed.

Whether or not Eakins represents his own desire here, consciously or unconsciously, as debates around the picture have assumed or tried to ascertain, is not really the point. The painting remained for its audience one which made too clear the function of the homoerotic. *The Swimming Hole* described too clearly the border between the licit and the illicit, between beauty and obscenity. It moves from the first definition of homoerotic, as controlling desire in order to maintain a separation of homosocial and homosexual, to the second, a discourse on the first. In this it proves to be transgressive. The gaze it invites – the male gaze on the male body – is offered no context for enjoyment other than delight in the body itself. The male nude is insufficient as a frame if there is no legitimate reason for nudity.

The point is this: the homoerotic is acceptable – indeed, necessary – but to name it is not. *The Swimming Hole* effectively deconstructs the category, and locates its own position as/at the frame. These men have frames we catch

ourselves looking at. They may be as steel; they are flushed with health; their eyes could conceivably be shining with fiery desire. But these frames have no frame of their own, no war or standardised exercise. The style insistently draws the viewer beyond the aesthetic; there is no system of power to accommodate the gaze; and the spectator is interpolated as both masculine and desiring. The image presents the undisciplined male body as the object of a desiring subject.

To summarise, homoeroticism needs to be theorised as both a means of keeping the homosocial and the homosexual apart, of marking the visible relations between men, and as a discourse which reveals those limits and what lies beyond them. In the example from Roosevelt's book, the first of these is apparent. Desire is legitimated by the site, the context of the army and its hierarchy; the gaze is valorised and pleasure can be both functional and aesthetic (and therefore disinterested). In Eakins' painting, this breaks down into the second, and the tenuous division held in place by the homoerotic

becomes visible. The image is therefore deviant.

The category of the homoerotic (if deconstructed as I have tried to do) is, I think, useful. It removes the problem of the potentially inaccurate labelling of something as homosexual, and its permits *us* to talk about the containment of desire as not simple repression, but as a holding-in-place, as much social as psychic. It permits *us* to think desire in an unspecific way; and while one may feel that some degree of specificity is needed, we are dealing here with the formation of desires and the process of their first articulation. The homosexual, while not coming into being for the first time, is evolving into a modern deviance that is now clearly recognisable. Perhaps this process is not something that can be captured in a history, but a fully theorised account of the homoerotic will, I hope, allow us to point to an invisible frame, a something expressed that is in a sense homosexual and yet not merely the accomplishment of the sexual with a person of the same sex.

Notes

1 Letter from Edward Coates to Eakins dated 27 November 1885, quoted in Kathleen A Foster and Cheryl Liebold, *Writing About Eakins: The Manuscripts in Charles Bregler's Thomas Eakins Collection*, Philadelphia, 1989, p 172.

2 Compare, for example, the huge bibliography on Eakins' first major painting, *The Gross Clinic*; see Michael Fried, *Realism, Writing, Disfiguration: On Thomas Eakins and Stephen Crane*, Chicago and London, 1987, pp 163-64.

3 Gordon Hendricks, *The Life and Works of Thomas Eakins*, New York, 1974, p 160.

4 For this kind of view see, for example, Barbara Novak, *American Painting of the Nineteenth Century: Realism, Idealism* and the American Experience, second edition, New York and London, 1979, and John Wilmerding, *American Art*, Harmondsworth, 1976.

5 On the vogue for French academic art and the importance of the Parisian art world to American painting see H. Barbara Weinberg, *The Lure of Paris: Nineteenth-Century American Painters and Their French Teachers*, New York and London, 1991; Lois Marie Fink, *American Art at the Nineteenth-Century Paris Salons*, Washington, DC, and Cambridge, 1990; and Annette Blaugrund et al, *Paris 1889: American Artists at the Universal Exposition*, New York, 1989. For the American penchant for Millet and mid-century French landscape, see Peter Bermingham, *American Art in the Barbizon Mood*, Washington DC, 1975.

6 Edward Lucie-Smith, *The Body: Images of the Nude*, London, 1981, p 26.

7 There is a huge amount of literature on the historical validity of the term and the debate between 'essentialism' and 'social constructionism'. For a useful collection on this question see Edward Stein, ed, *Forms of Desire: Sexual Orientation and the Social Constructionist Controversy*, New York, 1990.

8 Sigmund Freud, 'The Unconscious', *Pelican Freud Library*, vol 11, Harmondsworth, 1984, pp 167-210.

9 Michael Fried, *Realism, Writing, Disfiguration: On Thomas Eakins and Stephen Crane*, Chicago and London, 1987, pp 1-89.

10 *ibid*, p 68.

11 *ibid*, p 172, n 59.

12 William H Gerdts, *The Great American Nude: A History in Art*, New York, 1974, pp 122-23.

13 Evan H Turner, 'Introduction', in Theodor Siegl, ed, *The Thomas Eakins Collection*, Philadelphia, 1978, pp 25-26.

14 Donelson Hoopes, *Eakins Watercolours*, New York, 1971, p 18.

15 Guy Hocquenghem, *Race d'Ep!: un siecle d'images de l'homosexualité*, Paris, 1979, p 89.

16 By including Hocquenghem above, I do not wish to imply that he works with an unsophisticated model of homosexuality; this is, perhaps, the last criticism one could make of his work. The point is, rather, that his use of the photograph by Eakins represents a rather naive approach to the visual image.

17 Emmanuel Cooper, *The Sexual Perspective: Homosexuality and Art in the Last 100 Years in the West*, London, 1986, p 25.

18 *ibid*, pp 33-34.

19 Hendricks, op cit, p 160.

20 Both Hendricks and Lloyd Goodrich are also very revealing in their discussions of Eakins' relationship with his student Samuel Murray. Again, both cannot *not* mention the possibility of homosexuality, but both finish by concluding that the relationship was, in Hendricks' words, 'simply a father-and-son association' (p 221). For Goodrich on this see his magisterial monograph, *Thomas Eakins*, 2 vols, Cambridge, Mass, and London, 1982, vol 2, pp 190-210.

21 Thomas E Yingling, *Hart Crane and the Homosexual Text*, Chicago and London, 1990, pp 24-25.

22 Theodore Roosevelt, *The Rough Riders*, London, 1899, pp 79-80.

23 *Oxford English Dictionary*, 2nd edition, vol V, Oxford, 1989, p 374.

24 *Oxford English Dictionary*, vol VII, p 339.

25 Guy Hocquenghem, *Homosexual Desire*, trans Daniella Dangoor, London, 1978, p 36.

26 Jacques Derrida, 'Parergon', in *The Truth in Painting*, trans G Bennington and I McLeod, Chicago and London, 1987, pp 15-147.

27 *ibid*, p 45.

28 I do not mean to imply here that the sexual is entirely separable from the social, but to mark out licit and illicit male bonds in terms of what the homoerotic makes acceptable – that is, the licit is seen as social and therefore non-sexual; anything sexual is, in commonsense terms, by definition, anti-social.

29 Hocquenghem, op cit, p 39.

30 Owen Wister, *The Virginian, A Horseman of the Plains* (1902), Harmondsworth, 1988, p 3.

31 See, for example, Mark Cousins, 'The practice of historical investigation', in D Attridge, G Bennington, R Young, eds, *Post-Structuralism and the Question of History*, Cambridge, 1986, pp 126-136. This volume is particularly useful in outlining the debate about the position of history in deconstruction.

32 I am thinking here of articles by Spivak such as 'Can the Subaltern Speak', in Cary Nelson and Lawrence Grossberg, eds, *Marxism and the Interpretation of Culture*, Basingstoke and London, 1988, pp 271-313, and 'Subaltern Studies: Deconstructing Historiography', in *Other Worlds: Essays in Cultural Politics*, New York and London, 1988, pp 197-212; or of the pieces collected in *The Post-Colonial Critic: Interviews, Dialogues, Strategies*, Sarah Harasym, ed, London and New York, 1990.

33 Jacques Derrida, 'Le facteur de la verité', in *The Post Card: From Socrates to Freud and Beyond*, trans Alan Bass, Chicago and London, 1987, pp 411-96.

34 *ibid*, p 414.

35 Jacques Derrida, *Of Grammatology*, trans Gayatri Chakravorty Spivak, Baltimore, 1976, p 26.

36 Derrida, 'Le facteur de la verité', op cit, p 415.

37 I have discussed this in '"Making a Man of Him": Masculinity and the Black Male Body in Mid-Nineteenth-Century American Sculpture', *Oxford Art Journal*, vol 15 no 1, 1992, pp 21-35.

38 See David I MacLeod, *Building Character in the American Boy: the Boy Scouts, YMCA, and their Forerunners, 1870-1920*, Madison, 1983.

39 On the female nude and its relation to ideas of the erotic and the sexual see Lynda Nead *The Female Nude: Art, Obscenity and Sexuality*, London and New York, 1992.

40 For instance, W J Stillman describes Millet as an idealist and Meissonier a realist, labels which in many respects go against the grain of modern art historical taxonomy: see 'The Decay of Art' in *The Old Rome and The New*, London, 1897, p 182.

41 Kenneth Clark, *The Nude*, London, 1956, pp 1-26. Even more radical voices seem to have accepted Clark's thesis; eg, John Berger, *Ways of Seeing*, London and Harmondsworth, 1972. For a more subtle response, see Nead, op cit, pp 12-16.

42 Cf Clark, op cit, p 9. According to Clark, the medieval artist Villard de Honnecourt fails to draw the nude; instead the result is 'painfully ugly': 'The Gothic artists could draw animals because this invoked no intervening abstraction. But they could not draw the nude because it was an idea; an idea which their philosophy of form could not assimilate.' Clark defines the nude as a specific unified type, where style dictates whether a figure is nude or not.

43 It could be argued that to use neoclassical idealised sculpture as an example is historically inappropriate. By the 1880s, sculptors such as Saint Gaudens, Ward and French were far more in the public eye. Nevertheless, neoclassical sculpture was still being produced, was being bought up by American museums – particularly the recently founded Metropolitan Museum in New York – and the idealising philosophy of art it represented was still a highly articulated trope in the discourse of art. So, although it was in some respects old-fashioned, its aesthetic force was still evident, and, as the paradigmatic instance of the stabilisation of the nude, the example of neoclassicism clarifies the argument.

44 Quoted in Cornelia Carr, ed, *Harriet Hosmer, Letters and Memories*, London, 1913, p 333.

45 William Wetmore Story, *Conversations in a Studio*, vol II, Boston and New York, 1890, p 344.

46 Story, op cit, vol I, p 22.

47 William Wetmore Story, *The Proportions of the Human Figure, according to a new canon of Polycletus, and of the principal ancient and modern systems*, London, 1864.

48 From WC Brownell, 'The Art Schools of Philadelphia', *Scribner's Monthly Illustrated*, 1879, quoted in John W McCoubrey, ed, *American Art 1700-1960*, Englewood Cliffs, 1965, p 152.

49 Brownell, op cit, quoted in Goodrich, *Thomas Eakins*, vol I, p 185.

50 Sarah Burns, 'Barefoot Boys and Other Country Children: Sentiment and ideology in nineteenth-century American art', *American Art Journal*, vol 20 no 1, 1988, pp 24-50.

51 See Gordon Hendricks, *The Photographs of Thomas Eakins*, New York, 1972.

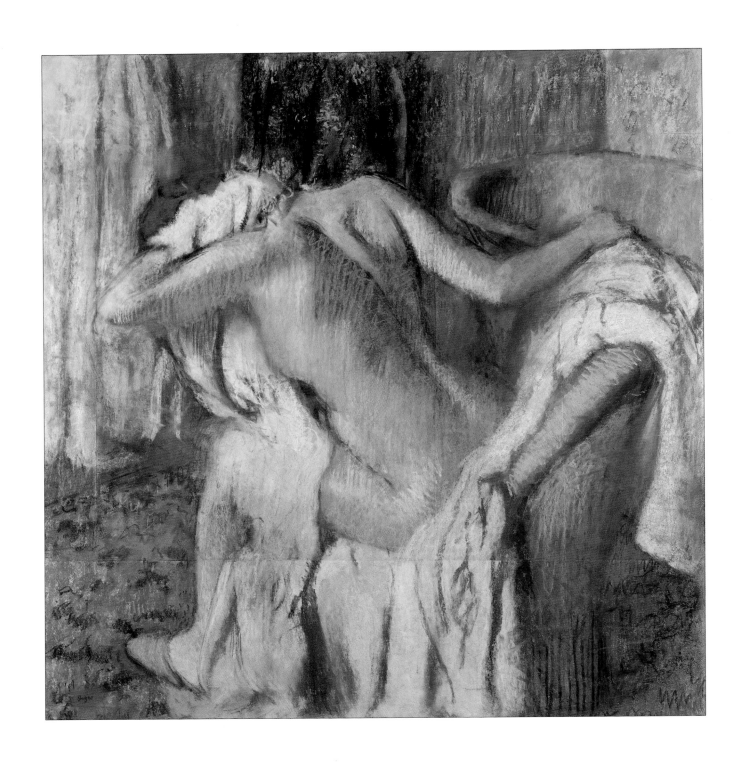

Edgar Degas, After the Bath – Woman Drying Herself, *late 1880s, pastel on paper*

ANTHEA CALLEN
COLOURED VIEWS
Gender and Morality in Degas' Bathers *Pastels*

'Drawing is the masculine sex in art, colour in it is the feminine sex.'[1] Thus wrote the critic Charles Blanc in a treatise on the arts in 1867. Blanc was founder and editor of the major Parisian art journal, the *Gazette des Beaux-Arts*, and his treatise, the *Grammaire des arts du dessin*, was the most influential of the period. 'Sexual analogy', as used by Blanc, serves to gender phenomena in order to classify and constitute difference. Gender difference was a particular sign of urban modernity – its representation was markedly visual in character. As the anthropologist Mary Douglas points out, difference is a mark of civilised society: 'Progress means differentiation . . . modern means differentiated.'[2] Blanc's obsession with marking out sexual boundaries was a common affliction, for gender difference underpinned bourgeois ideology in later 19th-century France.

This paper is divided into two parts. First, it analyses the views of Charles Blanc on colour as symptomatic of broader cultural issues; second, it looks in close-up at pastel – a pure pigment medium. The focus of discussion is on Degas' *Bathers* pastels, a group of which were shown in Paris at the Eighth Impressionist Exhibition of 1886.[3] The paper examines how different forms of language – words and visual – work together to create cultural meaning. For both theorist and artist, colour signified not simply the 'feminine sex' – but an 'effeminisation' of culture. For them, unrestrained colour signalled moral decline – a degeneration which required hygienic containment. Art theory, criticism and the art objects themselves produced a reflexive network of images which constituted the feminine. However, these are men's views, their subject is masculine: the 'invisible' man, the artist-spectator. The ideological function of Degas' images was to produce masculinity.

I Theorising colour, technique and difference

Blanc's statement that 'Drawing is the masculine sex in art, colour in it is the feminine sex', reinforced the broader project of his treatise. Its very title, *Grammaire des arts du dessin*, was chosen to mark the pre-eminence of drawing in the arts. Blanc's aim was to revive and modernise Renaissance art traditions.

The inscription of difference in the art of the French Academy worked in terms of both class and gender. The Italianate model of art training adopted by the French Academy from its inception marked a clear division between, on the one hand, drawing, perspective and anatomy – the civilising, intellectual elements akin to the Liberal Arts – and, on the other hand, painting, which – following the Guild tradition of master/apprentice – was taught solely in Academicians' teaching studios, or *ateliers*. Thus, the mechanical arts, the dirty 'manual' side of the trade, retained their link with the crafts – and with the materiality associated with the 'feminine'.

Fear of the young artist's head being turned by colour, and his powers of reason being undermined, was one of many gender-specific metaphors in 19th-century artistic circles. Renoir's disagreement over colour with his teacher Charles Gleyre is a well-rehearsed example. Gleyre warned his pupil that too premature an interest in 'devilish colour' would lead Renoir to neglect the essential control and distance which drawing brought to the construction of the nude. And for Gleyre, the *matière* of painting could only be successfully handled when the artist had 'complete mastery of the brush'.[4] Renoir's story merely reiterates a long-standing fear of colour and *matière* which goes back to 17th-century debates between the Poussinistes and Rubensistes, and thence, to Italian Renaissance debates over *colore* versus *disegno*. The historical development of this polarisation of line and colour, masculine and feminine, parallels the emergence of modern ideas of the two sexes as quite separate and distinct – as incommensurate.[5]

Blanc argued that even in painting, where colour was essential, it came second rank to drawing. Here, the 'sexual' in Blanc's sexual analogy becomes more explicit: 'The union of drawing and colour is necessary to engender painting, just as is the union of man and woman to engender humanity . . .'[6] Blanc equated the union between drawing and colour with heterosexual intercourse. The creative act was conflated with the sexual act, and sexual incontinence was thought to deplete creative powers. The assumption, of course, is that the artist is a man. Artists' manuals stressed that celibacy – or at least moral restraint in fornication – was required to ensure optimum artistic performance. Art theory thus popularised the ideas of medical science which, from the early 19th century, insisted upon self-control – especially for those men

'devoting themselves to mental toil'. For such men, complete abstinence was recommended – particularly during the execution of their work – because 'venal pleasures debilitate the body and cloud the mind.'[7]

The Romantic myth of the artist with a hearty sexual appetite was thus tempered by the need to sublimate it for the greater (cultural) benefits of his mental exertions. Both directly (through sexual intercourse) and indirectly (through the seduction of colour), the 'feminine' was therefore ascribed the power to render the painter impotent. 19th-century artistic discourse aimed to contain this threat by inscribing the feminine as subsidiary to – and given meaning by – the dominant norm of the masculine. Just as colour was subordinated to drawing, so the feminine was subsumed in the notion of 'male genius'.[8] Images of female procreativity were used to underwrite the masculine creative act. The work of art entailed not only 'conception', but 'gestation' and 'giving birth' in a new discourse which appropriated disturbing ideas of female sexual potency in order to empower male creativity. Simultaneously, this discourse encoded woman's creativity as reproductive, biological and thus, inferior; women were thereby excluded from cultural production.

Blanc warmed to his theme:

. . .drawing must conserve its preponderance over colour. If it is otherwise, painting will run to ruin; it will be lost through colour as humanity was lost through Eve.[9]

Here Blanc appealed to Christian laws to legitimise his thesis. Colour was like Eve, a seductress responsible for the Fall of Man. In case this were not argument enough, he appealed also to 'Nature's laws': feminine Nature chose to be ruled by line. 'She', Blanc argued, wished objects to be known by their 'drawn' and not their 'coloured' properties, for where the colour of objects often rendered them indistinguishable, no two forms were ever alike. Colour (the feminine) represented formlessness – an absence of distinguishing traits which produced incoherence. It was drawing (the masculine), which carried meaning: it signified legibility, individuality, character. Line was dependable, whereas colour, like woman, was changeable, unreliable. Blanc likened colour to a desert camouflaging a lion; the feminine was thus an uncharted, unstable terrain, blandly concealing man-eaters and sexualised dangers. Colour, like Algeria, had to be colonised, mastered by the authority of line: only the draughtsman-cartographer could impose order and 'draw' meaning from this deceptive, shifting landscape. Like woman, colour was a desert waiting to mapped by the male text.

Although Blanc specified the Orient, Egypt, Morocco and Spain as the haunts of colourists in search of 'gaudy' accessories for hollow, 'descriptive' paintings, he did not refer directly to Algeria – France's very own 'colourful' colony.[10] But he made a connection between colour, woman and the 'primitive' which articulated not only gender difference; it also engaged in a nationalist discourse in which ideals of French male racial superiority served to rationalise the 'civilisation' and exploitation of the ethnic 'other' of the French colonies. For Blanc, the colourists' passions for the material world – landscape, costume and 'inert substances' – had led to a decline in 'great [French] art', which was 'gradually decaying and threatened to disappear'.[11] In this Darwinian rhetoric, the triumph of colour over drawing signalled the onset of degeneration in 'masculine' culture.

Blanc's fear can be read as symptomatic of four contemporary social concerns. It equates, firstly, with a fear of the feminine – which signified the material and sensual, as opposed to the spiritual, the intellectual; secondly, and linked to the first, with the fear that uncivilised foreign, thus effeminising, influences were diluting the spiritual purity of French culture; thirdly, with anxieties over the vigour of the French Nation in the final, decadent years of the Second Empire, on the eve of the disastrous Franco-Prussian War of 1870. Fourthly, it equates with the growing materialism of bourgeois consumer culture, which was eroding high moral taste and replacing it with the crude values of the marketplace.[12]

Significantly, Blanc associated colour with 'organic life, the interior and individual life' which, without colour, would not be manifest. By contrast, drawing and *clair-obscur* 'set into relief' all that pertained to 'the intellectual life, that is to say the life of communication.'[13] Colour represents the life of the unconscious, as opposed to consciousness. Interiority was associated with the feminine; communication, language, were associated with the masculine. Thus, Blanc used colour and drawing as metaphors to articulate a division between the private and public spheres of life, the domestic and the civic – woman and man. However, the complexity of this binary deepens because Blanc's idea of colour also embodies the attributes of the stereotypical bourgeois: the uncultured materialism of the Philistine, the conceit of the nouveau-riche 'speculator' engaged in the gratification of ephemeral, immediate desires rather than in enduring 'spiritual' wealth. Thus, the Liberal education which distinguished the professional intelligentsia from the modern technocrat served here to inscribe a further nuance of social difference. Blanc argued that, just as writers inclined towards decadence when they allowed images to take over from ideas, 'so art is made material and infallibly declines when the spirit which draws is vanquished by the sensation which colours.'[14] The decadence associated with bourgeois culture from the late 1860s on is thus written into Blanc's text as the 'feminine'.

II Pastel: Means and Meanings

The pastel medium was at the height of its popularity in the 18th century. As a result, 19th-century artists and theorists associated pastel with Rococo frivolity and the excesses of the *ancien régime* – as well as with women artists.[15] Pastel regained favour only in the late 1850s, when writings by the de Goncourt brothers, and William Bürger ('Théophile Thoré') on 18th-century French art brought the medium renewed attention.[16] Thus, M Thénot wrote in his treatise on pastel in 1856:

> Unfortunately there is a fashion in the arts as in all things, and for a long time this capricious goddess looked unfavourably on pastel, which one might have thought a forgotten genre, but, as the taste for Louis XV furniture has returned, so pastel has taken its place again amongst the productions nowadays.[17]

Pastel, then, was a Second Empire fashion accessory, a timely signifier of the aristocratic luxury to which the bourgeoisie then aspired.

During the latter half of the 19th century, pastel still retained connotations of a soft and sensual femininity in fine art. It was considered inappropriate for subjects or for techniques requiring breadth or grandeur. Thus, in his treatise, Blanc characterised pastel as an auxiliary medium, appropriate only for the lowest types of subject matter: portraits, landscapes and still life. For Blanc, pastel could never compete with oils in the academic hierarchy of painting. Pastel colour was soft, feminine and frivolous; oil colour was strong, vigorous and manly. The gender-specificity of pastel is embodied in the language used by Blanc to describe the medium: his metaphors were also in common use for woman. Pastel was an 'exquisite powder', a 'flower of youth'; its colours were fresh and

> the lustrous and tender flesh-tints, the down of the skin, the bloom of a fruit, the velvet of fabric, cannot be better rendered than with these crayons of a thousand nuances which can be vigorously juxtaposed or melted with the little finger, and whose impasto seizes the light. Their soft, blond aspect, strengthened by some decisive browns, ravishingly expresses not only the brilliant tint of a young girl, the flesh of an infant, the finesse of a hand, the glisten and transparency of skin, but also certain delicacies of colour that oil mixtures might ruin.[18]

Like woman, the charm of pastel – its fragility – was also its shortcoming. Unlike oil colours, the absence of oil binder and painting medium in pastel meant that it had the advantage of neither darkening nor yellowing with age. But it was so friable as to be vulnerable to the slightest knock, and tended to fall into dust. The techniques used to fix pastel (as with beauty in women) often destroyed its finest qualities.[19] Pastel was considered a good medium for fugitive effects; the fugitive, the ephemeral, the temporal were all associated with the feminine. Degas' medium was therefore discursively apt for his principal subject matter, woman. But the feminine sensuality of his medium is subverted by Degas' unconventional handling of the medium, and by his un-idealised view of the female body; these conflicts heighten the discursive complexity of the *Bathers*. Degas' *Bathers* pastels give the medium, and colour, a new notoriety – a new modernity. These works privileged the human figure in a way traditionally associated with oil painting. Thus, it was not only his subject-matter and style, but his novel techniques – particularly his mixed-media combinations – which inscribed the pastel medium as 'modern'.

Blanc described pastels as pastes of various colours, applied dry, and sufficiently soft to be crushed beneath a finger. Pastels are, quite simply, coloured pigments with enough blue binder to hold the particles together when rolled to form sticks: they are coloured drawing sticks.[20] In his pastels, Degas thus used a drawing medium which is at once coloured; his draughtsmanship contained the feminine element: colour. By fusing colour with line, by literally drawing with colour and subordinating it to a strong compositional framework, Degas claimed colour for the male visual hegemony, and pastel's 'effeminacy' served masculine needs.

In the *Bathers* pastels, Degas rarely used smudging techniques in the final layer describing the figures' flesh. On the contrary, incisive drawing controls the forms with the clarity of an Ingres graphite study. Indeed, one critic in 1886 referred directly to this source, noting that Degas' line was 'characteristic of Ingres . . . pure, confident and rare . . .'[21] The critic Gustave Geffroy recognised the 'scientific' nature of Degas' fascination with 'lines that envelop the figure from the hair down to the toenails'.[22] Contour plays a vital role as the primary structural component, the boundary separating and distinguishing forms in space; contour is the rational, abstract means to contain and isolate the body. Degas' contours hold within their bounds the female anatomy; equally, the lines of his compositional geometry and the picture's framing edge symbolically represent woman's confinement within the given boundaries of her social space.

Degas' inherent difficulties in his project to employ the feminine – colour and pastel – while at the same time containing it, emerge in the pictorial ruptures which are apparent in the *Bathers*, and in the meanings they embody. His contours are in fact rarely fixed or definitive; in *The Tub*, different positions for the limbs remain visible in almost every contour. The raised right elbow remains in the process of realignment, to coincide with the curve of the flat tub – thereby suggesting the enclosure of the body in an elliptical device which grips it within the compositional frame. Blurring of the towelled hand reaching awkwardly to the hip implies the action of drying.

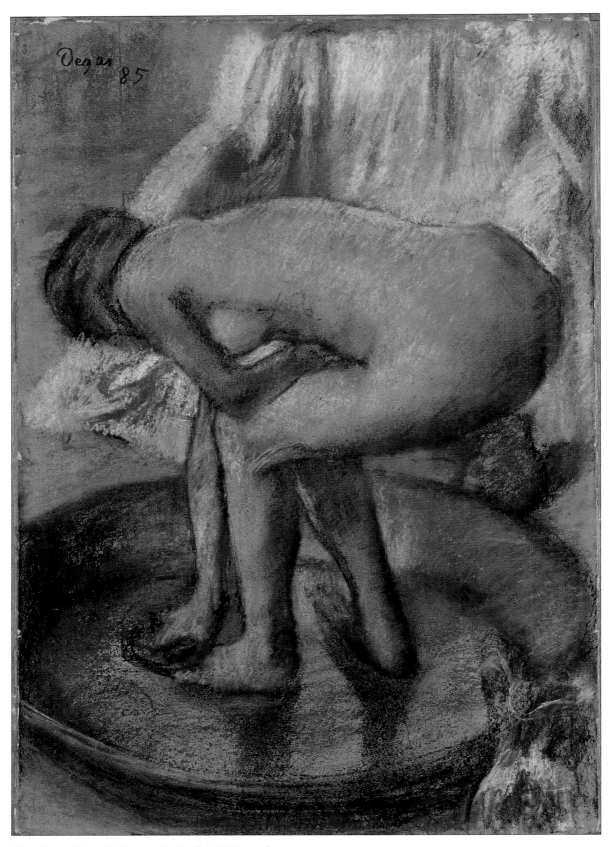

Edgar Degas, Woman Bathing in a Shallow Tub, *1885, pastel on paper,
81.3x55.9cm*

But Degas' lines are by no means limited to contour; his use of pastel turns the entire surface of his *Bathers* into complex webs of line – of hatchmarks which 'stand for' the body, but often move free of it, too. Line retains its independence from the female form while still marking it out.

At times Degas' hatching explicitly denies the structure and movement of the form. Unlike 'bracelet' hatching, where circular lines produce rounded forms, Degas' hatch-marks are straight and parallel, in conflict with the illusion of modelled form. Frequently, as in the *Woman in a Tub*, marks which contradict the form are used to be read as highlight, or as the fall of direct light; here a strong daylight falls from left to right across the figure. This is similar to the main function of the hatched striations on the near side of the torso in *After the Bath, Woman Drying Herself*. These run vertically, reiterating the picture plane instead of following, and thus emphasising, the volumes of the body. The marks read as direct light moving into softened, reflected light: from the bright lights on thigh and stomach through the rib-cage and up into the pink reflected lights behind the shoulder blade; orange marks on the further shoulder blade take up the vertical movement. Despite changes in the colour used, the direction of the lines remains almost constant, insisting on the effects of light – again the masculine – as the determinant of form.

The super-imposition of warm colours over cool, and cool colours over warm, is characteristic of the open, layering techniques used in Degas' pastels. Thus, the successful 'marriage' of these components of colour – which contemporaries denoted as warm and cool, active and passive, male and female – was required to produce 'harmony'. Optically, pale tones over dark produce cool bluish hues, whereas dark tones over light give the impression of warmth. Complementary effects of hue and colour temperature produced by the actual layering are enhanced by the illusion of warmth or coolness resulting from optical contrast – or 'dynamic' colouring.[23]

Just as pastel served to represent intense, opaque lights because of its inherent capacity to catch and reflect light off the surface of the picture, so too was it an effective medium for exploiting the effects of brilliant colour working across the composition to direct the movement of the eye. In *Woman in a Tutu*, the orange-blue complementary pair dominate. Intense, cold blues appear as shadows in the white of the towel and in the tub. They connect visually with the warmer, more violet blues used amongst deep oranges for the carpet; the paler yellow-orange striations were combined with marks of blue for the walls, and overworked with short accents of the same violet-blue which served for the signature. More subtly, the oranges and blues structure the light, shade and reflections on the figure itself. Their complementarity both enlivens the individual colours and works to unify the composition,

'naturalising' an appearance of wholeness and coherence in the work. These orange-blue complementaries – in varying degrees of saturation and purity of hue – were adopted throughout all the pastel *Bathers* exhibited in 1886, providing an internal coherence not simply to the individual pictures, but to the entire series.

The same complementaries also dominate in *After the Bath, Woman Drying Herself*. The sharp vermilion-oranges for the carpet reappear throughout the background; pale oranges appear among the flesh-tints of the figure. To the right of the torso, a patch of orange was added late: a reworking of the rib-cage contour disguises alterations to the hip-line which emphasise the waist and exaggerate the swell of the hips. This orange stands out, refusing to stay in the background plane to suggest the 'edge' where solid form turns in space, disappearing from view. Instead, it advances, reminding the spectator of the picture's two-dimensionality by encouraging the eye to make a visual link with the prominent oranges elsewhere in the composition, particularly the head-hair and the marks representing body hair in the left armpit. This stresses the object/figure's sensual materiality, by drawing attention to surface, to colour and texture resting on the picture plane. This effects an oscillation between 'artifice' and 'illusion', and between marked paper surface and described form in space. The taut interplay of line and colour, space and flatness, form and surface texture, are left unresolved, the figure held in a state of tense visual – and discursive – ambiguity.

Conventional handling of the nude in oil colours posited a norm of health – both moral and physical. Flesh 'tints' required smooth blending of tones from light to dark. The modern nude subverted these academic conventions, making *facture* – mark-making – evident to the eye and altering the familiar, 'normal' balance of both tone and colour. In particular, the modelling of form with colour (warm hues which advance and cool colours for shadow, where forms turn away from the eye) gave colour a disturbing predominance in the discourse of visual propriety. And this modern convention was itself subverted in Degas' pastels – where hot colours appear in shadows, and the lights are often cold off-whites. The use of strong, jarring complementary colours carried the sign of modernity – and the figured flesh of modern nudes signalled abnormality, ill-health. Such flesh was not tinted, but *discoloured*.

In Degas' hands pastel took on a direct physicality; he avoided the blurred softness and charm with which the medium was then most commonly associated. His marks were usually left raw and unblended, each separate touch and striation a witness to the painter's actions, his surfaces scarred with the built-up layering of powdery pigment. His pastels are palpably tactile but, of course, physically un-

touchable: they encode the sensation of touch – both the artist's touch and the experience of touching skin – relived by the eye, vicariously. Degas' handling of pastel secures the medium's particular aptness as a metaphor for the texture of skin, and particularly female flesh, since the sense of touch was associated with the feminine.

This metaphor was found equally evocative by Degas' critics. His surface pitting and scarring, the look achieved in parts of the more heavily worked pastels like *Woman Dressing* and *Woman Getting Up* (the so-called *La Boulangère*), inscribed a moral meaning apparent in the criticism of Félix Fénéon, for whom Degas' 'rich patinas' of the flesh suggested disease. Fénéon's choice of words, in his review of Degas' *Woman Bathing in a Shallow Tub* encodes this ambivalent message. Referring to the tense, uncomfortable pose in this pastel, Fénéon wrote:

A bony spine becomes taut; forearms, leaving the fruity, pearlike breasts, plunge straight down between the legs to wet a washcloth in the tub-water in which the feet are soaking.

The problem with fruit, which, like the flesh of corpses is associated with the prostitute, is that it has a tendency towards rapid putrefaction. Thus, the sexual analogy in his vegetable symbolism takes on a darker meaning when Fénéon uses a word normally reserved for fruit to describe the women's bodies as 'bruised' (*talés*). 'Bruising' evokes connotations of flesh blemished beyond palatability by excessive handling; it is also emblematic of man's violence towards woman. Fénéon took the meaning of his analogy further, since he ascribed this 'bruising of the flesh' to overtly sexual causes; woman's bruising was the product of her relations with man – the product of 'marriages, childbirths and illnesses'.[24]

The moral position adopted by Fénéon in his reading of Degas' *Bathers* was not new in modern art criticism. The link forged between 'modern' nudes, prostitution and female degeneracy had a notorious lineage, most notably to Manet's *Olympia*, exhibited at the Paris Salon of 1865. In their readings of the *Olympia*, Manet's critics wove a complex web of metaphor which linked death, filth, ordure and disease – links already established in the twinned discourses of public health and prostitution developed in the 1830s by the eminent medical hygienist, Alexandre Parent-Duchâchelet.[25] Like the discoloured flesh associated with the *putain*, with putrefaction, Manet had rendered the Olympia's body 'corrupted', 'yellow-bellowed', 'a cadaver', 'dirty like a heap of soiled linen', 'putrefied . . . as if it were at the morgue'.[26] At least four critics picked specifically on the corpse/morgue metaphors, and the association with disease (by implication venereal), putrefaction, aging and decay was common. The analogy between 'discoloration' and degeneracy was reinforced during the 1870s in the critics' response to Renoir's *Nude Torso in Sunlight*. It was felt that the want of drawing and conventional modelling in this figure produced a 'formless' nude, a 'mass of flesh in the process of decomposition with green and violet spots'[27] – a putrefying corpse of unrestrained, feminine colour.

Degas' critics wrote within this discursive tradition, reading colour as emblematic of morality – or rather immorality. The sensuality of the pastel medium, and of Degas' handling of colour, seemed at times to deuce his critics, offering a means to reconcile the tension between the easy intimacy of the medium and the disturbing starkness of his subject matter – what the critic Geffroy called his 'distressing poem of the flesh'.[28] However, the conflict in Geffroy's view – his juxtaposition of 'distressing' and 'poem of the flesh' – is emblematic of Degas' own conflict *vis-à-vis* the feminine. It is manifest, too, in Fénéon's views; he could focus on the picturesque details like a 'red mop of hair' or a 'wet towel', which allowed the writer – in his equally colourful prose – to privilege the painter's control over his subject. Thus, Fénéon characterised Degas' 'artificial and personal mastery' over colour which he saw in the artist's 'sultry and almost hidden effects'. However, the uncertainty of Degas' mastery of the feminine remains, since the adjective chosen by Fénéon to characterise his colour, his 'effets *étouffés*',[29] also denotes 'suffocating heat' – and thus, the dark side of female sexuality. The critics' views thus constitute Degas' own ambivalence: colour and subject-matter at once seductive and repulsive, a pastel medium sensual but overblown. Right down to its most basic, physical level, the artist's visual language embodied his conflicting distaste and obsessive fascination with the feminine.

Degas' emphatically material surfaces were metaphors for the physical experience of female flesh – and more specifically, for the experience of illicit flesh. But woman here constitutes not merely the titillating object of a sexualised male gaze. Woman is embedded in her inherent materiality and the female body thus represents a naturalised 'other'. She functions as the sign of masculine difference: he is what she is not. Through his projection of the feminine 'outside himself', onto paper, Degas marks out and secures masculinity.

Notes

1 C Blanc, *Grammaire des arts du dessin*, Paris, 1867, p 22 (hereafter referred to as Blanc).

2 M Douglas, *Purity and Danger: An Analysis of the Concepts of Pollution and Taboo*, London, 1966, p 77.

3 'Suite de nues de femmes se baignant, se lavant, se séchant, s'essuyant, se peignant ou se faisant peigner', catalogue of the 8me Exposition de Peinture, May-June 1886, reproduced in facsimile in C Moffett, *The New Painting: Impressionism 1874-1886*, Oxford, 1986, p 444 (hereafter referred to as Moffett). Six pastels of bathers have been identified from descriptions in contemporary reviews; the present paper uses the identifications made in *Degas* (exhibition catalogue), Paris, Ottawa, New York, 1988-89; cf the conflicting views of R Thomson in *Degas: The Nudes*, London, 1988, p 131.

4 A André, *Renoir*, Paris, 1919, quoted in A Callen, *Renoir*, London, 1978, p 6.

5 T Laqeuer, *Making Sex: Body and Gender from the Greeks to Freud*, Cambridge, Mass and London, 1990, especially ch 5.

6 Blanc, pp 22-23 and cf p 595.

7 Y Knibiehler quoting Virey (1812-22) and Réveille-Parise (1837), in 'Les Médicins et "l'Amour conjugale" au XIXe siècle', *Aimer en France 1760-1860*, Publication de la faculté des lettres de l'université de Clermont-Ferrand-II, pp 357-66.

8 M Ellan, 'Sexual Analogy' in *Thinking About Women*, London, 1968, especially pp 15-18. See also C Battersby, *Gender and Genius: Towards a Feminist Aesthetics*, London, 1989, especially chs 11 and 12.

9 Blanc, pp 22-23; on contemporary debates over colour in sculpture – especially over the fraught question as to whether Greek classical sculpture was originally polychromed, see CW Millard, *The Sculpture of Edgar Degas*, Princeton, New Jersey, 1976, pp 61-63.

10 E Said's *Orientalism*, Harmondsworth, 1985, is the standard text on the representation of the Near East; see also M Bernall, *Black Athena: The Afroasiatic Roots of Classical Civilisation*, vol I – The Fabrication of Ancient Greece, 1785-1985, London, 1987. On the visual construction of the 'Orient', see L Nochlin, 'The Imaginary Orient', *Art in America*, 71, May 1983, pp 118-31. Blanc, who admired and discussed Delacroix at length, did not refer to this artist's direct connection with Algeria (see, for example, L Johnson's discussion of Delacroix's colouristic debt to Algeria in *Delacroix*, London, 1963). Monet was posted to Algeria on military service as part of the French forces of occupation there in June 1861; he was due to serve six years but a 'replacement' was paid for by his family and Monet served barely a year in Algeria (see D Wildenstein, *Claude Monet, Biographie et catalogue raisonné*, vol I, pp 14, 20). Renoir made a painting trip to Algeria in spring 1881.

11 Blanc, p 610. Similar readings were made of Japanese culture; see for example E Evett, 'The Late Nineteenth-Century European Critical Response to Japanese Art: Primitivist Leanings', *Art History*, vol 6, no 1, March 1983, and PH Tucker, *Monet in the 90s*, New Haven, Boston and London, 1990, pp 134-39, who refers to French use of the notion of *japonisme* to sanction their own racial superiority. For a critical analysis of *japonisme*, see M Melot, 'Questioning Japanism', *Block*, 13, 1987, pp 51-61.

12 For an analysis of the literature on late Second-Empire decadence, see R MacGraw, *France 1815-1914: The Bourgeois Century*, Oxford, 1983, pp 187-96; see Rachel Bowlby on the development of consumption, *Just Looking: Consumer Culture in Dreisser, Gissing and Zola*, New York and London, 1985.

13 Blanc, p 594.

14 *ibid*, p 610.

15 See R Parker and G Pollock, *The Old Mistresses: Women, Art and Ideology*, London, 1981, pp 28, 29, 32.

16 E and J de Goncourt, *L'Art au dixhuitième siècle*, first published as separate monographs between 1859 and 1875; William Bürger ('Théophile Thoré'), 'Exposition de tableaux de l'école français, tirés de collections d'amateurs', *Gazette des Beaux-Arts*, 1860, vol VII, pp 257-77, 330-40, and vol VIII, pp 228-40.

17 M Thénot, *Le Pastel mis à la portée de toutes les intelligences*, Paris, 1856, p 10.

18 Blanc, pp 624-25, 626; see also Thénot, op cit, p 19.

19 On problems with fixing pastel, see Blanc, p 626; on pastel fixatives see M Doerner, *The Materials of the Artist*, London, 1976, pp 251-53; on Degas' fixed methods, see T Reff, 'The Artist as Technician' in *Degas, The Artist's Mind*, London, 1976, ch 8, p 276 and B Dunstan, 'The Pastel Techniques of Edgar Degas', *American Artist*, 36, no 362, September 1972, p 46; see also D Rouart, *Degas à la recherche de sa technique*, Paris, 1945.

20 Blanc, p 624. On binders for pastel, see Doerner, op cit, p 244; he also discusses prepared surfaces for pastel – which required a reasonable key to hold the powdered colour – pp247-48, and cf Thénot on supports for pastel.

21 P Adam, *La Revue Contemporaine, Littéraire, Politique et Philosophique*, April 1886, quoted in Moffett, p 454.

22 G Geffroy, *La Justice*, 26 May 1886, quoted in Moffett, p 453.

23 A term used by Sir Charles Lock Eastlake, *Methods and Materials of Painting of the Great Schools and Masters* (first published 1847), New York, 1960, vol II, 282ff, discussing the work of the Venetian painters which was very popular in 19th-century France.

24 F Fénéon, 'La VIIIe exposition impressionniste', reprinted in *Au-delà de l'impressionnisme*, Paris, 1966, pp 58-59.

25 See A Callen, *The Spectacular Body: Science and Technique in the Work of Degas*, London and New Haven, 1993, ch 2: 'Reviewing Prostitution'.

26 From quotations of contemporary reviews of the *Olympia* in TJ Clark, *The Painting of Modern Life: Paris in the Art of Manet and his Followers*, London, 1985, pp 94-97.

27 The conservative critic Albert Wolff in 1876, quoted in Callen (1978), op cit, p 16.

28 Geffroy, op cit, quoted in Moffett, p 453.

29 Fénéon, op cit, p 59 (my italics); 'étouffé': suffocated, stifling, asphixiating – also sultry heat.

FROM LEFT TO RIGHT: Hannah Höch (1889-1978), Burst Unity, 1955, collage, 40x29.5cm. In the collages and paintings that Höch produced throughout her long artistic life, she tried 'to wipe away the firm boundaries that human beings are inclined – self-confidently – to use to bring things within grasp.' Höch allied herself with the otherness that is beyond firm identity, comparing the techniques of alienation implicit in photomontage with the acrobatics, mimicry and fluctuating effects of choreography. At its most extreme (as in this image), Höch's scissors transform the given fixity of paper images into a celebration of indeterminacy.

Sue Arrowsmith, One, Two, Three: Nine, 1985, photo(graphic), nine parts, each 103x80cm. The nine images have been created by direct contact between the nude female body and light-sensitive paper in ways that evoke the boxed spatiality theorised by recent work in feminist phenomenology. Identity is established via the dynamics of a self moving in relationship to otherness. This body is no closed and hermetically sealed container. Its boundaries are not deconstructed, but are constructed as permeable.

CHRISTINE BATTERSBY
HER BODY/HER BOUNDARIES
Gender and the Metaphysics of Containment

In Mark Johnson's *The Body in the Mind* (1987), we read:
Our encounter with containment and boundedness is one of the most pervasive features of our bodily experience. We are intimately aware of our bodies as three-dimensional containers into which we put certain things (food, water, air) and out of which other things emerge (food and water wastes, air, blood, etc).[1]
Johnson then goes on to spell out five characteristics of the containment relationship from which I infer that, for him, the self is inside the body in much the same way that a body is inside a room or a house. Bodies are containers that protect against and resist external forces, whilst also holding back internal forces from expansion or extrusion. All that is other is on the outside, and the inner self is shielded from the direct gaze of others by skin and other non-transparent features of the body-container.[2]

Mark Johnson develops large claims on the basis of this analysis. Containment is made one of a number of underlying structures of embodiment which shape and constrain the imagination via gestalt-type patterns or 'schemata' which operate at a preconceptual level. Johnson adds bodies to an essentially Kantian account of the functioning of the understanding. Contributing to the new field of 'cognitive semantics', he argues that 'meaning' is a product of the way an experience, a theory, a word or a sentence is understood by an individual who is 'embedded in a (linguistic) community, a culture, and a historical context'.[3] At the most basic level, this understanding rests on schemata of the imagination which arise out of the (universal) experience of embodiment. Cultural differences act merely as an overlay which affects the way meanings are encoded and transformed; underneath there is human sameness. We all inhabit bodies in similar ways. We all experience the body as a container for the inner self.

These claims are elaborated in another book of cognitive semantics: George Lakoff's *Women, Fire and Dangerous Things* (1987). Because we live in bodies and move between containing spaces via our bodies, we recognise that 'Everything is either inside a container or out of it'. Our grasp of the law of Boolean logic which determines the relationship of classes – of 'P or not P' – is grounded on our experience of being embodied selves. Lakoff refers to Johnson's 'proof' to establish the links between the law of the excluded middle and the intimate experience of bodily containment. 'On our account, the *container* schema is inherently meaningful to people by virtue of their bodily experience.'[4] Lakoff addresses the problem of whether there might be cultures that fail to fit the cognitivists' model of meaning, but secures the 'universal' status by arguing that even the Australian aboriginal language of Dyirbal – which puts together in a single category human females, water, fire and fighting – obeys the logic of containment, despite the strangeness of its classificatory system. Just fitting things into categories relies on the fundamentally human experience of embodiment.

For feminist theorists who have long complained of the neglect of the body by Western philosophers, the development of cognitive semantics might seem a promising move. However, as I read Johnson's and Lakoff's accounts of embodiment, I register a *shock* of strangeness: of wondering what it would be like to inhabit a body *like that*. The shock intensifies as I note that the description purports to be of a preconceptual experience that is so immediate and obvious that it would command intuitive assent. I live/have always lived in the West, and am a full – and I hope sophisticated – user of the English language. So why do I feel so alienated as I read these descriptions of what it is like to inhabit a body? How is it that the cultural imperialism of the cognitivists' model can manage to position aboriginal Australians with the 'universal', whilst managing to make me feel singular: odd; a freak; outside the norm?

My reaction raises a dilemma that constantly confronts feminist philosophers. By the double use of the definite article in the title of his book – *'The' Body in 'the' Mind* – Mark Johnson gestures at a level of the universal which must be registered by all linguists and philosophers interested in the cognitive aspects of language and metaphor. However, feminist philosophers know that in terms of actual practice, philosophers throughout the history of the discipline have taken (and continue to take) male life-patterns, personalities and life-experiences as ideals and/or norms. Thus, writing and reading self-consciously as both a philosopher and a woman, a feminist philosopher always confronts a methodological dilemma. She cannot easily know whether her failure to recognise herself as fitting the philosophical paradigms is

due to simple idiosyncrasy; to issues of sexual difference; to historical and cultural factors; or to the fact that the theories were false even for males at the time they were propounded.

In order to think which of these explanations is right in this instance, I will explore five competing hypotheses for my 'failure' to recognise myself in the cognitivists' description of what it is like to inhabit a body. In doing so, I will gradually displace the focus of my analysis away from an experientially-based semantics and confront current debates within feminist theory regarding the nature of boundaries. I will end not by demanding their deconstruction in the manner of many post-modern and post-structuralist feminist theorists, but by suggesting that we return to metaphysics – a metaphysics revisited from the perspective of gender – in order to reconstitute the inside/outside, self/other, body/mind divides. This is, in effect, an argument against the semantic approach to the questions of philosophy that has dominated Anglo-American philosophy this century. It is also an argument against modelling woman's otherness in terms of a Lacanian understanding of language. The move into feminist metaphysics opens up other possibilities which allow us to theorise a 'real' *beyond* the universals of an imagination or a language which takes the male body and mind as ideal and/ or norm.

These are the five hypotheses that I will examine for my 'failure' to think of my body as a container:

1 That I am idiosyncratic or peculiar: that there is something the matter with my image schematism, perhaps in the manner of Oliver Sacks' freakish case studies in *The Man Who Mistook his Wife for a Hat*. Sacks' subjects are neurologically peculiar in the way they match bodily and mental imaging to concepts, and thus in terms of the way that they *use* language.
2 That I *do* think in the bodily containment schemata that Johnson outlines; but that something (too much philosophical introspection? some crisis or trauma?) has made me repress this awareness.
3 That I *as a woman* have a different relationship with my body than does a man, and that the containment model for bodily boundaries and selves might be more typical of *male* experience.
4 That I as a Westerner living in the last decades of the 20th century no longer think in terms of the outmoded science that this container model presupposes; that *something* (exposure to media, science fiction, fiction, philosophy) prevented me ever developing (at least in a way that I can recall) the containment model.
5 That there have in the West *always* been alternative models for thinking the relationship between self and body and self and not-self; and that for contingent reasons (reading? social environment?) exposure to these

alternative models prevented the container model from ever really taking hold in my case.

Taking these hypotheses in order, I wish first to reject the claim that my response might simply be idiosyncratic. I do not (I think!) manifest the bizarre disturbances of correlation of spatial co-ordination and behaviour and word-usage which characterise Oliver Sacks' neurological case studies. I am not like Sacks' 'Disembodied Lady' who has lost proprioception and with it the ability to feel her body. It is not that I – like Sacks' Christina – am unable to remember or even imagine what embodiment is like.[5] As support for my claim that I am not merely a freak, I would appeal to Emily Martin's analysis of the way women talk about themselves as bodies in *The Woman in the Body* (1987).

Martin's work is particularly relevant in this context, since she is an anthropologist who applies to Western female subjects some of the techniques of metaphor analysis adopted by Johnson and Lakoff. Emily Martin uses the imagery employed by women to describe their reproductive processes (menstruation, pregnancy, childbirth, menopause) to determine the woman-as-body-image of the subjects she interviews. Arguing that different models are prevalent in the language of middle-class and working-class women, her work demonstrates that women of all classes quite frequently talk about their bodies in ways that suggest extreme fragmentation, with the self located 'outside' the body. Working-class women tend to resist altogether the spatialised model of the body as 'container' of eggs, blood, womb etc. Although many of the middle-class women do use the language of bodily containment and inner functioning to describe their reproductive processes, a number of them also go on to note 'that this internal model was not relevant to them'.[6] Martin thus interprets the containment imagery as the educated subjects' (unsuccessful) attempts to make body-image coincide with the 'medical' or 'scientific' renditions of female reproductive processes. Her research thus implicitly undermines any simplistic understanding of bodily containment as a universal schema, as well as any attempt to restrict the containment schema to a homogenised 'Western' self.

The second hypothesis for explaining my cognitive failure to image my body as a container posits that I do (unconsciously/subconsciously) think in this way; but the sense of my body as a container is subject to repression. Now this might be true. But it would be hard to know how to test this. I have very clear memories of my childhood relationship with my body: of the way the 'I' was 'zoned' into body regions that were at war with other body regions; but I have no memory at all of thinking of my body of some form of closed, safe space that encloses an 'I'. It is true that I use such linguistic expressions as 'pain in the foot'; but are those who infer from this some reference to spatial or territorial containment right

so to do? Might not the term 'in' be functioning merely as a dead metaphor? Thus, I also say of a person that he is a 'pain in the neck', without in any way meaning this in a literal sense. Furthermore, not all prepositions referring to bodily happenings are ones of containment: I can have 'a funny feeling somewhere *around* my middle'. 'weakness *at* the knees' or feel 'a shudder *through* my body'. Even the use of 'in' can be deceptive. We might now think of the preposition primarily in terms of the mapping of a location, but cartography was only developed as a science with the invention of compasses, globes and other 'objective' means of recording place towards the end of the 15th century. In Latin and old English the term 'in' did not necessarily imply spatial containment or territorial inclusion. And nor does it now – as the *Oxford English Dictionary* shows via some quite bewildering examples of diversity of usage.

Anorexics carry on referring to things happening 'in' their bodies, even though a number of researchers have shown that typically they:

> grow up confused in their concepts about the body and its functions and deficient in their sense of identity, autonomy and control. In many ways they feel and behave as if . . . neither their body nor their actions are self-directed, or not even their own.[7]

Anorexics typically describe their stomachs as rejecting the food – a process based on horror at food or disgust. Helmut Thomä quotes from one treatment session with a female anorexic:

> Bottle – child – disgust, if I think of it – injections – the idea that here is something flowing into me, into my mouth or into the vagina, is maddening – integer, integra, integrum occurs to me – untouchable – he does not have to bear a child – a man is what he is – he need not receive and he need not give.[8]

This anorexic woman uses disgust to try and produce body boundaries; but the way that she talks about herself makes it simultaneously clear that she does not view herself as a spatial container hermetically sealed from the outside.

In *Powers of Horror* Julia Kristeva ascribes to the mechanism of disgust a constitutive role in the formation of identity during the process of weaning:

> *nausea* makes me balk at that mild cream, separates me from the mother and father who proffer it. 'I' want none of that element, sign of their desire; 'I' do not want to listen, 'I' do not assimilate it, 'I' expel it. But since food is not an 'other' for 'me', who am only in their desire, I expel *myself*, I spit *myself* out, I abject *myself* within the same motion through which 'I' claim to establish myself.[9]

According to Kristeva, the boundary of the body and the distinction between self and not-self is established through the processes of repulsion which occur at a preconceptual stage and before the infant has clearly demarcated the boundaries between self and (m)other. Inner space is thus not known intuitively or immediately, but is secured only via an expulsion of things that cannot be embraced within its borders.

In the Kristevan model identity is secured at the level of the imaginary; before the child is inducted into language (and hence in Lacanian terms before entrance into the realm of the father). Disgust operates at the level of the pre-oedipal *féminin*. However, there is in Kristeva (as in Lacan) no necessary connection between femininity and women. The words of the anorexic filled with disgust at drinking from a bottle might lead us to question this, however. The female anorexic in the above example – and 90 per cent of all anorexics are female – knows that her body is permeable; penetrable; capable of becoming two bodies; of fissuring. The boundaries of her body – in so far as they are establishable at all – are insecure and thus require careful policing. And this observation thus leads onto a consideration of the third hypothesis for my failure to register my body as a container with a self safe 'within' and the dangerous other on the outside: the claim that this is typical of *women*.

There is a good deal of work by psychologists, artists and theorists of opposing political persuasions that shows that females in our society employ space differently – even whilst young – and that this can be detected by observing their games, their bodily movements and the projects that they devise for themselves. The problem, however, is in deciding what this difference *means*, particularly if what we are asking is whether this shows that women typically lack an awareness of their bodies as containing spaces. Thus, on the basis of research conducted on boys' and girls' games in the 1940s and 50s, Erik Erikson concluded that girls' bodies destine them towards a preoccupation with inner space that fits them for childbearing. Supposing that all females must experience their bodies as empty containers until filled by pregnancy, Erikson asserts that

> in female experience an 'inner space' is at the centre of despair even as it is the very centre of female fulfilment.
> Emptiness is the female form of perdition.

This 'inner space' or 'void' is presented as a 'clinically obvious' fact that biologically determines women's personalities, potentialities and development.[10] By contrast, many feminist theorists such as Marianne Wex in *Let's Take Back Our Space* (1979) write as if female space-manipulation is entirely a function of socialisation, and can thus be modified, in ways that allow public – and hence, also private – body-space to be reclaimed.[11]

Via anorexia, slimming, cosmetic surgery, the fashion industry and simply the way they stand, move or play, women

discipline their body boundaries intensively. In her classic paper, 'Throwing Like a Girl', Iris Young has ascribed women's constricted posture in stretching, reaching, catching, throwing and moving generally to the construction of a spatial field surrounding the female body which is experienced as an enclosure, instead of as a field in which her intentionality can be made manifest.[12] But *why* this occurs and *what* it shows about the phenomenological body-experience of all – or some (?) – women is a matter of dispute. Not only is there the obvious difficulty that women exist in a patriarchal reality and hence use the same language as men to describe the body/mind relationship, but there is also a surprising lack of work on masculine embodiment.

Some recent theorists, such as Michèle Montrelay and Paul Smith, suggest that the repressed of masculine consciousness might be the sense of the 'flowing out and away' of ejaculated bodily substances.[13] On this model, the boundaries of normal male selves are secured against flowing out, in ways that would make sense of the Johnson/Lakoff construction of (male) selves as 'three-dimensional containers into which we put certain things (food, water, air) and out of which other things emerge (food and water wastes, air, blood, etc)'. Since the same logic would not apply to the construction of female identity, we could indeed have a hypothesis here that would explain why I as a woman would fail to recognise this as a description of what it is like to inhabit a body. My identity is secure precisely *because* I do not envisage my body-space as a container in which the self is *inside*: protected from the other by boundaries which protect against and resist external forces, whilst also holding back internal forces from expansion. I construct a containing space *around* me, precisely because my body itself is not constructed as the container. Adopting the container body-ideal and inhabiting a female body would be likely to pathologise me, as the anorexic's commentary on herself as a container lacking integrity would tend to show. The anorexic *desires* the completion that pertains to the ideal male body-image.

Fascinating though such speculations are, it makes little sense to treat these claims about the phenomenological relevance of male and female body-spaces as testable psychoanalytic claims in terms of the metaphysical boundaries of the self and the not-self as constructed in the history of Western philosophy. This is the move that Luce Irigaray makes – most notably in 'Volume without Contours' (1974), 'The "Mechanics" of Fluids' (1977) and 'Is the Subject of Science Sexed?' (1985).[14] According to her, identities based on spatial containment, substances and atoms belong to the *masculine* imagery, and what is missing from our culture is an alternative tradition of thinking identity that is based on fluidity or flow. It is important to note that Irigaray is not making an experiential claim: she is not asserting that

women's 'true' identity would be expressed in metaphors and images of flow. What she is claiming, by contrast, is that identity as understood in the history of Western philosophy since Plato has been constructed on a model that privileges optics, straight lines, self-contained unity and solids. According to Irigaray, the Western tradition has left unsymbolised a self that exists as self not by repulsion/exclusion of the not-self, but via interpenetration of self with otherness.

Irigaray's analysis of the history of philosophy can be read as a discourse on boundaries. She explores the way that woman/the mother serves as the projective screen, barrier and the (unobtainable) obscure object of desire that remains always just out of reach. Woman both is the boundary/the other *against* which identity is constructed, and that which confuses all boundaries. In the tradition of philosophy that reaches from Plato and Aristotle to Freud and Lacan woman falls both inside and outside the boundaries of the human, the genus, the self itself. Although I will later argue against Irigaray's tendency to close down the history of philosophy to a trajectory in which sameness is always privileged over difference, viewed as a commentary on woman as boundary *Speculum of the Other Woman* makes a powerful case.

For Plato woman was – despite the apparent moves towards egality in *Republic V* – the state of existing transitional between animal and man. A male who failed to live the good life would be re-born as a woman; a second failure would mean that the next re-birth would be as an animal.[15] For Aristotle, moreover, woman was literally a monster: a failed and botched male who is only born female due to an excess of moisture and of coldness during the process of conception. A female lacks essence: that which makes an entity distinctively itself and not something else. She is both of the species and not of the species: she is neither the goal of the processes of reproduction, nor is she able to pass on to her offspring characteristics which represent the species. The female is simply allied with matter – an undifferentiated mass of unshaped material – which can only be formed into an entity by the *logos* or generative power of the male.[16] Change is hylomorphic: an active form (male) imposed on homogeneous matter (female). As such, she cannot even be said to have an identity of her own. She represents the indefinite: neither one nor two. The female sex is, literally, a 'sex which is not one'.[17] Woman is indefinite; she exists at the margins – an enigma – but in ways that problematise the human subject placed at the centre of the traditions of philosophy and psychoanalysis.

Irigaray uses the technique of philosophical terrorism to mount raids on past philosophers and psychoanalysts. And via these skirmishes an intriguing conjecture emerges: that the privilege given to form, solidity, optics and fixity in the

history of the West has, in fact, delayed us from developing alternate models of identity which would treat flow or the indefinite in its own terms, and not simply as a stage *en route* to a new development fixity. In Irigaray's texts the Lacanian account of the 'fixing' of identity in the mirror of the (m)other's eyes becomes symptomatic of the West's refusal to think a self that is permeated by otherness. Psychoanalysis is presented as a repetition of the philosophical moves of Kant and Hegel, in which self is only established via opposition to, and spatial symmetry with, a not-self. Via insistent questioning and mimicry, Irigaray suggests that this model of identity is the Oedipal one of the world of the boy: in which self-identity is established against an oppositional other.

What remains unsymbolised in the whole process according to Irigaray is mother/daughter relations: the formation of a self which can be permeated by otherness, and in which the boundary between the inside and the outside, between self and not-self, has to operate not antagonistically – according to a logic of containment – but in terms of patterns of flow. Irigaray is not claiming, of course, that Western philosophy and psychoanalysis has not theorised female identity. Her claim is simply that it has been understood according to what she will term the 'hom(m)osexual economy of the same'.[18] Woman has been conceived as like the male – only different; both lacking and excessive. To put it in my own language: the male has acted as both norm and ideal for what it is to count as an entity, a self or a person.

I will return to the problem of how identity might be constructed according to a different logic, but first I want to comment on a problem with Irigaray's position: one that bears on the fourth hypothesis that might be used to explain why I 'fail' to think of my body as a three-dimensional container. This was the hypothesis that my deviance from the Johnson/Lakoff model was not to be ascribed to my gender, but to the fact that I am a Westerner living in the last decades of the 20th century. For although it is surely true that in the history of Western science, there has indeed been a privilege given to solidity, space as a container and the mechanics of solids, this science has been out of date since around the time of the first European war. The mathematics of fluidity and the indefinite (Catastrophe Theory, for example) is now central to the scientific tradition. If Irigaray wants to characterise an emphasis on the indefinite as 'feminine' science, then we now live – and also kill each other – with the techniques of femininity.

New scientific, mathematical and topographic models have superseded hylomorphism, with its attempt to explain change by reference to an active form imposed upon an inert, homogeneous and unshaped matter. As Sanford Kwinter has recently explained, classical science is reductionistic. Although not strictly speaking limited to static models of form, it is limited to conceptualising and measuring movement or change in linear terms.[19] Modern topological theory became possible on the basis of work produced by the mathematician Henri Poincaré during the years 1889-1909. On the new model, matter is not in any sense homogeneous, but contains an infinity of singularities which may be understood as properties that emerge under certain, but very specific, conditions. What topology does is provide a way of mathematically explaining the emergence of those singularities. Thus, 'ice' and 'water' as well as 'magnetism' and 'diffusion' are forms on the new model, and these forms all depend on singularities for coming into existence.

> A singularity in a complex flow of materials is what makes a rainbow appear in a mist, magnetism arise in a slab of iron, or either ice crystals or convection currents emerge in a pan of water.[20]

Although the classic differential calculus could successfully plot the movements of a body within a system, it did so by regarding the system itself as closed and as incapable of change. By contrast, in the new theory it is possible to measure not only transitional changes within the system, but also transformations that the system itself undergoes. Because of this shift of reference, modern topological theory is able to offer a dynamic theory of birth, manufacture and change, in which form is not something that is imposed on matter, but which erupts in matter or is a state of matter. On the new model there is no fundamental difference between states and forms: forms simply are structurally stable moments within the evolution of a system (or space). Indeed, for a new form to emerge on this model the entire space or system is itself subject to transformation or distortion from exterior spaces or systems. We are dealing here with open dissipative systems and with leaks of energy into and out of the system.

To make the links with Irigaray more explicit, Irigaray claims that the West has been slow to develop a science that can measure and model patterns of the indefinite and of fluidity. However, even if that science was slow to come into existence, it does now exist. The new topologies see form as no more than an apparent and temporary stability in the patterns of potentiality or flow. To quote Kwinter:

> A potential is a simple concept: anything sitting on one's desk or bookshelf bears a potential (to fall to the floor) within a system (vector field) determined by gravity. The floor on the other hand is an attractor because it represents one of several 'minima' of the potential in the system. Any state of the system at which things are momentarily stable (the book on the floor) represents a form. States and forms then are exactly the same thing. If the flow of the book on the shelf has been apparently arrested it is because it has been

captured by a point attractor at one place in the system. The book cannot move until this attractor vanishes with its corresponding basin, and another appears to absorb the newly released flows.[21]

Forms – *apparent* stabilities – are brought about only because dissipative systems tend to remain in equilibrium or at a state of rest up to a certain threshold of destabilisation. However, because energy pervasively leaks to and from the system and is also transported between macro- and micro-levels within the system, such destabilisation could occur at any moment and be triggered by an apparently minor deformation in a contiguous system. Catastrophe Theory is one of the models for mapping this, with its celebrated example of the flapping of a butterfly's wings in the Pacific 'causing' a hurricane at the other side of the world.

For my purposes, what matters is not the details of the theory; but the new metaphysics entailed by the new topological models. For on these models, forms are not fixed things, but temporary arrestations in continuous metastable *flows*, potentialities or evolutionary events. If we think about boundaries then from the point of view of the new sciences, the boundaries of our bodies are not the edges of 'three-dimensional containers into which we put certain things (food, water, air) and out of which other things emerge (food and water wastes, air, blood etc)'. The boundary of my body should rather be thought of as an event-horizon, in which one form (myself) meets its potentiality for transforming itself into another form or forms (the not-self). Such a body-boundary neither entails containment of internal forces nor repulsion of/ protection against external forces. Those who are aware of themselves as centred 'inside' an insulated container – free from contamination by the threatening other which is located on the 'outside' – are captured by an illusion generated by the mechanisms of ego-protection, as well as by spatial models inherited from a classical science which is now outmoded. To imaginatively construct the self as inhabiting a 3D 'container' is to treat the self as a system that is closed: a form of narcissism. it means blocking out other systems (including other selves) from which and to which energy might leak. It means to refuse to model the self as a *dissipative* system.

In terms of the way the new topological paradigms impinge on feminist theory, Donna Haraway can be read as seeking to align 'woman' with the new sciences. In 'A Manifesto for Cyborgs' (1985), Haraway takes the image of the cyborg – a machine/human hybrid – and evokes an imaginative schematism in which there is no nostalgia for the (illusory) oneness of the autonomous (male) self. What Haraway is doing here can be easily misunderstood and assimilated to just one more form of North American post-modernism in which the impossibility of defining what women have in common is supposed to entail the necessity of abandoning gender as a framework for political organisation. But what Haraway is rejecting is not feminism as such, but merely the dialectics of self versus other as figured by those feminists who both recognise the oneness of the self as illusion, and identify with the 'other' rather than the self.

> The self is the One who is not dominated . . . To be One is to be autonomous, to be powerful, to be God; but to be One is to be an illusion, and so to be involved in a dialectic of apocalypse with the other. Yet to be other is to be multiple, without clear boundary, frayed, insubstantial. One is too few, but two are too many.[22]

Haraway is, in effect, rejecting the predominant forms of deconstructive, cultural and psychoanalytic feminist theory. She envisages another form of feminism which charts the self – and disruptions to the 'system' of patriarchal control – by cybernetic schemata made possible by the new topologies.

> Our bodies, ourselves; bodies are maps of power and identity. Cyborgs are no exceptions. A cyborg body is not innocent; it was not born in a garden; it does not seek unitary identity and so generate antagonistic dualisms without end (or until the world ends); it takes irony for granted. One is too few, and two is only one possibility . . . The machine is us, our processes, an aspect of our embodiment. We can be responsible for machines; *they* do not dominate or threaten us. We are responsible for boundaries; we are they.[23]

Thus, read carefully and in terms of the new scientific paradigms of form and identity, it can be seen that Haraway is embarked on much the same project as Irigaray: of asking that female identity be conceptualised in terms of a different understanding of boundaries. Selves become *dissipative* systems. it is not that all identity disappears on this model; but rather that identity has to be understood not in terms of an inner mind or self *controlling* a body, but in terms of patterns of potentialities and flow.

Coming back to the hypotheses as to why I might not have picked up the 'container' view of my body (with the self safe inside it), I would like to suggest that hypotheses three and four are not mutually exclusive, and perhaps even reinforce one another. Hypothesis three ascribes my 'failure' to schematise my body as a container to sexual difference. I have offered limited support for this thesis by indicating how women in our culture are precariously placed by reference to boundaries. This is both because the primary model of the self is based on that of an individual who does not have to think of himself as potentially splitting once a month into two individuals; and also because women are accustomed to seeing humanity and persons described in ways that both include and exclude women. Hypothesis four ascribed my 'failure' to historical factors. The fact that new models for self/ other, mind/body relationships are now prevalent in science

– and hence, whether we are aware of it of not, in fiction, computer-games, advertising and in the media generally – can provide a resource with which women are able to *resist* the schemata that would render bodies containers and selves autonomous. There are alternative models for the phenomenology of the self to those provided by 3D spatiality. Indeed, it is notable that the richest accounts of phenomenological experience (Sartre, Merleau-Ponty, Beauvoir etc) also stress potentiality, force, flow, over stasis and containment. There always has been more than one way of thinking the mind/body, self/other relationship in the history of the West.

This brings me to the fifth and final hypothesis that I wish to consider: that my 'failure' to think of myself in terms of a hermetically sealed container might be ascribed to currents in the history of Western thought that preceded the new sciences. Again, I want to say that I see this hypothesis not as a *contrast* to the two preceding explanations, but as adding an additional factor. Kwinter describes Catastrophe Theory as a 'fundamentally Heraclitean "science"'.[24] We can also find in Nietzsche a model for individuation that conceptualises the ego as an (unstable) balance between different, overflowing sources of energy. For Nietzsche, the self expands only until it finds some energy field that it cannot appropriate. Health or individuality is not a given, but something that is only maintained via a war of energies. Whatever does not kill me makes me stronger: resistance is what forms the boundaries of the ego. Although this antagonistic account of self/other differentiation is not identical to modelling individuality in terms of leakages of energy between levels of system or contiguous systems, it certainly provides a model for thinking the self that involves an acceptance of flux.

The Nietzschean body does not involve a containment which entails protection against external forces or which holds back internal forces from expansion. On Nietzsche's model the boundaries of the self are potentially fuzzy, and hardened only by the processes of appropriation and expansion. The dangers come from within as well as without: disease simply is the tendency for the parts to exert energies in an anarchic way and act independently of the whole. Death is merely an intensification of this process, and entails dissolution into the micro-organisms that constitute any apparent unity. Although antagonism and conflict mark the Nietzschean world into an infinity of sub-systems, in discussing the overman he also suggests a less conflictual form of energetic relationships: via the economy of the gift.

I am not disagreeing with Irigaray's suggestion that patterns of meaning and inference have in the West been shaped by containment metaphors and relationships. However, I would deny that this sense of the self as housed by a container is common to all socialised Western subjects. Indeed, the homogenising of the West in this fashion is a dangerous political move. The potentiality of thinking beyond the predominant models of the self/other, mind/body schemata has been severely limited by the tendency in post-structuralist and post-modernist feminist theory to look back at that history and find only an 'economy of the same'. It is on this point that I depart most radically from Irigaray who, despite criticising Lacan for his synchronic treatment of language and the imaginary (and despite being profoundly influenced by Nietzsche), views the history of Western philosophy since Plato as a unitary symbolic system.[25]

Irigaray finds only one Oedipalised – and masculinised – model of the self in the historical past. This model becomes more sophisticated as it evolves, but remains caught within a logic that privileges form, solidity and optics over the indefinite, fluidity and touch. For Irigaray, the history of Western philosophy remains the expression of a seamless masculine imaginary. For her, therefore, change can only come from attempting to symbolise that which exists but which has remained unsymbolised in historical times: mother/daughter relations. It is this relationship that forms the 'Other of the Other': a position of speaking/viewing from beyond the masculine symbolic that orthodox Lacanians would fiercely deny. Although I agree with Irigaray as to the prevalence of the masculine model for the self, I do not see the history of the West as homogeneous. There have been *singularities* within it. Openings come from the writings of some familiar philosophers, such as Nietzsche, Diderot, Kierkegaard, Bergson or Foucault. But we need also to look in some unfamiliar places: in texts by past *women* writers who register that they must count as abnormal, peculiar or singular in terms of the dominant models of the self – and then go on to make imaginative or theoretical adjustments.[26]

If the emphasis is on generalities (about philosophy, science or 'the West'), *singularities* (and hence, women) can be overlooked: they are merely exceptions to the rule. By contrast, the new topologies *work* with singularities. Indeed, singularities embody radical transformative potential. By adopting the paradigm of patriarchy as a dissipative system, feminists can register the centrality of masculine models of identity to all existing symbolic codes, without becoming trapped in an impossible dualism of having to choose between the (over-pessimistic) strategy of deconstruction or the (over-optimistic) strategy of searching for a place to speak from that is beyond the symbolic. Dissipative systems are not closed: there are other systems both without and within. Without a model of the system of patriarchy as *itself* a dissipative system, speaking from the position of 'Otherness' – even from the position of 'the Other of the Other' which Irigaray posits – has limited political point. Applying insights

from the new topologies allows us to see how patriarchy might itself be inherently unstable as a system and hence how the slight flapping of the wings of a feminist butterfly might – metaphorically – provide the catastrophe that would enable it to flip over into a state of anarchy or radical change.

At this point I need to emphasise the difference between my own position and more standard treatments of the feminine (or *féminin*). Having registered that it is the *male* self that is privileged as unitary and contained in the history of the West, post-modernists, deconstructionists and post-structuralists have frequently proceeded to argue for an abandonment, trangression or deconstruction of boundaries. I hope it is clear from the argument that I have mounted here that I would sharply disagree. Without talk of identity (and hence also of boundaries), I do not see that there can be a basis for responsibility or action, including political action. What I have been wanting to stress throughout this paper is that not all talk of identity involves thinking of the self as unitary or contained; nor need boundaries be conceived in ways that make the identity closed, autonomous or impermeable. We need to think individuality differently; allowing the potentiality for otherness to exist within it, as well as alongside it; we need to theorise agency in terms of patterns of potentiality and flow. Our body-boundaries do not *contain* the self; they *are* the embodied self. And the new sciences give us topological models for imaging self in these terms.

Thus, I would agree with those feminist theorists who have argued not for an abandonment of boundaries, but who have asserted that a *feminist* metaphysics demands a *different* account of identity construction. Irigaray and Haraway come nearest to doing this – even if it is perhaps misleading to present the focus of their work in this way. The re-thinking of the female self that I am demanding does not entail a cognitivist claim: it is not necessary to essentialise a specifically *female* experience. I am not claiming that all women *do*, as a matter of empirical fact, fail to think of themselves in terms of the containment schemata. It is rather that feminists need – for political ends – to exploit the difficulties of containing female identity within the schemata provided by classical science and metaphysics, and use the resources provided by contemporary science and the history of philosophy to think selves, bodies and boundaries in more

revolutionary terms. In this respect I agree with Donna Haraway in the alliance with the cyborg. It is time to turn our backs on those forms of feminist theory that castigate all science and all Western philosophy as rationalist, masculinist and weapons of the enemy. It is time to investigate the imaginative schemata that old philosophies and new sciences offer us for re-visioning the female self.

Precisely because there is not just 'the' system of patriarchy or 'one' model of the self in the period of philosophical Modernity, we can look outside the dominant accounts of the history of Western philosophy, literature and art to find different visions of the self and its boundaries. I would argue that this entails giving up a semantics that is blind to issues of gender and focuses only on abstract issues of meaning, or that registers bodily experience only in terms of shared cognitive and imaginative 'universals'. In effect, this entails giving up semantics as a philosophical starting point. Even where semantics does not treat language as a monolithic system, it tends to over-emphasise consensus either between languages or within a single language. In matters of gender, such strategies can be radically misleading. It is no accident that there are strong semantic links between English-language 'gender', French *genre* and Latin *gens*: all of which purport to link things of the same sex, type, family or genus. Neither is it an accident that in most European languages there is no linguistic equivalent to the English word 'gender', for the latter is just *one* of the ways that the boundaries of a genus can be marked.

Women both are and are not monsters. Languages both do and do not require a separate word for the characteristics that women have in common. We need to think of boundaries from a perspective that can engage with that enigma, but which does not get trapped by it. That can only happen when we look back at history and to contemporary science for models of identity which are capable of treating the lived reality of female bodies – with their potential for penetration and pregnancy – as neither exceptional, nor monstrous, but as both ideal and norm. We need to move from a semantic model of boundaries into a new metaphysics of boundaries. This metaphysics will not appeal to an unsymbolised imaginary, but to *singularities* in the past and present that can dynamically open up conceptual change.

Notes

1 Mark Johnson, *The Body in the Mind*, University of Chicago Press, 1987, p 21. My paper was triggered by the defence of cognitive semantics in an unpublished paper by Paul Chilton, 'The Semantics of Boundaries', the *European Humanities Research Centre Interdisciplinary Seminars on Boundaries*, no 1, Warwick University, 9 December 1992.

2 *ibid*, p 22.

3 *ibid*, p 190.

4 G Lakoff, *Women, Fire and Dangerous Things*, University of Chicago Press, 1987, pp 272, 273. Lakoff and Johnson had worked together previously: see G Lakoff and M Johnson, *Metaphors We Live By*, University of Chicago Press, 1980.

5 Oliver Sacks, *The Man Who Mistook His Wife for a Hat*, London, Duckworth, 1985, p 50.

6 Emily Martin, *The Woman in the Body*, Open University Press, 1987, p 106.

7 Hilde Bruch, *The Golden Cage*, Harvard University Press, 1978, p 39. Cited Noelle Caskey, 'Interpreting Anorexia Nervosa' in *The Female Body in Western Culture*, ed SR Suleiman, Harvard University Press, 1985, p 180.

8 Helmut Thomä, 'On the Psychopathology of Patients with Anorexia Nervosa', *Bulletin of the Menninger Clinic* 41, 1977, pp 437-52. Cited Rudolph M Bell, *Holy Anorexia*, University of Chicago Press, 1985, p 16.

9 Julia Kristeva, *Powers of Horror*, trans L Roudiez, Columbia University Press, 1982, p 3.

10 Erik H Erikson, 'Inner and Outer Space: Reflections on Womanhood' (1964) in *Sex Differences: Cultural and Developmental Dimensions*, eds Patrick C Lee and RS Stewart, Urizen, New York, 1976, pp 121.

11 Marianne Wax, *Let's Take Back Our Space: 'Female' and 'Male' Body Language as a result of Patriarchal Structures* trans J Albert, Frauenliteraturverlag Hermine Fees, Munich, 1979. This extraordinary book contains over 2,000 photos of male and female body posture and gesture, together with a textual analysis. Its historical sections are methodologically weak and its causal account consequently badly flawed. However, the documentary material from the 1970s clearly establishes a differential use of space by male and female subjects.

12 Iris Young, *Throwing Like a Girl and Other Essays*, Indiana University Press, 1990. See also Sandra Lee Bartky, 'Foucault, Femininity and the Modernisation of Patriarchal Power' in *Femininity and Domination: Studies in the Phenomenology of Oppression*, Routledge, London and New York, 1990.

13 Paul Smith uses the work of Michèle Montrelay (a psychoanalyst who broke with Lacanianism later than Luce Irigaray) in his 'Vas' (1988), *Feminisms: An Anthology of Literary Theory and Criticism,* eds Robyn R Warhol and DP Herndl, Rutgers University Press, 1991, pp 1011-1029. For Montrelay see *L'Ombre et le Nom*, Minuit, Paris, 1977.

14 (1974): first translated as 'Volume-Fluidity' in Luce Irigaray, *Speculum of the Other Woman*, trans Gillian C Gill, Cornell University Press, 1985; a more accurate translation is included in *The Irigaray Reader*, ed Margaret Whitford, Blackwell, Oxford, 1991, pp 53-67, (1977): *This Sex which is not One*, trans Catherine Porter, Cornell University

Press, 1985, pp 106-118. (1985): trans in *Feminism and Science*, ed Nancy Tuana, Indiana University Press, 1989.

15 Plato, *Timaeus,* 42b-c; 90e-91a.

16 For an extended discussion of Aristotle on woman see the essays by Lynda Lange and Elizabeth V Spelman in *Discovering Reality*, eds Sandra Harding and Merrill B Hintikka , Reidell, Dordrecht, 1983, pp 1-30.

17 The title, literally, of Irigaray's (1979) book and one of its essays: see note 14. Irigaray's infamous use of the metaphor of woman's 'two lips' in that essay (pp 23-33) – which keep 'her' in constant touch with the other within her – has been mistakenly read as a form of biological essentialism, but metaphorically represents this metaphysical move.

18 The pun is on the French term '*homme*' for (the supposedly gender-neutral) 'man'.

19 Sanford Kwinter, '*Quelli che Partono* as a general theory of models', *Architecture, Space, Painting*, Journal of Philosophy and the Visual Arts, ed Andrew Benjamin, Academy, London, pp 36-44. My account is deeply indebted to Kwinter's which is offered in the context of discussing a Futurist triptych by Umberto Boccioni.

20 *ibid,* p 37.

21 loc cit.

22 Reprinted in Donna Haraway, *Simians, Cyborgs and Women*, Free Association Books, London, 1991, p 177.

23 *ibid*, p 180. Haraway's argument here extends that offered in her *Primate Visions*, Routledge, New York, 1989 and Verso, London, 1992. The philosophical implications emerge perhaps most clearly in her 'The Biopolitics of Postmodern Bodies: Determination of Self in Immune System Discourse', *Differences* 1 (1), pp 3-43.

24 Kwinter, op cit, p 39.

25 For Irigaray's most extended dialogue with Friedrich Nietzsche see her *Amante Marine* (1980); *Marine Lover of Friedrich Nietzsche*, trans Gillian C Gill, Columbia University Press, 1989. As well as the disagreement with Irigaray noted here, I should add that I am deeply unhappy about the general direction of her most recent work.

26 It is, for example, interesting to read Biddy Martin's analysis of the model of ego-construction provided by Lou Andreas-Salomé (loved by Nietzsche and Rilke, and a close associate of Freud) in the light of the argument in this paper. See her *Woman and Modernity*, Cornell University Press, 1991.

Wendy McMurdo, Untitled, 1990, photoimage, glass, wire and wax on paper, 80x80cm. Disturbingly, identity is established via external imposition (the stocking mask) and by lines of tension linking the head/face to an otherness which is both amorphous and yet (via the suggestion of nipple, breast, and hair), nevertheless, apparently female. In ways reminiscent of Luce Irigaray's critique of the form/matter distinction, the privilege given to optics, straight lines and solids in the history of the West is both evoked and undermined.

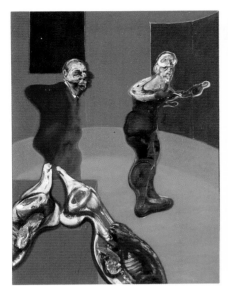
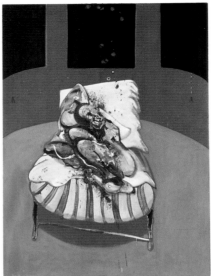
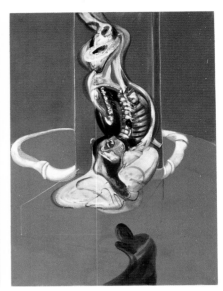

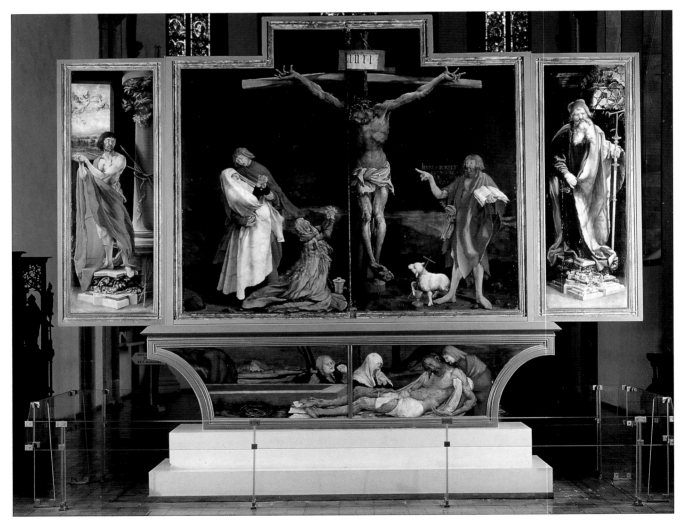

FROM ABOVE: Francis Bacon, Three Studies for a Crucifixion, 1962, oil on canvas, triptych, each panel 147.5x198cm; Grunewald, Crucifixion, 1512-16 (Isenheim Altarpiece)

NICK MILLET
THE FUGITIVE BODY
Bacon's Fistula

. . .and often I have asked myself whether, taking a large view, philosophy has not been merely an interpretation of the body and a misunderstanding of the body.

Nietzsche

Painting is that which, in a relationship with techne *and not* logos, *creates the experience of a gift of the body to matter.*

Christian Bonnefoi[1]

Os

Six months ago I started writing on Gilles Deleuze's book *Francis Bacon: La Logique de la Sensation* with an anecdote from adolescence telling of a book whose frenzied circulation depressed the economy of the pornographic black market which thrived in the privative confines of a boys' boarding school. The adolescents behaved as if this document was outlawed, the lost fragment of an irrepressible subversion.

The book was a Syrian medical record of diseases of the mouth. The penchant in the Middle East for the hookah, *qat* and various types of chewing tobacco provided an exotic array of disease and cancer. These high-resolution colour photographs were sensational; their fascination certainly libidinal. But even more compulsive than these monstrous deformations of jaws, lips and larynges was the *colour* of the flesh, of the growths. These inflamed areas had variations and extremes of colour only Space knew. And what is more, if you looked hard enough, if you concentrated between variations, you could actually see this flesh *move*. These faces, this matter . . . *seethed*.

Uncannily, three months after writing this, my fascination would be provoked again in a closer encounter. Suffering from a venereal infection which flayed the interior of my mouth to an extreme sensitivity, I lay beside a mirror, unable to eat and prone with a fever, compulsively examining myself in silent horror: tongue swollen and flaccid with ulcers beyond the capacity of speech, lower gums inflamed red and holed at the bases of the teeth, upper gums disintegrating into a black viscosity dripping between teeth. Despite the sores opening up my genitals, what I feared most was the loss of my teeth, brilliant now against the decaying flesh.

An 'inveterate sensationalism'[2]? Perhaps. But then that is a charge, and it is of course precisely a *charge*, often brought against Francis Bacon's paintings. It is predicated on a distinction between two orders which Bacon himself used: that between the *sensational* and *sensation*.[3] Through a conjunction of Bacon's painting with the thought of several of his contemporaries I hope to show how his use of the distinction differs from and undoes that which grounds the *charge*. It is out of the diseased mouth of one of those contemporaries, Georges Bataille, that both this paper and Bacon's painting spin – as much as out of the image that begins both.[4] Another, Jean-Francois Lyotard, provides an important term, the 'figural', which functions both to elaborate on and withdraw from its use in Gilles Deleuze's book on Bacon.[5] Lyotard's book introduces the first siting of the mouth: Bacon's mouths do not *discourse*.

And yet, the mouths that obsessively dominate the early paintings let in the illustrational or narrative interpretations that were to incarcerate Bacon's painting in the discursive from then on. The mouth is the property of a subject, the scream its expression: the critics' psychological lexicon is installed. Such criticism is dominated by psychoanalytical and phenomenological thought; Lyotard describes the latter:

faithful to Western philosophical tradition, it is still a reflection on knowledge [*connaissance*], and such a reflection's function is to absorb [*résorber*] the event, to recuperate the Other in the Same.[6]

Lyotard's language is telling: *résorber* denotes making something (such as an organic liquid or tumour) disappear internally or reducing something (such as inflation – internally solving an economic crisis); whilst *résorption* leads us further into our problematic:

1 *Physiol* Passage (of substance) across a mucous membrane. Intestinal absorption of a medicament taken through the mouth . . . 2 *Phys* Absorption by a body or a system which had been liberated (from a previous absorption) . . . 3 *Fig* Suppression.[7]

Accounting for a passage between the sensible and the intelligible appropriates the sensible to build an ontology, a *logos*. Or, in another register, the sensible is diluted or taken in small doses, such that not only is its toxicity diminished but

that it serves an inverse function: a preventative medicine fortifying the system against the event by rendering benign the distance sensation opens between the sensible and the intelligible. For sensation is not what the organism calls the sensible; sensation can't be swallowed, builds nothing. This is the crux in the critical treatment of Bacon's painting: either the system erects its wall – this is *sensationalism*, exploitation of the sensible to provoke superficial emotions; or, this is moving and profound, provoking sensation in the sense of intense emotion. The second's moral dissimulation is more important here than the first's moral denunciation. For if both interpret these early paintings as representations, the second actively values its dissimulation of the effect produced in a psychological modality. The scream is a representation of catharsis which produces a cathartic emotion in the spectator. The greater the effect the harder to swallow: discourse gets its teeth out. But there is no limit to this recuperation, for the logic of catharsis dictates that the greater the shock the *stronger* the medicine: discourse *likes* getting its teeth out.

'What I feared most was the loss of my teeth' – the deliquescence of flesh horrified most in that it was taking the ground away from my teeth, their brilliance the last glint in an encapsulating darkness. The teeth in Bacon's mouths emit such a last light, a light that is almost unbearable. Ruskin knew this, knew that the timidity of the human tooth (its low intensity, its relative deadness) was the secret of its utility, just as the reduction of the mobility of the jaw is its servitude to the discursive. In 'The Grotesque Renaissance', the happy march of Ruskin's theoretical enterprise is brought to a sharp halt by one head, 'huge, inhuman and monstrous – leering in bestial degradation, too foul to be either pictured or described, or to be beheld for more than an instant.' But breaking point is reached when even 'the *teeth* are represented as *decayed*'.[8] This is a representation in excess of Ruskin's two categories of the grotesque (the ludicrous and fearful): Ruskin stamps it illegitimate, sensationalist. He doesn't see that the *stones* of Venice stand, not by juridical exclusion, but by speculative appropriation of the waters.

Long before Ruskin, another Italian city and firmer ground: Rome. In the excavations beneath the city, an Augustan architect called Vitruvius opens his mouth to proclaim degenerate the art in this labrynthine cavity: it is 'grotesque'. Discourse announces itself in the structuring of the Roman city, filling in and erecting itself above the horizontal debauchery of the Baths of Titus. As the mouth of the human organism is articulated by its rows of tiny bones so too its vertical posture depends upon its skeletal frame; this alliance converging in the Latin homonym *os*, mouth and bone. Whilst the humanity of this mouth is extended in the metonymic extension of *os* to denote face or figure, the figural nature of this relation is expressed by the homophony in French between *os* (bones) and *eaux*. So that if Velasquez's Pope is enthroned in Rome, Bacon dethrones it in the sinking city, Venice. Yet the first of Bacon's 'screaming popes' after Velasquez, *Head VI* (1949), produces the major site of critical appropriation and construction in a double movement: the first heads in the series are sublated into or swallowed by this final mouth in a pharmaceutical critique which makes those mouths swallow their own medicine.[9] In an unsubtle domestication (economising), painting is recruited into the philosophical pharmacy to dispense its analeptics.[10]

As José Gil relates, Grunewald's *Crucifixion* had a therapeutic function: it was painted for the centre panel of a polyptych destined for the outside of an altarpiece in a monastery run by a monastic order devoted to healing the sick.[11] New patients were paraded in front of the altar in the hope of an instant cure. In reading the painting as dominated by John the Baptist's pointing at Christ and his words 'He must increase but I must diminish', Gil proposes a metamorphosis of the body, an energetic exchange whereby the illness is expelled into purified energy and offered to Christ who responds with the grace of miracle on the spectator: 'The representation of Christ is therefore situated before the transformation of the body.'

The monks who held the patients in front of the altar were Antonites, so the left-hand panel of the polyptych represented St Anthony – and it was 'St Anthony's fire' which their monastery at Isenheim sprang up to combat. This epidemic which gripped the middle ages had an alimentary origin – ergotic poisoning – which resulted in loss of limbs through gangrene and 'muscular spasms that deform'.[12] The French name, *mal des ardents*, suggests that a range of bodily disorganisation was addressed, not least syphilis and epilepsy. In administering his therapeutic shock the artist as pharmacist is diligent, employing a back-up system for the care of the terminally ill – patients and non-patients alike. This system is the whole altarpiece: opening it takes the spectator from the Crucifixion through the narrative to the Resurrection. The whole altarpiece functions as a mechanical mouth, its jaws the wings of the outer polyptych: one of Bataille's 'ontological machines'[13] designed for the consumption and purification of 'base matter' into idealist constructions, a reversal of the direction of flow of the alimentary canal, dissimulating matter in the spiritual skull-bone.[14] This passage to redemption which, as will be seen later, is also figured in the outer polyptych alone, is reiterated in the *mise-en-abyme* representation of the Lamb of God bleeding into a chalice.

Yet whilst this back-up system requires that Christ's body in the *Crucifixion* be sufficiently gruesome to mirror the patients' bodies, it also sets a limit on that gruesomeness. As

Gil suggests, the 'passion' of Christ here is no more than a dissimulation, the body still an integrity, putrefaction only a suggestion. But this representation was determined by the representation of Christ in the Bible itself: the condition for the Resurrection is the preservation of Christ's skeletal unity.[15] A general structure is determined: the *a priori* condition for organic representation is a transcendent form or articulation. The immortality of the organism depends on the pure form which is itself the dissimulation or appropriation of the body: the Body of Christ situates itself *after* as well as before a transformation of the body. The disjunctive structure of representation binds unbound energy, subjects bodies – the shamanistic ritual of Isenheim is a placing or *subjectification* of dislocated, fugitive bodies. Or: the Body of Christ is a continuous appropriation of the body; it is composed of the bodies that dissipate in front of it.

Osculum

'Lysergic acid is a natural product of the ergot fungus.'[16] The convulsing bodies placed in front of Grunewald's painting had had their nervous systems assaulted. The twinkle in Francis Bacon's eye would have been blinding if bodies lost control before his paintings. As opposed to a discursive (*logos*) administering of painting to anaesthetise a fugitive body, his desire was to produce (*techne*) an effect that would release a body. Not the pharmacy of God, 'guarantor of the identity of the self and of its substantive base, that is, of the integrity of the body'[17], but the pharmacy of Bacon *producing* a hallucination that releases an 'unformed, unorganised, non-stratified, or destratified body and all its flows: subatomic and submolecular particles, pure intensities, prevital and prephysical free singularities.'[18] If Grunewald's *Crucifixion* was supposed to hold at the centre of a detox zone, the right-hand panel of Bacon's *Three Studies for a Crucifixion* (1962) opens up that space to the contagion of the *event*.

The impetus for painting this right-hand panel came from Cimambue's *Crucifixion* – rather than the iconic representation, what strikes Bacon is the body 'just moving, undulating down the cross'.[19] Bacon's history of art approaches the figural level just breathing beneath the discursive padding. His infectious enthusiasm for past art affirms Nietzsche's thought that 'the effect of works of art is to *excite the state that creates art* – intoxication'.[20] It is perhaps gratuitous to stress how much this painting retained Bacon's satisfaction until the end or to note that he was himself drunk when most of it was painted.[21] But this dissoluteness is integral to Bacon's 'technique', which itself elaborates his notion of the redundancy of painting after photography, for in the disintegration of his pictorial act there is no attempt to recuperate a representational task for painting, but a spreading of that opening which is redundancy.

Bacon's bodies are extracted from representational space which has explicit pretensions to an objective recording function – Muybridge's metric space, figurative painting and the space of medical observation. These spaces incarcerate the body in closed spaces in order to represent it objectively: the transcendental structure of organic representation is indeed this imprisonment. The sovereign or redundant status of painting releases the body from this objectivity. In the particular case of this panel from the *Crucifixion*, the body is released from both the figurative space which maximally proliferates the anthropomorphic stratum, and the space of radiography. Whilst both spaces function to the same ends the coincidence of the bodies they constitute in this painting works inversely, enacting a positive release. I will come back to this dislocation of the body later on, but for the moment will note with Gowing the 'strange analogy' between the Crucifixion as the curing of the mortality of man and the fact that 'one passes people through X-rays in such a way so as then to be able to cure them'.[22] Gowing suggests that it would be 'chimerical' to follow up these associations, but the one step he takes further is telling. He paraphrases only the second of the following consecutive remarks of Bacon's on the condition of the modern painter: firstly, that photography has released painting from its representational function allowing it to concentrate on 'making the sensibility open up through the image'; secondly, in the disappearance of the possibility of redemption art becomes a game, while 'a kind of immortality' is to be bought through medicine.[23]

The suggestion is that representation and redemption are intimately related, but more importantly that it is an absence of finality that allows painting to 'give the sensation'[24], to 'unlock all kinds of valves of sensation'. When Bacon further emphasises his own receptiveness to energy[25] the connection between Nietzsche's 'intoxication' and redundancy can perhaps be seen. Indeed Bataille affirms that a 'state of excitation' or 'toxic state'[26] marks redundant activity and describes this state as sacrificial; after all, the artwork 'signifies, in the most precise way, creation by means of loss. Its meaning is therefore close to sacrifice.'[27] Whilst Bataille's description of the effect of this rite is strikingly close to Deleuze's description of egoic release, the conjunction of his anthropological mythology and Nietzschean physiology produces a terminology that is necessarily atheological: this sacrifice is a vomiting, the opposite of 'the communal eating of food'.[28] This expulsion is not a rite of passage in the sense of entering a realm or order, rather it is a passage 'into' innocence, an opening or passage out, a synonym for Bataille's 'sovereignty'. *Innocence*, where the body is a fluid surface not yet organised to swallow and retain the medicine of the Lord.[29] In his essay on Van Gogh's automutilation, Bataille describes an irrevocable, inutile sacrifice – the only

type which is no longer governed by representation: a gift of oneself (*se donner*) to matter. Although the destination of Van Gogh's ear recuperates the act of automutilation Bataille isolates the initial moment: the gift is a dispensing of organs, organs are the binding of energy in *ends*: Bataillean sacrifice sacrifices ends, sacrifices sacrifice. This is an act without a subject: Bacon's throwing down of 'non-rational marks', those which convey the 'mystery of fact'[30], not the mysteries. An expropriation.

'And you can't will this non-rationality of a mark.'[31] The moment of art production as an intentional event, as exteriorisation or representation (Hegel: *Vorstellung einer Vorstellung*), voluntarism (even a technicist voluntarism), mimetic theories, hylomorphism, theological linear theories of art production (and their rational humanist derivations), the art work as intentional, interpretative object . . . etc. These fantastic constructions fall with the contingency of the artistic process.[32] The artist is circuited, immanent to the production process – the agent–subject 'becomes the empty place where the impersonal affirmation emerges'.[33] The art-work is not traceable back to an original unity:

> The work of art where it appears without an artist, eg as body . . . To what extent the artist is only a preliminary stage. The world as a work of art that gives birth to itself.[34]

But it is in the moment or act of Bacon's non-rational marks, the moment of the circuiting, that Bataille's will to chance is given its full pictorial equivalent, the art-work produced in a throw of the dice.[35]

The artist is 'sick'[36], spilling its transcendence, emptying its site. An opening then, but not discursive, not a mouth, rather a mouth-like aperture, an *osculum*. Not an organ, but the artist become an opening. This is the other mouth that Bataille describes, not the mouth isolated on the anthropomorphic stratum subordinated to the expressive apparatus of the face, but a mouth more like the opening of an 'excremental skull'[37] or that at the end of the tube that the organism becomes – its spine no longer functioning for unity or verticality but as a sort of vociferous drainage tube, as in the right-hand panel of the 1944 triptych *Three Studies for Figures at the Base of a Crucifixion*.[38] This mouth is the site of 'weakest resistance'[39] – it is a figural mouth, unbinding, opening onto the obscene. Let us give this opening a name – place its beginning in the discursive, but signal its evasion. In the pictorial act this opening, Bacon's, is a *fistula*. A fistula is 'a pathological communication' facilitated by a pipe-like ulcer or a surgically made body-passage which carries body liquid. As will be expected by now the opening of this mouth can therefore either be a therapeutic act or a pathologic effect. There is a fistular typology which creates a Bataillean scale of sacrificial degree. Van Gogh's or the artistic would

be the pathological digestive fistula of the salivary gland (which can be caused by trauma) opening as a supplementary, abnormal mouth discharging an incontrollable flow of saliva. Since Bataille characterises sacrifice by *alteration* and emphasises fecal matter, the prime sacrificial fistula would be the jejuno-colic digestive fistula resulting in diarrhoea and an 'alteration of the general state'.[40] The pathological fistula has nothing to do with propriety, mocks at the auto-sufficiency and auto-determination of the subject just as auto-mutilation mocks at an auto-constituted act, immanent to itself. The pathological fistula is the toxic rupture the belly of the architect dreads; an opening of interiority. The fistula is not found on a stratum such as the anthropomorphic proliferating it by appropriation, but is passage as a surface-line of intensification or becoming: a wasting line destratifying, communicating heterogeneity.

In its 'non-logical difference'[41] the fistula joins Bacon's 'non-rational marks' to converge in the 'non-logical operations' of Lyotard's *figural*.[42] Lyotard injects the figural within the discursive space that had determined all figuration to be dependent on the relation of signified to signifier. The figural works from within, like a virus, scrambling the (genetic) code of regulated distances in the discursive, rupturing the identities that are thus spaced: revealing discourse's bones to be constituted on a generalised osteitis. Lyotard puts it well when he sees discourse as always the 'carrier' of figural elements which are also 'figure-forms', produced by 'non-logical operations' which 'do violence to the rules of constitution of spaces between terms'. Since it is constitutive of it the figural is epidemic and endemic to discourse. Lyotard sees it manifesting itself in modern art, where it deconstructs or critiques representation – producing *events*.

Osculation[43]

The event that I am calling *fistula* produces a body that Lyotard sees the space of painting to exemplify: the 'erotic body *par excellence*'.[44] This body *osculates*. In Bacon's painting such is the function of the band which so often disjoints (inclusively) the flats. In the 1962 *Crucifixion*, with the triptych form already disrupting narrative interpretation, the body is released from a transcendent determination of unity: if in the central panel the body is a mess of crushed cartilage, in this right-hand panel the *whole* body is subsiding. The monumental uprightness of John the Baptist and Christ, maintained vertical, capital, in Grunewald's painting, are given over to the horizontal movement of the expanding flow of flesh about to engulf the fixity of the base of the cross.[45] Whilst the skeleton's tardiness is no more than a sign of its relative solidity, the important transformation of bone occurs with the elliptical band at the base of the cross. Replacing the curve of the mourners in Grunewald's painting, which both

fulfils iconic recognition and creates compositional symmetry with John to direct the gaze to the head of the cross, Bacon's band doubles as a horizontal section suggesting the cross to be inverted, despite its base, and as an abstract framing device. Not subordinating the body to figurative or narrative ends by framing with figures in representational space, Bacon's band critiques discursive or 'architectural composition':[46] white and jointed as bone, but fibrous, intestine, like the pipe carrying the body away, head first, in *Figure at Washbasin* (1976).

The inversion of the figure is characteristic in Bacon's painting and is intimately bound to what I have described earlier as redundancy, the deterritorialisation of representational space. Intensifying the disintegration of 'eloquent poses', these inversions function with the non-rational marks in 'indifference' to the subject-matter that no one has described better than Bataille. Indeed the chapter in Bataille's *Manet* [47] entitled 'The Death of the Subject' takes on double significance: for the extraction of the body from representational spaces robs it of its verticality, deterritorialising the face. The decomposition of metric space that results undoes the organic and the 'primacy of human beings.'[48] The organic subject is no longer master of geometric space:[49]

The organic, with its symmetry and contours inside and outside, still refers to the rectilinear coordinates of a striated space. The organic body is prolonged by straight lines that attach it to what lies in the distance. Hence the primacy of human beings, or of the face: we are this form of expression itself, simultaneously the supreme organism and the relation of all organisms to metric space in general.[50]

It is Bacon's extraction of the body from Muybridge's photographs (whose function is mensuration) which is perhaps most important, enabling him to take no longer as model a body at the ends of movement, typical of the classical pose (as Lessing described). The organic equilibrium which Bataille saw as determining a geometric aesthetic of the beautiful with its 'economy of force'[51] is vertiginously destabilised. This inversion of the figure is the first stage of opening out space from a conception that was based on organic representation, the myth of interiority appropriating space into a harmonious commensurability.[52]

It is however the elastic bone or pipe which produces the most radical movement, displacing what Deleuze sees as its function and combining extraordinarily with another 'abstract' element to both exacerbate the downward movement of the figure and create a singular tension.[53] This element is the patch of black added at the bottom; despite the apparent compositional continuation and hence reinforcement of the vertical, this patch continues the movement to the horizontal by projecting *forward* the orange flat. A tension is created

between this forward movement and the backward movement of the ribbon which uses perspective without being subordinated to it. But this is no dialectical tension, for there is movement both right and left (the contour between colour planes, the ribbon itself), and furthermore the movement forward and back does not sclerose into an opposition but each pole exacerbates the other. What is produced is a vertical fall being split and ribboned into a horizontal plane, such that the vertical fall is *secondary* or incidental to the horizontal movement. Produced out of the figure of the body is a spreading surface; the body is spilling itself into a 'shallow depth' (Deleuze).

The problem with the spatial model of the fall is that it still requires transcendence, whereas the horizontal movement here produces the vertical as its dissimulation or miraculation. The strip of melting bone osculates both in the mathematical sense and as a communication between the figure and the flat – it is the fistula line of becoming, the figure becoming ground, its vertical space unfolding into a horizontal surface through the fistula. The fistula is not a passage *between* elements, just as the communication between art-work and spectator is not cognitive since the conditions of subjectivity and objectivity are no longer fulfilled; 'in the breach'[54] is an intensive distance, a contagious intensive surface. The fistula is not an organ but that by which organicity is excreted, making Bacon's body and the body of his painting 'a new body that can receive [decodified energy] and spill it forth'.[55] This allotropic mass, lightening in its catabolism, is the movement of Bataille's 'base matter'; not the passive organic matter of hylomorphism, but an emission of singularities 'of the cast of the dice kind, [constituting] a transcendental field without subject'.[56] This 'matter' is 'no good from the builder's point of view' (Beckett), neither constituting an interiority nor a unity, but a 'field of dehiscence' (Blanchot), 'astral straws on a timestorm, grit in the mistral' (Beckett).

Bacon's body is becoming this plural substantive (bodies), through the new technique that it is: escape. The initial movement of this escape is dislocation. It has already been seen how the transcendental space of the skeletal frame is opened up multiplying that space on a horizontal surface, but Bacon multiplies dislocations never allowing a stable form to be reinvested. This is carried out through an asyntax that Beckett calls 'punctuations of dehiscence'. All Bacon's framing or highlighting devices have this paradoxical property of displacement: containing a form only to void that space into an exposure of its forces. Circles and ellipses of all types, rivet-heads, syringes, circular beds, tubes, basins, pipes, toilets, the curved contours of the flats – even the cubes are cylinders: escape chutes.[57] Dislocation of structural bone and freeing of the forces and space incarcerated – such also is the logic of the radiographer's target circle,

redundant now, no longer therapeutic but an intensifier, dislocating the ectopic. Deleuze puts it well when he sees that the mouth 'acquires this capability of illocalisation . . . It is no longer a particular organ but the hole through which the whole body escapes, and by which the flesh descends.'[58]

With this notion of mouth becoming hole we are returned to the specific dislocation with which I began. Both Deleuze and Dawn Ades have noted well the becoming-animal that characterised the first two of the *Head* series in the late forties. Such a stratal infection (or osculation) carries greater significance when it concerns the anthropomorphic stratum, for it always results in a dislocation of that stratum's isolation, its detachment in a transcendent position outside the strata. Furthermore, this becoming (which is a positive and absolute destratification) is intensive, it unleashes energy that had been incarcerated on a stratum. It can perhaps be seen why these first heads are sublated into the last, *Head VI*, by the critics. For although this was painted in absolute indifference to the subject of its origin, Bacon being intoxicated primarily by the *colour* of Velasquez's painting, the suggestion of a papal tunic through that colour allows the figurative deduction of a nominal identity. The intensity of the initial heads in the series, this 'matter' or 'presence' at the 'heart of representation', which is unregulated and refractory to capture, incites the retroactive violence of the faculties of representation, neutralising the 'initial' violence of intensity, giving it form, 'a place in space', the absolutely dignified place of psychological subjectivity.[59] This mouth begins the reduction of Bacon's painting to illustration, dissimulating his bodies in the figurative, representation's sensationalism. The difference between the 'sensational' and 'sensation' becomes a merely local problematic on the level of narrative, secondary process; discourse dissimulating primary process, suppressing the figural, intensive sensation.[60]

Indeed, Freud's metapsychology tells a story of the organism as a defensive complex for the repulsion, diminution and inhibition of stimulus, functioning in accord with the homeostatic mechanics of the constancy principle. The organisation is preserved in its transcendence (its 'merely indirect connection [with] the external world').[61] The 'innocent' surface produced out of the fistula is not only a body without bones but a body without sensory organs, for the sensory organs function to diminish intensity; they are solidified channels which *as such* bind and filter force, producing *sensations*. As long as the reception of stimulus is controlled, facilitated, the production of representation – that is, the recognition of that reception – can continue; but if this stimulus exceeds the capacity of the secondary organisation damage occurs, shock is registered. Only shock is not *registered* since that which enables registering (facilitation etc) has not functioned. This is what *sensation* is: a shock that

overflows or bypasses the organs, being neither the essence of the sensible nor the sensible in itself, but in excess of recognisable (extensive) sensations. Freud's shock, Lyotard's event and Deleuze's encounter affect and release a body from representation.[62]

It is in this sense that Nietzsche declares that 'the Christian has no nervous system' and so 'a Christian who is at the same time an artist does not exist.'[63] The Christian body is an organism, well wadded with wafers.[64] With force incarcerated in organic representation, what Bacon called the 'brutality of fact'[65] is attenuated. The distance between fact and its attenuation is evident in another of the elements determined by Bacon's 'non-principle of punctuation' (Beckett): the arrows.[66] If for Lyotard deixis ruptures the closed system of discourse in a figural irruption, then this force is immediately recoded in Grunewald's painting by John's deictic gesture which illustrates his speech, interiorising the reference of the designation in the discursive space of the painting – deixis is actualised simultaneously in the pictorial representation, reduced to signification. There is no way out of this painting: direction is only centripetal, not opening distances, but swallowing them in the depth of the Place; not opening experience, but closing down sensation in the already distributed system of meaning.[67] The therapeutic success of the painting depends on the binding of force to form *one* passage, channelling that force to its transcendental source and destination. Bacon's arrows on the other hand share the paradoxical character of his framing devices: extracted from metric space they concentrate on a site which explodes, dispersing the initial arrow in all directions. These arrows are kamikaze: intensifiers rather than indicators. They are the arrows of the right-hand panel of Grunewald's *Crucifixion*, St Sebastian's, journeyed out of the symbolic to function in vectorial space, designating contagions and disruptions, opening a space no longer regulated by the 'syntax of the static'.[68] As in the stratal infection that occurs in *Head II* their movements intensify a body that is already movement: here their toxic character is shown in that infection's exacerbation.[69] Theirs is not the signifying dynamics of secondary process teleologically indicating (and fulfilling, retrieving) the lost object, but the non-reconciliatory energetics of primary discharge, leaving nothing over for representation. They intensify sites which are unbinding, space becoming unstriated: from the very beginning (*Head II* 1949) to the end (*Study from the Human Body* 1991), these arrows signal irruptions of intensive bodies out of carceral ones.

The complexity of Bacon's pictorial space itself unbinds molar entities – in particular the planar multiplication and material modulation of planes – creating zones of intensity which deform a traversing body (cf *Seated Figure* 1974). This

space takes on a new intensity in the eighties when Bacon's 'non-rational marks' and the tonal variation of the flesh that Deleuze has analysed mutate. The arrow in *Study from the Human Body* (1991) points to one such variation in tonal intensity, flesh seething in a molecular cloud, erupting out of the body. This effect was not limited to the body however, and the astonishing ground of *Study of the Human Body* (1987), with its arrow functioning like the fibrous bone in the 1962 *Crucifixion* (but reversing the direction of contagion), marks an exacerbation of Bacon's technique – the molecularisation of variation coming in a dispersal of the brushstroke in the use of an aerosol or aerogram. The paint's fragmentation, its nomad distribution literally 'the astral incoherence of the art surface' (Beckett) – and that of the intensive body.

There is no need to repeat here Deleuze's excellent descriptions of the production of variation by colour, the material modulation of space, nor Lyotard's various writings on colour's production of figural transgression. But colour tints the passage between Grunewald's and Bacon's paintings; perhaps more than anything else it describes the difference between their pharmacies. If the dispersion of Turner's clouds brighten Michel Serres' association of the arrival of thermodynamics in the 19th century with a loss of transcendental ground, it is their colour which draws the attention of Deleuze and Guattari.[70] After all, what struck Constable on Turner's return from Italy was colour: 'Turner is stark mad with ability – the picture seems to be painted with saffron and indigo.' Dispersal and colour produce variation – sensation. Thus, looking back on his epoch, Matisse affirms 'the rehabilitation of colour and the recovery of its power to work on us *directly*.'[71] Whilst the 1962 *Crucifixion* is certainly not the prime example of the tonal variation of Bacon's painting, and especially of his figures, the shocking tones of its colour planes (as with the 1944 *Crucifixion* triptych) witnesses no less a 'death of God' in painting. The disappearance of that hypercathexis releases colour. And colours, 'with their differences . . . establish distances, tensions, centres of attraction and repulsion, regions both high and low, differences of potential,'[72] displace the transcendent determination of *meaning* of colour in the metaphysics of light that determines Grunewald's painting: the dark exterior of the polyptych (leading to the light interior of the Redemption) gives way to the shock of Bacon's colour planes. Indeed, following Bataille, the energy in the 'transformation of energy' hoped for in the monastery is precisely *solar* energy, for the construction of light in the Crucifixion itself can be interpreted on the basis of Augustine's allegory where the sun diminishes from the solstice around St John's day (the last prophet of the Old Testament) to the Christmas solstice (New Testament), to increase thereafter. The metaphysics of

light depends upon an oppositional value hierarchically dominated by an image of a 'beautiful sun'; this passage (the Redemption), which is the appropriation or capture of the energy of a 'rotten sun'[73], is the *condition* of representation itself. Which is why Bataille would associate the modern artist not with a nurse-monk but with a syphilitic or an epileptic: an artist like Van Gogh propelled by the 'dislocation drive' of the sun.[74] With Bataille, Cezanne registers the release of the sun, of light:

> A painting does not represent anything, at first ought to represent nothing save colours . . . All beings and things are, more or less, only a portion of stored solar heat, organised, a recollection of sun.[75]

To turn again to Michel Serres is to exacerbate this thought in Bacon's direction, with his emphatically non-metaphorical statement,

> I am myself deviation, and my soul diminishes, my global body, open, drifting . . . Who am I? A vortex. A squandering which disintegrates.[76]

The organism *will* disperse. The sun. Why follow Deleuze in borrowing Lyotard's term the *figural* to write of Bacon? Perhaps to trace a little of the former's genealogy back to the sun. But primarily to open up a space – an *écart* – between the Bataille-Lyotard-Bacon and the Deleuze-Bacon matrices; or rather to re-open the fistula in this second body. For the operation that Deleuze performed was the first stage in bandaging it. Not that he did not underline the generative role of the fistula, or approximately, what he called the 'diagram': his criticism has nothing to do with Kuspit's 'hysterectomy with a trowel' (Beckett). But ironically it is the very attention that Deleuze pays to Bacon's paintings that lets in an overcoding of his aesthetic thought by the practical or ethical branch. This is made possible by a similar overcoding in *A Thousand Plateaux* (especially the eighth section 'How To Make Yourself A Body Without Organs'), but here appears more serious since an artist is annexed as supported. If there are other elements of Deleuze's book that remain problematic (such as the hypostatisation of the triptych structure above the series or the attribution of a form of time), they are largely dissolved in the rich array of functional distinctions his diagnosis introduces, complicating simple oppositions and art history in producing his Bacon-machine. The difficulty lies in the relation between discourse and figure in the artwork, and the relation between artist and body without organs in the pictorial act. And this I think is a question of the sun.

Bataille is never clearer than when he states that the sun is primary process, a universal death drive. Lyotard too is direct: 'the principle of figurality, which is also that of the dice game, is the death drive'.[77] Both also thought that the artwork has a *critical* function: 'the reversal of the nature of the relation between Eros-logos and the death-drive'.[78] These

are two moments: a problem arises if one is derived from the other, such that, for example, the necessary co-presence of figure and discourse determines a similar co-existence in the pictorial act. Deleuze's formula for making yourself a body without organs is to make sure you don't 'blow apart the strata without taking precautions'[79], and the same formula exists for producing the pictorial body without organs ('the Figure is precisely the body without organs'[80]). Bacon has taken precautions to produce the body without organs: he plays roulette and not Russian roulette.[81] Deleuze makes what he calls the 'art of caution' the *condition* for Bacon's painting, it is *restraint* which is productive: the artist becomes a dispensing pharmacist again, skilled in the 'art of dosages'.

Deleuze does not deny the role of the 'diagram', the 'non-rational marks', in fact seeing that restraint furthers that dissolution. But if in general he is involved in a philosophical 'calculation of the subject'[82], here the subject is tucked into a colostomy bag and smuggled in whole to negotiate with the plane of immanence in the pictorial act itself. Deleuze may come close to fulfilling Nietzsche's call for a philosophical physician but he does not cure art of the subject.[83] To counter-balance his reading and to make the aesthetic point I have chosen to all but ignore the second moment of the process of production that Bacon himself terms 'critical', locating that in the art-work, the paradoxical movement of tension which allows that his painting is not yet an 'incontinent art-work' (Bonnefoi). For the real critical force is produced by the *condition* of Bacon's painting: the *act* that is sovereign in Bataille's sense, redundant. It is an act in *immanent excess of itself*, the figural (substantive) become verb (impersonal).

Retaining the name of the death-drive for this moment does not mean subscribing to what Deleuze sees as the transcendental illusion of the entropy principle nor to an organic propriety. It does not resist the molecularisation of death that Deleuze seeks and neither does it prohibit a vitalism. Retaining the name rather abolishes the *comfort* that Freud suspected himself of in the very speculation on the death-drive – that death belonged to life. As Cézanne's and Serres' quotes show, the primary effect of thinking the death drive, be it as entropy or dissipation of the sun, is a problematisation of personal representation. Retaining the name evokes and embraces the 'dedication to futility'[84], joyful fatality or 'exhilirated despair'[85] that infects and powers the art of a Bataille, a Beckett, or a Bacon. Producing the body without organs is not an ethicopractical negotiation but requires an act that *itself* escapes to the plane of immanence; the subject of this act and its survival is chance. The pictorial 'act' (then), has nothing to do with the surgery nor with the kitchen,[86] but is a redundant act, for 'indifference translates itself into the intervention which manifests it, which exposes the force in it and, it can be said, the intensity'.[87] Indifference is intoxication: Bataillean sacrifice, a gift. This is the *material* of Bacon's pharmacy, giving access onto the sensible – donation itself. *Sensation* and not Hammer-horror, the sensational;[88] paint spreading the organism on a nervous system, freeing a body becoming sensation. No, the first name given to auto-immune disease is more apt to this painting: *horror autotoxicus*.[89] Understanding Bacon's fugitive body incarcerates it, dissimulates it; perhaps Bataille's *experience* (non-knowledge) or Michaux's *connaissance par les gouffres* is the nearest one can come. At any rate, to adapt Artaud's *hommage* to Van Gogh, to understand the body, it is necessary to give your own body to Bacon's painting.[90]

Notes

1 Christian Bonnefoi 'A propos de la destruction de surface', *Macula* 3-4, 1978, p 103.

2 Lawrence Gowing denies that the connection of the medical and the artistic is of such an order, discussing instead the history of their relationship in painting. 'La Position dans la Representation: réflexions sur Bacon et la figuration du passé et du futur' in *Cahiers du Musée National d'Art Moderne* no 21, September 1987, pp 79-102 (hereafter PR).

3 Bacon makes the distinction in an interview with Peter Beard for the Metropolitan Museum of Modern Art's exhibition catalogue *Francis Bacon: Recent Paintings '68 -'74*, March 1975, p 17.

4 'Another thing that made me think about the human cry was a book that I bought when I was very young from a bookshop in Paris, a second-hand book which had beautiful hand-coloured plates of diseases of the mouth, beautiful plates of the mouth open and of the examination of the inside of the mouth; and they fascinated me, and I was obsessed by them' (David Sylvester *The Brutality of Fact:*

Interviews with Francis Bacon , London, 1987, p 35; hereafter I). It was no doubt on this visit to Paris that Bacon came across Bataille's journal *Documents*, which included his article 'Mouth' in the 'Critical Dictionary' section of that journal (cf *Documents* second year 5, 1930, p 299; also Oeuvres Completes vol 1, Paris, 1970, p 237 (hereafter OC and volume number); also Visions of Excess edited Allan Stoekl, Minneapolis, 1985, p 59 (hereafter VE). Dawn Ades makes the Bacon-Bataille connection in 'Web of Images' in *Francis Bacon* , London, 1985, pp 8-24.

5 Gilles Deleuze *Francis Bacon: La Logique de la Sensation*, Paris, 1981 (hereafter FB). The book opens with Deleuze's acknowledgement and the problematic description of Lyotard's 'opposing' the term to the 'figurative' (FB p 9). Jean-Francois Lyotard *Discours, Figure*, Paris, 1971 (hereafter DF).

6 DF, p 21.

7 *Petit Robert*.

8 'The Grotesque Renaissance', *The Stones of Venice* in *The Com-*

plete Works, ed E T Cook, London, 1904 (these references: III, XI, pp 144-5, p 162).

9 In these footnotes I will follow an extreme example of this critical appropriation, chosen because it presents a curiously traditional hybrid of psychoanalysis and phenomenology: Donald Kuspit's 'Hysterical Painting' in *Artforum*, January 1986, pp 55-61. That Kuspit undertakes a reading that Deleuze would call 'brute psycho-analytic' (as in *The Logic of Sense* (trans Mark Lester and Charles Stivale), New York, 1990, p 237; hereafter LS) is shown in his equally ridiculous (but rather more shrill) review of Bataille's *Visions of Excess* (*Artforum*, October 1985, p 3). However, Kuspit is right (but for the wrong reasons) when he preludes his reduction of Bataille's writing 'to the pathology of anal fixation' and of his theories to 'recasting in societal terms his personal Oedipal attempt to establish homogeneity within the family' with the assertion that 'Sickness is the key to Bataille'. It is not irrelevant, but perhaps unreasonable here, to note that Deleuze reduces Bataille's fiction to 'Oedipus' dirty little secret' (*Dialogues*, London, 1987, p 47).

10 On 'pharmaceutical critique' cf Sarah Kofman, *The Melancholy of Art*, Paris, 1985. For 'Plato's Pharmacy' cf Jacques Derrida, *La Dissémination*, Paris, 1972.

11 José Gil, *Metamorphoses du corps*, Paris, 1985, p 202.

12 A description from the tenth century, cited by A Hayum in *The Isenheim Altarpiece: God's medicine and the painter's vision*, Princeton, 1989, p 21.

13 VE, p 51.

14 For the spiritual skull-bone see paragraphs 309 to 346 in Hegel's *Phenomenology of Spirit* (trans A V Miller), Oxford, 1977; my approach to Bacon here is to be expanded in specific relation to Hegel and his aesthetics elsewhere. Need it be remarked that the site of the crucifixion was Golgotha, 'Place called Skull' (*Matthew* 27:33).

15 Cf *John* 19:36: 'none of his bones shall be broken', fulfilling eg *Exodus* 12:46, *Psalms* 34:20, *Numbers* 9:12. The Antonites were put under the rule of St Augustine by Pope Boniface VIII in 1297; the theological, philosophical and historical matrix of bodily integrity broached here can be explored more fully in E Brown 'Death and the Human Body in the later Middle Ages: Legislation of Boniface VIII on the division of the corpse', *Viator* 12, 1981, pp 221-270.

16 Dr J R Malpass cited by A Stieglitz, 'The reproduction of agony: toward a reception-history of Grunewald's Isenheim altarpiece after the first world war', *Oxford Art Journal*, 12:2, 1989, pp 87-103.

17 LS, p 294.

18 Gilles Deleuze and Felix Guattari, *A Thousand Plateaux*, London, 1988, p 43 (hereafter ATP). LSD is produced in an organic chemistry laboratory: 'a non-natural derivative of lysergic acid' (Stieglitz, op cit). My 'hallucination' here should be thought of as 'real'; cf Artaud's 'plastic spectre' in *The Theatre and Its Double*. It is necessary to track, less erratically and more thoroughly than I do here, the relations between Deleuze's non-organic vitalism, what he and Guattari call a 'technological vitalism' (ATP, p 407), Bacon's 'artifical real' (I passim) and notions of art as health from Nietzsche and Deleuze's Nietzsche to Bataille's pharmacy and Michaux's notion of the 'hygienic' quality of belles-lettres. (Does 'health' have as univocal a sense across Michaux's works as Deleuze suggests when he continues his exposition of art as medicine in *Qu'est-ce que la philosophie?* Paris, 1991, p 163?) I take up this discussion briefly at the end.

19 I, p 14.

20 *The Will to Power* (trans Walter Kauffman and R J Hollingdale), New York, 1967, (hereafter WP).

21 '. . . I sometimes hardly knew what I was doing. And it's one of the only pictures that I've been able to do under drink.' (I, p 13). He singles out the third panel from all his crucifixions in his last interview: 'Le Pathos et La Mort: Entretien de Francis Bacon avec Jean Clair', *Corps Crucifiés*, Paris, 1992.

22 PR, p 94.

23 I, pp 28-29.

24 *ibid*, p 65.

25 *ibid*, p 141.

26 VE, p 128.

27 *ibid*, p 120.

28 *ibid*, p 70. Deleuze: '. . . the ego opens itself to the surface and liberates the acosmic, impersonal, and pre-individual singularities which it had imprisoned.' (LS, p 213) Bataille: '. . . the power to liberate heterogeneous elements and to break the habitual homogeneity of the individual . . . Sacrifice considered in its essential phase would only be the rejection of what had been appropriated by a person or by a group.'(VE, p 70)

29 'Truly, anyone who is still living on milk cannot digest the doctrine of righteousness because he is still a baby. Solid food is for mature men with minds trained by practice to distinguish between good and bad.' *Hebrews* 5: 12-15. It should be noted that once Grunewald's polyptych is opened St Anthony is represented on a throne, in authority, able to dispense judgement – in other words, to cure or inflict disease.

30 I, p 58. And certainly not therefore the 'mysteries' which 'teach the truth about sensuous things', like Hegel's dialectic: cf *Phenomenology of Spirit*, op cit, section 109.

31 I, p 58.

32 *ibid*: Bacon: 'No, I don't start blind. I have an idea of what I would like to do, but as I start working that completely evaporates . . . Anything that comes about does so in the actual working of the painting.' Cf also Picasso to Braque: 'Do you know Matthias Grunewald's *Crucifixion*? I like this painting and I have tried to interpret it . . . But scarcely have I started to draw it, it becomes something completely different' (Heck p 107).

33 Maurice Blanchot, *The Space of Literature*, Nebraska, 1982, p 57.

34 WP, p 796.

35 Cf WP, p 659.

36 Cf Jean-Francois Lyotard 'Freud selon Cezanne' in *Des Dispositifs Pulsionnels*, Paris, 1980, p 74; 'carence' denotes deficiency or illness – its antonyms being solvability, action and presence.

37 VE, p 77.

38 Cf Ades, op cit.

39 VE, p 89.

40 'Jéjunum' would have to join the list of words composing Bataille's 'Jesuve' – as in the 'heavy intestines' of the eighth section ('The Jesuve') of 'The Pineal Eye' (VE, p 84). See also the editor's note on 'Jesus' being 'also a kind of sausage' (VE, p 259). Other types can be imagined: the Bacon critic's or the Hegelian might be the surgical act opening the gastronomic-jejunostomic digestive fistula, a supplementary mouth in the stomach allowing direct feeding of the body; the deconstructive operation would open the ileostomic colostomic fistula, an artificial anus allowing the regulated relief of fecal matter, etc. The fistula information is drawn from the *Encyclopédie*

Française, Larousse, 1975.

41 VE, p 129.

42 'Entretien: Jean-Francois Lyotard: "En finir avec l'illusion de la politique"', *La Quinzaine Littéraire*, p 18.

43 Osculate: 1 Kiss 2 be related through intermediated species, have common characters with another 3 (Math, of curve or surface) have contact of higher than first order with, meet at three or more coincident points.

44 'Freud selon Cezanne', op cit, p 82.

45 Gowing quotes *Psalms* XXII: 'But I am a worm, and no man . . . I am poured out like water, all my bones are dislocated.' This is the prophecy that needs to be suppressed in the passage to the New Testament.

46 OC, vol I, p 171.

47 OC, vol IX.

48 ATP, p 498. The deterritorialisation of the face and decapitation of the head can be seen in both Degas's photography and painting – cf the painting Bacon discusses (*After the Bath* 1903; I, p 47) and the photograph and painting *After the Bath, Woman Drying Herself* 1896 (figs 334 and 335 in *Degas: Le modèle et l'espace*, Paris, 1984). Degas prefigures surrealist photography's disorientations and distortions of the body that Rosalind Krauss has discussed in *L'amour fou: Photography and Surrealism*, New York, 1985.

49 On the Cartesian mastery of space in Euclidean geometry see Michel Serres *La Naissance de la Physique dans le texte de Lucrèce, Paris*, 1977 (eg p 66).

50 ATP, p 498.

51 VE, p 77.

52 Lyotard's remarks about phenomenological absorption earlier were addressed towards Merleau-Ponty, and indeed Ponty's notion of incarnate subjectivity as a place 'beneath . . . the ephemeral body' which is 'the instrument of my personal choices' as well as his notion of bodily space is profoundly disturbed by this dispersion of organic unity (*Phenomenology of Perception*, Paris, 1945, p 294); cf the opening of the second part, 'The Perceived World': 'One's own body is in the world as the heart is in the organism' (p 234).

53 For Deleuze it 'forms an armature, a bone structure' ('Books', *Artforum*, p 68).

54 OC, vol V, p 74.

55 Gilles Deleuze on Nietzsche in 'Nomad Thought' in *The New Nietzsche*, ed David Allison, Cambridge, 1977, p 142.

56 'A Philosophical Concept. . .' in *Who Comes After the Subject*, ed Eduardo Cadava, London, 1991, p 95.

57 The importance of these elements can be seen in the increased definition of the curved railing in the second version (1971) of *Painting* 1946. While much of the time these bands and contours are also figurative elements, they function merely for the figural elaboration of the body, causing Deleuze to see them as trapezes for acrobatics. Bacon's use of the circular contour both for acrobatics and as framing device is surely highly influenced by Degas whose baths and tubs function similarly (cf the Tub series of 1885-86 and also *Femme sortant du bain*, 1877-79). If Bacon stresses the X-ray qualities of *After the Bath*, 1903 (I, p 47), he cannot have missed the emphasis placed on the violence of the spine by the compositional offset of the tub. Apart from the circular beds the elliptical contours rarely complete themselves in the frame, but create a horizontal movement in tension with the downward movement. Both however carry beyond the frame.

58 FB, p 22.

59 These quotations are from Lyotard's *Heidegger and 'the Jews'*, Minneapolis, 1990, pp 5,17.

60 So Kuspit's article, evaporating in a mélange of adjective and metaphor, reads the 'signs' and 'suggestions' of the 'story' of the figure (which is of course 'psychically twisted') governed by the logic of the 'as if'. He reduces the 1953 *Study after Velasquez's Portrait of Pope Innocent X* to the banal psychologism of the question 'Is the scream of Innocent X recognition of his dissolution?'. His description of the painting as 'naked emotion' highlights the value given to the term 'sensation' at this level. The isolation or framing of the figure that I have discussed is just another sign of the figure as personality's transcendence: 'Its existence in the limbo of space confirms its self-realisation and its authenticity.' Phenomenologically informed, Kuspit understands Body without Organs phenomena in terms of the organism, indeed the 'purpose' of Bacon's style is to 'help us remember the obscure self hidden beneath'. But far worse are the psychoanalytical excesses: just as Bataille was seen to appropriate his own excrement (Kuspit's scatological language not of course forming an 'anal fixation' but legitimised by psychoanalysis), Bacon 'absorbs' heterogeneity to achieve his own integrity. Bacon and the figures are by turns sadistic, hysteric, exhibitionist, melancholy, unhappy, spiteful – his pique at 'the impossibility of representational inadaquacy' causes the 'aggravated attack on the figure'. But the logic of catharsis holds: while the transcendence of subjectivity is reasserted precisely in the figure's survival of 'painterly abuse', Bacon himself, after 40 years on the rack (the couch?) manages to 'discharge painterliness'. Little shows more the impoverishment of this approach to art than the semiological crudity of 'The cricketer's leggings are a sign of social identity'. *Head VI* (1949) is reproduced here under the influence of Magritte and Foucault – a response to such 'quickness' (see note 64).

61 *Beyond the Pleasure Principle* in *Metapsychology*, PFL II, p 299.

62 Deleuze too emphasises that representational thought is dominated by recognition, insisting that what forces one to think is encounter with the sensible – 'that by which the given is given' *Différence et Répétition*, Paris, 1968, p 182.

63 WP, section 227, and *Twilight of the Idols* (trans R J Hollingdale), Harmondsworth, 1968, p 72.

64 The successful Christian painting would be an 'anodyne', the word Bacon uses to describe T S Eliot's turning to the church, having confused Eliots after Sylvester quotes George Eliot's phrase: 'Human kind cannot bear very much reality'; the passage ends: 'The quickest of us walk about well-wadded with stupidity.' Who are the 'quickest'? Perhaps onto-theological philosophers, producing 'a conception in order to be able to live in a world, in order to perceive just enough to endure it.' (Nietzsche)

65 I, p 182.

66 My Beckett quotes are all from the stunning *Disjecta*. It should be noted here that my approach to Grunewald's painting is primarily concerned with its function and how its figuration is determined by the structure of representation. As Bacon would be the first to declare, in contradistinction to Lyotard's excessive fidelity to periodisation, the figural always escapes to some extent its discursive overcoding. The massive influence of Grunewald on Bacon and the art of this century testifies to that escape. For a more Bataillean approach see Taro Okamoto (a member of the Acephale society),

L'Esthétique et le Sacré, Paris, 1976.

67 Cf DF, p 39.

68 Arrows and mouths function alike in Bacon's painting, a schizoid function such as Deleuze and Guattari describe in *Anti-Oedipus* (London, 1984, p 369): 'Organs become direct powers of the body without organs, and emit flows on it that the myriad wounds, such as Saint Sebastian's arrows, come to cut and cut again in such a way as to produce other flows.''Syntax of the static' is how Michel Serres characterises the Euclidean space of classical representation in a painting by Vermeer (*La Traduction*, Paris, 1974, p 189). This space addresses itself to a subject, responding to 'the visual condition of being observable from a point in space external to [it].' (ATP, p 371)

69 Just as one negotiates with metaphysical grammar (subject-predicate structure) by suggesting that Bacon's is a 'moving body' (it is movement), or confuses extensive with intensive space by placing that body in space, so too a 'toxic arrow' is not only tautological ('toxic' itself being derived from a metonymical inflection – Gk: *toxicon pharmakon* – poison for arrows (*toxon* – arrow)), but in this instance dissimulatory: for movement is toxic.

70 Cf Serres, 'Turner traduit Carnot' in *La Traduction*, Paris, 1974, p 239; Deleuze and Guattari, *Anti-Oedipus*, op cit, p 132.

71 Quoted in John Russell, *Meanings of Modern Art*, London, 1981, p45 (my stress).

72 Michel Foucault 'La Peinture Photogenique' in *Fromanger, Le Desir est partout*, Paris, 1975.

73 VE, p 57.

74 'La fragilité même de ce miraculeux châpeau de flammes exprime sans doute à quelle impulsion de dislocation Van Gogh a pu obéir chaque fois qu'il était suggestionné par un foyer de lumière' (OC, vol I, p 261). *Visions of Excess* (p 63) has 'striving' for 'impulsion': given the context it is hard to imagine a more incongruous translation. The insertion of a psychological lexicon relocates the artistic process in an intentional subjectivity – Bataille's argument is mutilated.

75 Quoted in Mireille Buydens, *Sahara*, Paris, 1990, p 99.

76 'Je suis moi-même écart, et mon ame décline, mon corps global, ouvert,à la dérive . . . Qui suis-je? Un tourbillon. Une dissipation qui se défait.' *La Naissance de la Physique dans le texte de Lucrèce*, Paris, 1977, p 50; on non-metaphoricity cf pp 175-186.

77 DF, p 354.

78 *ibid*, p 360.

79 ATP, p 161.

80 FB, p 33.

81 *ibid*, p 61.

82 Cf Jacques Derrida '"Eating Well", or the Calculation of the Subject: An Interview with Jacques Derrida' in *Who Comes After the Subiect?*, op cit, p 96.

83 Cf Nietzsche *The Gay Science*, Preface 2; on liquidating the subject cf Lyotard 'Capitalisme Energumène' in *Dispositifs Pulsionnels* (op cit) and Derrida (n 49).

84 I, p 134.

85 *ibid*, p 83.

86 Roland Barthes, *L'obvie et l'obtus*, Paris, 1982, p 194; painting as cuisine. It follows from my argument that Bacon's critics would agree. But the only eating going on in the pictorial act is like Orestes eating his finger – which Bataille qualifies as non-appropriative sacrificial eating.

87 Bataille, *Manet*, OC, vol IX, p 150.

88 'English critics, who are hung up on literature, are wrong to go on about the Hammer-horror aspect of his work; . . . it's about perception, movement and paint. Above all, about paint.' *Guardian*, 26 Oct 1989.

89 Cf Donna Haraway, 'The Biopolitics of Postmodern Bodies: Determinations of the Self in Immune System Discourse', *Differences* 1:1, 1989.

90 'To understand the nature of a sunflower, it is now necessary to come back to Van Gogh; so too to understand the nature of a storm, a stormy sky, a plane, it will no longer be possible not to return to Van Gogh.' in 'Van Gogh, Le Suicidé de la Societé', OC, vol XIII, p 47.

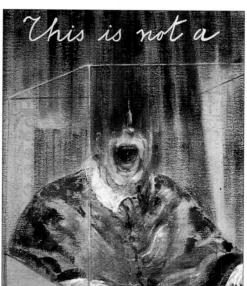

LEFT TO RIGHT: Francis Bacon, Head II, 1949, oil on canvas, 65x80.5cm; Head VI, 1949, reproduced by the author under the influence of Magritte and Foucault (see notes 60 and 64)

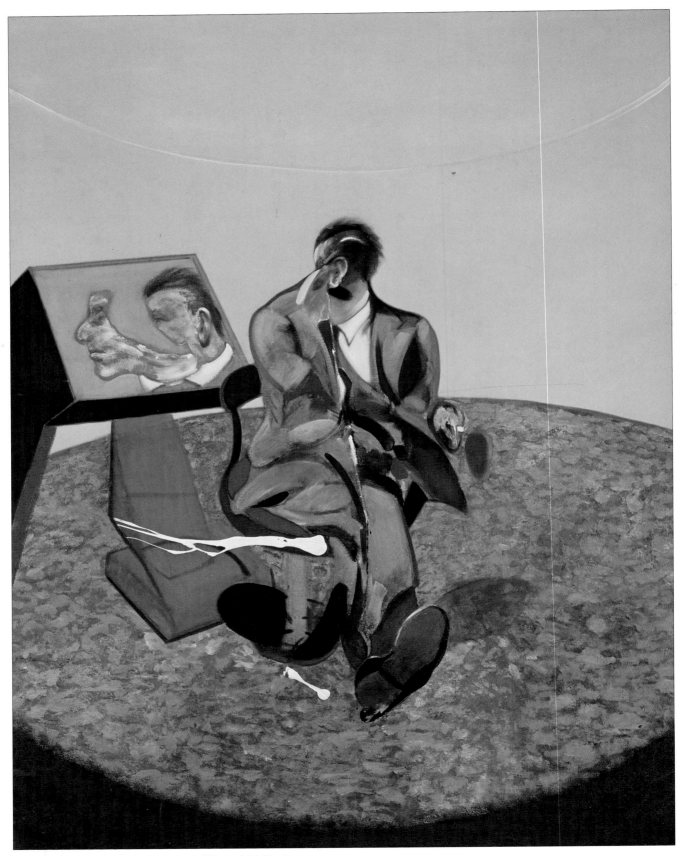

Francis Bacon, Portrait of George Dyer in a Mirror, *1967-68, oil on canvas,*
147.5x198cm

PARVEEN ADAMS
THE VIOLENCE OF PAINT

I

In the conversations between Francis Bacon and David Sylvester published under the title *The Brutality of Fact*, Bacon makes several statements about what he thinks art is and about his own ways of making paintings. He rejects illustration and narration and seeks to replace them with what he calls 'matters of fact'. These turn out to be nothing less than sensations that act directly on the nervous system. This allows him to compare the violence of reality in his paintings with the violence of everyday life:

> Isn't it that one wants a thing to be as factual as possible and at the same time as deeply suggestive or deeply unlocking of areas of sensation other than simple illustration of the object that you set out to do? Isn't that what all art is about?[1] . . . As an artist you have to, in a sense, set a trap by which you hope to trap this living fact alive. How well can you set the trap? . . . I think the texture of a photograph, because the texture of a photograph seems to go through an illustrational process onto the nervous system, whereas the texture of a painting seems to come immediately onto the nervous system.[2]

Clearly something quite other than representation is at stake. For Bacon, what is important in his own method is the use of what he calls the 'accident'. But this does not diminish his belief in order:

> I think that great art is deeply ordered. Even if within the order there may be enormously instinctive and accidental things, nevertheless I think that they come out of a desire for ordering and for returning fact onto the nervous system in a more violent way.[3]

Indeed, the 'accident' is precisely what allows this 'deep' order.

> To me, the mystery of painting today is how can appearance be made. I know it can be illustrated, I know it can be photographed. But how can this thing be made so that you catch the mystery of appearance within the mystery of the making? . . . One hopes one will be able to suddenly make the thing there in a totally illogical way but that it will be totally real and, in the case of a portrait, recognisable as the person.[4]

Bacon's contrived accidents – squeezing paint into his hand and throwing it at the canvas, the use of sponges, the rubbing in of studio dust and so on – allow him to pursue an alternative practice of painting to that of representation. They permit the possibility not so much of the transformation of his figures, but of their *deformation*. This becomes clear in his remarks about Picasso and the cubists.

> DS: In the early analytical-cubist pictures it's fairly clear what is happening: you can more or less analyse the dislocations and the relationship of the forms to reality. But when you get to the very late analytical-cubist works, there's a totally mysterious relationship to reality which you can't begin to analyse, and you sense that the artist didn't know what he was doing . . . somehow he was working beyond reason . . .[5]
>
> FB: As you say, with early analytical cubism you can just literally see the town on a hill and all that kind of thing – they've just been cubed up. But perhaps in the later ones Picasso knew what he wanted to do but didn't know how to bring it about. I don't know about that. I know that, in my case, I know what I want to do but don't know how to bring it about. And that's what I'm hoping accidents or chance or whatever you like to call it will bring about for me.[6]

II

This article puts forward a psychoanalytical hypothesis about the physical effects of the paintings, starting from Lacan's insistence on the fact that perception is not just an issue of vision, but an issue of desire. The question of perception must take up the problem of what I want to see, and the way in which it structures the gaze which captures me. Instead of thinking of perception as just a visual field, it must be thought of as the field that is structured by the relations and forces of objects and desires. Lacan puts it thus:

> If one does not stress the dialectic of desire one does not understand why the gaze of others should disorganise the field of perception. It is because the subject in question is not that of the reflexive consciousness, but that of desire. One thinks it is a question of the geometral eye-point, whereas it is a question of a quite different eye – that which flies in the foreground of the *Ambassadors*.[7]

The Holbein picture is a masterpiece of theatrical, illusionis-

tic space. It feels as though our vision and pleasure are at one. I enjoy what I see and I see what I enjoy. But it is well known that there is something else. At the bottom of the picture there is something scroll-like. In moving away it comes into perspective as a skull. This phenomenon of anamorphosis involves a projection which is distorted from the point of view of the subject who is perceiving the rest of the picture. Only from another angle can the projection be deciphered. This distortion in fact unhinges the whole point of view. In Holbein's terms, death unhinges worldly pleasures. In Lacan's terms, castration undoes the certainty and given character of visual space. Lacan identifies the oblique form as the annihilation of the subject 'in the form that is . . . the imaged embodiment of . . . castration'.[8] Usually, I am transfixed by fascination of the picture. It feels as though I am looking there where I desire to look. But at the anamorphic moment I become aware of something else, aware that seeing and the gaze within which I am caught are different. The gaze and the picture have become detached in the skull, which stands as the castration of perspective.

For Lacan then the gaze is not an action. It has more the quality of an object. This gaze as object, this gaze detached from the issue of vision, is added by Lacan (along with the voice) to faeces, phallus – which are objects in the particular sense that they all materialise fundamental relations of possession and loss. Holbein has detached the gaze from the painting in order to warn against worldly pleasure. Above all, the effect of anamorphosis is to subvert the certainties which are induced by illusionistic space – that is that *this* space is all-inclusive, that this is what there is. Anamorphosis reveals that the condition of this illusion is that there is something hidden *behind* space:

> At issue, in an analogic or anamorphic form, is the effort to point once again to the fact that what we seek in the illusion is something in which the illusion as such in some way transcends itself, destroys itself, by demonstrating that it is only there as signifier.[9]

In effect the experience of anamorphosis in general is to discover that what we take as 'reality' is based upon a trick, a trick of light. One experiences a momentary headiness, a sudden capacity to think. In going beyond the signifier the subject gains a certain leeway.[10]

Now this idea of the detachment of the gaze is important for my understanding of Bacon, although in my view Lacan's terms need some modification.[11] Both the issue and the modification can be dealt with by considering an issue raised by Ernst van Alphen in his recent book on Bacon.[12] He ends the book by asking to what extent Bacon's paintings might be said to undermine contemporary concepts of masculinity. In particular it concerns the way in which in order for the phallic power of the symbolic order to reign, it is vital that the father's

genitals must not be seen. Why? Why not display them? Because they must remain at the level of the signifier. The only way to ensure this is to prohibit the sight of these genitals, for otherwise they might become signifieds. The child might see the flaccid penis of his father and identify with that, with a penis and not with the phallus. This reminds me of something Lacan says about anamorphosis. He suggests an experiment for his audience – they are to imagine, first, a tattoo etched onto a flaccid penis and then the perspective picture that would unfold as it took on its tumescent form. Following the schema suggested by Lacan, we could say that the detumescent penis is connected with the reality beyond the illusion of the signifier. A collapsed detumescent form threatens the filled-out perspectival space and the phallic position. And isn't that just as though the child saw the detumescent penis of the father?

The problem with van Alphen and indeed Lacan's account of perspective, the phallus and the detached gaze is that it remains phallic itself. In a way they legitimate the phallic by seeing the phallus behind it. In one case, both masculinity and the undermining of masculinity remain tied to a phallic model, just as in the other case, a certain going beyond the symbolic/phallic order is explained in terms of the rise and fall of the penis. When Bacon and Sylvester agree on the distinction between the early and late analytical-cubist work, their thoughts move beyond the phallic metaphor. For the early 'cubed up' works obey precisely a topological transformation that Bacon refuses. When the idea of cubing up fails, so too does the phallic metaphor for anamorphosis. Deformations are not to be measured by phallic transformations. My argument is that nevertheless the detachment of the gaze remains crucial here. If we want to talk about how a *psychical* detumescence is to be achieved, something more than the phallic metaphor is required.

Bacon puts something of this into words through the notion of an appearance which is made to appear by being 'remade out of other shapes':

> DS: And the otherness of those shapes is crucial.
> FB: It is. Because if the thing seems to come off at all, it comes off because of a kind of darkness which the otherness of the shape which isn't known, as it were, conveys to it.[13]

It is the image in all its materiality that throws out this darkness, that marks itself by darkness; it is not the other way round, it is not that the darkness gets reflected in the image. In other words, the otherness is that which has remained outside the signifying chain, desired and only dimly seen by the artist and acceded to only with the help of 'accidents' and 'chance' interventions. All this has to do with the reality behind the illusion of the signifier, but it can no longer be explained with a phallic metaphor.

III

To understand the force of Bacon's images we have to understand the way in which they undercut the regime of representation. Now this regime is described by the fact that it ties together my wish to see and what is presented to me, a unity of the scopic field and the spectator. But when the gaze as an object becomes detached from this scene, a dislocation occurs. A gap opens up – the circuit is broken. The illusion of wholeness has been as it were castrated. In fact we can treat Bacon's images as just that – castration erupting within our wish to see, within the scopic field.

To the extent that pictures are narratives – and it must be remembered that Bacon specifically and repeatedly refused narrative – they depend on the fascination of the spectator, they act as traps for the gaze. Let us now look at a clear and simple example of this that is not perspectival: a 1989 installation by Genevieve Cadieux titled *Hear Me With Your Eyes*.[14] It consists of three very large photographs: the first is a black-and-white photograph of the head and shoulders of a woman with eyes shut and slightly parted lips. Opposite it is a colour photograph of the same woman but there is a greater tension in the lips and the head is represented simultaneously both full face and in three-quarter profile. Finally, on the third wall, forming a U shape, is another black-and-white photograph, this time a hugely enlarged pair of slightly parted lips. The spectator feels self-conscious and conscious of being a seeing subject. Why? Because the spectator's relation to the images of the woman is always interrupted by that other spectator, the pair of lips. But they, of course, are *in* the picture. In fact they function as the eye that flies in the foreground of Holbein's *Ambassadors*. The lips serve the function of detaching the gaze so that the spectator's relation to the image is disturbed. This detachment constitutes the object as object of loss, a loss that it is the very function of representation to deny.

Obviously this suggests Bacon's images of screaming heads: I have *Head VI* (1949) in mind. It is a particularly successful version of the paintings of heads with open mouths, teeth/mouths and no visible eyes, just a dark hint of sockets. This head neither sees nor sees us. If we were to say that we see *it*, we would fail to mark the difference of this image. For while we use our eyes, we *hear* the head with them. The scream effects what Deleuze calls 'the confusion of the scene'. It is the heard scream (which is nevertheless 'seen') which marks the detachment of the gaze. It seems that one of the features of the anamorphic moment is that the confidence in how we sense is shaken and a synaesthetic mobility is introduced. Above all, the day-to-day fluency of the world and our place in it is radically overthrown.

There are, of course, other ways in which Bacon opens up that gap. The 'mirrors' in his painting, as one might expect, do anything but reflect. They work in the opposite direction of the narcissistic circuit. They recast the mirror as the tain, as the backing of the mirror, as the *surface* of the mirror which is repressed by the operation of reflection, the creation of space. Van Alphen takes this for granted when he writes of *Figure in Movement*, 1978:

> Our gaze at the figure is repeated, not mirrored in the mirror. Looking itself, not the object in front of the mirror, is reflected.[15]

What is this if not the detachment of the object; the loss of the object; castration. The same theme again is in *Portrait of George Dyer in A Mirror*, 1967-68. Van Alphen translates and quotes René Major from an interview on Bacon:

> This negative hallucination is an early experience, for it may also be held responsible for the cry of the infant at the moment he does not perceive the presence of his mother, while at that very moment she is at his side (*alors même qu'elle est à ses côtés*).[16]

So, *Portrait of George Dyer in a Mirror* is also about looking. But instead of a doubling, an addition as in the 1978 painting, here we have the detachment of the object gaze by a subtraction, a vertiginous absence. The gaze detaches itself from the image and detaches *us* from the image.

IV

There are other, more complex ways in which Bacon effects his 'violence of sensations' and his 'matters-of-fact'. While he is interested in the 'violence of sensations', it is not at all the case that the more violent paintings are the more successful ones. Deleuze suggests that these violent paintings are the ones that still contain narratives and he instances the two version of *Study for Bullfight No 1* (both 1969) to make his point.[17] Yet, of course, the violence of sensations can also be very powerful and the question of the violence of sensations in Bacon's work is an important point to which we will return. In the two versions of the bullfight studies we have the detachment of the gaze; or rather, we can see the process by which this is brought about in the gap between the two paintings. In the first version there are spectators and hence a story; in the second version the spectators' stand is empty and blank. Of course this immediately puts us as spectators, in a different place. Our expectations of a spectacle are disrupted. The emptiness of the stand is like the unseeing white of an eye. It is this unseeingness that allows the gaze to detach itself from vision.

This stand can be compared to the mirrors that reflect nothing. The striking, ubiquitous black rectangles behind many figures in Bacon may be added in as backings of the mirror. This aspect of the mirror, the black surface, is somehow just beyond the limit of, but is also the condition of, reflection. It is the moment, the point at which the gaze is detached.

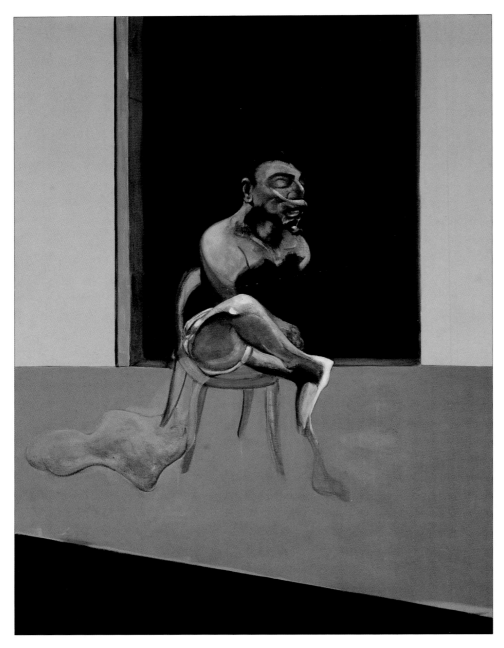

Francis Bacon, Triptych, *August 1972, oil on canvas*

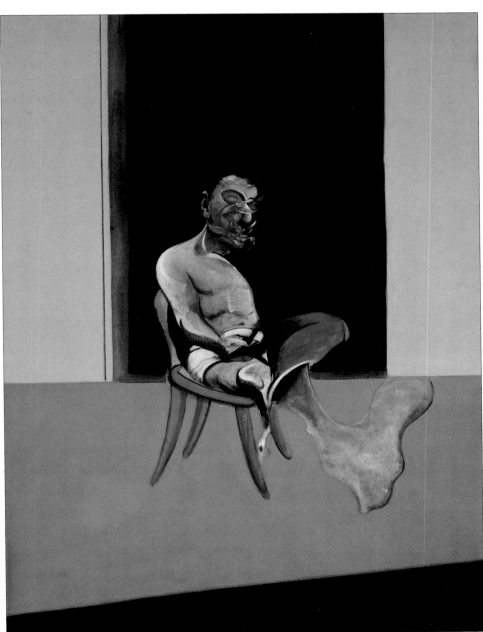

This account may seem to overlook the question of the violence of sensation. But in fact this route allows us to form a view about the violence Bacon creates, as opposed to the violence of the world. Nothing could be more bland and obtuse than to use Bacon's work as a narrative about the lamentable violences of the age. The violence which Bacon creates concerns a certain experience of the body and something to do with the horror of a too-close presence. This violence can indeed be usefully treated through the question of the detachment of the gaze. It will be that which enables us to distinguish in Bacon's paintings between a violence of painting and the painting of violence. If the violence at stake were a violence against the subject, a masochism, it would only be so by enabling us, even forcing us to identify, to put ourselves in the place of the object in the same way as the masochist does. But in fact the detachment of the object gaze is the very antithesis of any identification with the object. We can see this in *Triptych* (August 1972) where the artificially produced violence of sensations is almost at a maximum.

In what follows my debt to Deleuze's extraordinarily detailed and perspicacious observations on Bacon is obvious.[18] Here is the passage in which he writes that in Bacon's images the body escapes through the orifices:

> The body endeavours, precisely, or expects precisely to escape. It is not me who tries to escape my body, it is the body which tries to escape itself through . . . In short, a spasm: the body as plexus, and its endeavour or its expectation of a spasm. The whole series of spasms in Bacon is of this type, love, vomit, excrement, always the body trying to escape *through* one of its organs in order to rejoin the flat tinted area, the material structure. Bacon has often said that the shadow has as much presence as the body: but the shadow only acquires this presence because it escapes the body, it is the body which has escaped through one or other point localised in the contour. And the scream (*le cri*), Bacon's scream, is the operation through which the entire body escapes through the mouth.[19]

I would put it differently and say that what escapes through the orifices is *libido*. The body squeezes itself out, empties itself. What oozes out is the lamella, the organ of the drive.

> Whenever the membranes of the egg in which the foetus emerges on its way to becoming a new-born are broken, imagine for a moment that something flies off, and that one can do it with an egg as easily as with a man, namely the *hommelette*, or the lamella. The

lamella is something extra flat . . . it survives any division, any scissiparous intervention.[20]

I am saying that it is the lamella that is the outcome of Bacon's efforts to avoid narrative and representation and to act directly on the nervous system. Bacon's 'matter of fact' turns out to be the lamella. And I mean you to take this quite literally. Within Bacon's paintings, attached to bodies, there are flat, bounded shapes. Usually they are called shadows by commentators. I want to think of them as lamellae. You can see it clearly in many canvases including the *Triptych*. Not all the shadows are 'extra flat' but we can easily take the pink and mauve oozing matter to be the lamella. There is no dearth of flat shadows in other paintings.

What can we say of the lamella and its relation to the gaze? If Cadieux appeals to us to hear with our eyes, what is Bacon asking of us? The answer is that we are being invited to enjoy (*jouir*) with our eyes. In the Holbein a quite different eye (the image of the skull) flies across the foreground at that point in time when one turns away; in the Cadieux there are eyes (the pair of lips) in the space behind you that are directed at the back of your head; in Bacon it is not a question of this time or space: there is a void, an abyss (the lamella).

The void comes about through the body's endeavour to evacuate itself as Deleuze says. What do we have in the *Triptych*? On the one hand, a heavy flux of contorted movement, a mass of wounding colours and jagged edges of the body, and on the other hand, the lamella, smooth, flat colour without volume. Is this not the substance of the living body, now no longer zoned into the senses and criss-crossed by castration? If what is readily available for speech is the violence of these bodies (the violence of sensation), the lamella marks the completion of another process, *dissipation*. Deleuze is right:

> There is immobility beyond movement; beyond standing, there is sitting and beyond sitting, lying down, in order finally, to be dissipated.[21]

That is to see nothing, *jouir*. One no longer has vision, but the eye lives on. The function of vision has been subtracted from the eye. The violence of sensation has squeezed out a literal essence of being, the lamella, a puddle of being. To claim that the lamella appears in Bacon's work is to claim that he has taken the detachment of the gaze to its limit. The paintings are as far as possible withdrawn from the painting of everyday life, while yet capturing the 'appearance' of a human being. The violence of the painting is the correlate of the violence of appearing. What is at stake is not violence but paint.

Notes

1 David Sylvester, *The Brutality of Fact: Interviews with Francis Bacon*, third edition, London, 1987, p 56.

2 *ibid*, pp 57-58.

3 *ibid*, p 59.

4 *ibid*, p 105.

5 *ibid*, p 100.

6 *ibid*, p 102.

7 J Lacan, *The Four Fundamental Concepts of Psychoanalysis*, (Seminar XI, 1964) trans A Sheridan, Hogarth/Institute of Psychoanalysis, 1977, p 89.

8 *ibid*, pp 88-89.

9 J Lacan, *The Ethics of Psychoanalysis* (Seminar VII, 1959-60) trans D Porter, Tavistock/Routledge, 1992, p 136.

10 P Adams, 'The Art of Analysis: Mary Kelly's Interim and the Discourse of the Analyst', *October Special Issue*, ed P Adams, 'Rendering the Real', no 58, 1991.

11 For an elaboration of this theme see P Adams, 'The Three (Dis)graces', *New Formations*, Perversity Issue, 1993.

12 E van Alphen, *Francis Bacon and the Loss of Self*, Reaktion Books, 1992.

13 Sylvester, op cit, pp 105-106.

14 Reproduced in *Passage de L'Image*, Editions de Centre Pompidou, 1990.

15 Van Alphen, op cit, p 63. There is no explicit indication that there is a mirror in *Figure in Movement*. Yet intuitively one feels that van Alphen is right about the dark, black oblong behind the figure in movement. Of course one may think simply that it is his own mistake which he overlooks because the repetition of the figures startles him and thwarts his expectations of some kind of mirror reflection. But I think there is more to it than that and I discuss the mirror function of large areas of white and black in Bacon's work further on in this article. It should be noted that Gilles Deleuze also takes blackness as mirrors: 'Bacon's mirrors are everything one wishes except a reflecting surface. The mirror is an opaque, sometimes black thickness (une épaisseur opaque parfois noire).' (Gilles Deleuze, *Francis Bacon: Logique de la Sensation*, Editions de la Difference, 1984, p 17.)

16 Van Alphen, op cit, p 64.

17 Deleuze, op cit.

18 It is Deleuze who has analysed Bacon's work in the greatest material detail and, while his framework is very different from that adopted in this article, his text is indispensable for many reasons, including his careful distinction between Bacon and abstract art on the one hand and 'action painting' on the other. While Bacon's 'actions' are very important, it is the deformation of the body that is central to an endeavour where strangely enough, the recognisability of the person in the portrait is also a goal.

19 Deleuze, op cit, pp 16-17 (my translation).

20 Lacan, Seminar XI, op cit, pp 197-98. The quotation from Seminar XI about the skull in Holbein's painting referred to the 'question of a quite different eye – that which flies in the foreground of the *Ambassadors*' (p 89, my emphasis). Notice that now it is the lamella that is referred to as 'something that flies off'.

21 Deleuze, op cit, p 30.

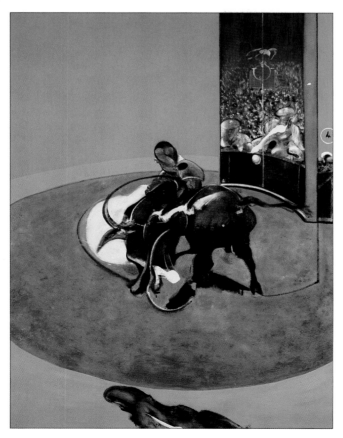

Francis Bacon, **Study for Bullfight No 1**, *1969, oil on canvas, 147.5x198cm*

FROM ABOVE L TO R: Pseudocopulation between Gorytes mystaceus *wasp and* Ophrys *orchid flowers. Distribution of hairs on the* Ophrys insectifera *fly orchid (frontal and side views) compared with the distribution of hairs on its pollinator, the* Gorytes mystaceus *wasp. David Reed, No 276 (for Nick), detail, 1987-88, 63.5x259.08cm.*

GREG LYNN
BODY MATTERS

Since the time of Vitruvius and throughout its history, the *whole* concept of architecture has been dependent on the model of a unified body. Only the characteristics of whole bodies are described in terms of architecture: any body in particular is rejected in favour of all bodies in general. There are many variations[1] of ideal or whole bodies in architecture, all of which result from a search for a universal model of symmetry and proportion for the regulation of whole bodies. Because of its desire for a holistic model of the body – one that is essentially static – only bodies that can be ideally reduced to whole numbers, through a process of division, are acknowledged in architecture. The proportional correspondence between a temple and a 'well shaped man' are based firstly on a single organisation regulating all parts to the whole and secondly on the presence of a common module. This formulation of the body as a closed system in which all parts are regulated by the whole is organised from the top down. Proportional orders impose the global order of the whole on the particular parts. This *whole* architectural concept ignores the intricate local behaviours of matter and their contribution to the composition of bodies. An attention to the matters out of which bodies are composed suggests a reformulation of the concept of the whole. An acknowledgement of base matter does not necessarily lead to a transgression of the concept of the body itself (as has been the recent reaction to the repression of differences by the logic of the whole) but could engender a more open and dynamic conceptualisation of how bodies are composed.

Bodies can emerge through local intricate connections, alliances, aggregations and affiliations of base matter. These bodies cannot be reduced to any single, general, universal or ideal organisation as they result from the complex interactions of disparate systems. In order to define a body without appealing to the proportional logic of a whole organism, it is necessary to develop new categories of stability and unity. A reformulated concept of the body, that is composed from the bottom up through a process of continuous differentiation and multiplication, mandates *anexact yet rigorous* topological descriptions that are neither ideal nor reducible. Edmund Husserl developed the category of the *anexact yet rigorous* in the 'Origin of Geometry' (1936), to describe forms which are neither exact (they cannot be reduced to mathematical statements) nor inexact (they cannot be measured with precision). The necessity of these vague descriptions to any ideal geometry has been developed more extensively by Jacques Derrida[2] in *Edmund Husserl's 'Origin of Geometry': An Introduction* (1962). This category of the anexact is capable of describing the vague characteristics of bodies that are not fixed statically.[3] These geometries are capable of describing the architectural characteristics of bodies that are *both more and less* than whole.

Composition Through Differentiation

An alternative model for architectural organisation is based on the behaviour of local particularities (base matter) as they contribute to the composition of provisional unities (bodies) from the bottom up, describing various degrees of cohesiveness and unity within bodies. Questions of *composite bodies* seem intimately related to questions of urban and architectural *composition*. Within such a base approach, any body's provisional unity is dependent on the stabilities and alliances between local elements. The manner in which bodies are composed and diffused from the motions of differential forces differs from the more familiar modelling of ideal bodies and wholes against which variations can be measured and reduced from the top down.

This base procedure can inform new compositional sensibilities towards the development of dynamic, incorporative stabilities. Therefore, the definition of non-static but stable bodies could not be less interested in the decomposition of the concept of the body. The practices in architecture, associated with philosophical deconstruction, typically operate from the top down, beginning with the model of the body as a whole, which is then dismantled through the identification of necessary internal differences which are seen as contradictory to the organisation of the whole. Without an appeal to internal contradictions, differentiation can play a constructive role in the composition of stable bodies that are capable of continuous transformation and mutation. The now apparent failure of deconstruction to develop an adequate theory of composition in architecture (apart from its interpretation through strategies of decomposition) is most likely due to its proclivity for arresting internal differences in forms of contradiction and conflict. Rather than

displacing stability and unity through difference, a continuous process of differentiation can be seen as the very possibility for the composition of an always incomplete and provisional unity. Bodies emerge through processes of differentiation, yielding varying degrees of unity based on specific affiliations and mutations. By beginning with bodily matter the possibility for singular bodies is not to be precluded, but rather, bodies are sedimented, aggregated, unified and stratified through differential forces and the continual fusion of matter. An architectural model of bodily matter, such as this, exists as a fluid interface. Difference in this bottom-up approach is the basis for a compositional sensibility that rejects the transgressive project of what has come to be called deconstructivism in architecture.

Parasitic Exchanges

The concept of the parasite has recently and frequently been invoked by several deconstructivist architects and theorists as a model for a necessary supplement that internally destabilises an existing structure. Mark Wigley has identified the integrity of internal difference to any stable structure in his description of 'a subversive alien, a foreign body that already inhabits the interior and cannot be expelled without destroying its host.'[4] Wigley is careful to articulate this deconstruction of the whole as a displacement of a still intact structure rather than as a dismantling, decomposition or demolition. Yet in his description of Coop Himmelblau's *Rooftop Addition*[5] it is clear that the parasite is seen as a surplus to the existing 'form that houses it', displacing the relationship between interior and exterior necessary to the reading of the house as a body. Likewise, in the recent projects of Liz Diller and Richard Scofidio, including the *Para-Site* installation at the Museum of Modern Art, the model of the parasite operates as a critical armature for the deconstruction of previously whole constructions. This critical method uses difference as an 'other' that has been excluded or repressed from an already extant whole. These uses of difference to produce discontinuity and disjunction rely on a stable frame against which they operate as a critique of unity.

Alternatively, the cybernetic paradigm proposed by Michel Serres in *The Parasite* (which is quoted as a source but does not seem to support Scofidio's and Diller's claims to displacement) suggests that the parasite has to configure the possibility for its own existence: 'The parasite invents something new. Since he does not eat like everyone else, he builds a new logic.'[6] For Serres, parasitism is the only possibility for the definition of any body in the first place. The parasite discovers unity and stability within an entropic system through connectivity. A parasite does not attack an already existing host but invents a host by configuring disparate systems into a network within which it becomes an integral part. There is no interior before the parasite, the parasite is the active agent of unification. Such a sensibility configures difference as a compositional, rather than decompositional force. Rather than a threat to unity, difference becomes the very possibility for stability and order. Countless instances of parasitism, symbiosis, codependencies and mutualism illustrate that the differential processes of involution and coevolution bind disparate bodies into integral unities.

The familiar example of the wasp and orchid cited by Gilles Deleuze and Felix Guattari[7] is just one such example of a composite body that emerges through parasitism. Friedrich Barth[8] discovered that in the case of the orchids *(Ophrys insectifera)* and the digger wasps *(Gorytes mystaceus* and *Gorytes campestris)* there is not a mutualism but the inverse of the typical relations of insects and flowers: a parasitism of orchids on the wasps through *pseudocopulation*. The orchid becomes what Barth calls a *false female* that sexually attracts the wasp through pheromone-scented hair follicles on the thick appendage of its labellum, on which the wasp rubs its abdomen with the copulatory organs extended. As the wasp flutters on the orchid, pollinia become entangled on the wasp's head. Unsatisfied, the wasp eventually tires and repeats this behaviour on other orchids fertilising their stigma with the transported pollen from previous orchid contacts. By becoming a surrogate sexual partner to the wasp the orchid gains mobile genitalia in the wasp. The multiple orchids and wasps unify to form a singular body. This propagating unity is not an enclosed whole but a multiplicity: the wasps and orchids are simultaneously one and many bodies. What is important is that there is not a pre-existing collective body that was displaced by this parasitic exchange of sexual desire but rather a new stable body that is composed from the intricate connections of these previously disparate bodies. Difference is in the service of a *fusional multiplicity* that produces new stable bodies through incorporations that remain open to further influence by other external forces. This formulation of bodies whose interiors are both produced by and are openly continuous with their external surroundings does not require a displacement of the oppositions between inside and outside as those categories are merely degrees of intensity located along a continuity. The familiar utilisation of the model of the parasite as a deconstructive tool for the displacement of already existing orders overlooks the ability for parasitic exchanges to actually compose new bodies and new orders where none existed previously. These composite aggregations of new stabilities proceed through the continuous differentiation of matter.

Continuity and *differentiation* are the two conditions by which any collection of animate matter can be described as a body. Conventionally, architecture describes itself as an inanimate, modular, divisible, universal and static body. An

alternative model of the body in architecture involves processes of *continuous, indivisible differentiation*. Where divisibility is *extensive*, differentiation is *intensive*. Extensive systems obey an internal order that expands without changing its nature. Intensive systems follow a provisional internal order that adapts to, while influencing, its surroundings. Architecture has configured itself as an extensive system apart from exigencies and contingencies. An intensive model of the body is defined through the internalisation of external, differential, disparate forces such that a stability emerges that is greater than the constituent elements. In this instance, no body can be absolutely coherent, cohesive, singular or unified as there are no pure unities apart from their specific contexts and the matter from which they are composed. Intensive bodies measure degrees of continuity within heterogeneous matter rather than the consistency of homogeneous modules. Composite organisations of base matter exhibit varying degrees of unity and bodiliness based on the influence of external forces.

For example, when drinking a glass of water one often ingests e-coli bacteria into one's body. These external organisms are introduced into the interior of our bodies. The bacteria become integrated with the operations of our bodies as they enter the digestive system and begin to breed with other existing e-coli bacteria. These colonies of bacteria are both outside the body's influence and also integral to its existence. They are bodies in themselves and at the same time, they are organs of a more extensive human body. They are both free bodies and part of a composite body that they will eventually decompose and disperse from the inside out. The concept of multiplicity allows for the theorisation and modelling of such bodily matters: matters that are folded continuously between the one and the multiple, between organs, free bodies and composite bodies. This multiplicitous insight into bodies is only possible when unity has been loosened from the concept of the whole and can be considered as a stability that emerges from differential forces that move from the bottom up rather than from the top down.

Monstrous Bodies

Monstrosities are those bodies which seem to 'deviate from nature'.[9] Erwin Panofsky, in 'The History of the Theory of the Proportions as a Reflection of the History of Styles', has provided an overtly architectural example of such a monstrous deviation from the natural proportions of architecture. His example of Egyptian sculpture is related to architecture in that the Egyptians inscribed profiles on the faces of stone blocks before carving them. The profiles consisted of a geometric network of squares of an equal size that regulated the proportion of the figure. Unique to the Berlin Sphinx Papyrus drawing are three different regulating networks, as

that particular sphinx was composed of three heterogeneous parts: the body of a lion, the human head, and the small goddess. The proportions were prescribed by each figure: the canon of the lion, the canon of the Royal Heads and the canon of twenty-two squares for a complete body. The sphinx was assembled from three disparate components, each of which was conceived and proportioned as if it was standing alone. Through the composition of unrelated disparate free elements that lacked any common *module* the sphinx is seen as an 'anomaly easily explained by the fact that the organism in question is not a homogeneous but a heterogeneous one'.[10] The lack of transcendent modularity leads, Panofsky maintains, to monstrous, hybrid, recombinant and heterogeneous bodies. The sphinx is not a mere collage[11] of fragments as the three disparate networks are fused to produce the body of the sphinx. Bodies produced through combinatorial differentiation are not divisible by any single module; they are both irreducible unities and collections of heterogeneous elements; they are simultaneously a unified whole and freely associated parts.

Fusion and Diffusion

From processes of continuous differentiation heterogeneous bodies emerge.[12] Bodies are capable of both gathering stability through alliances and dispersing matter freely in the same gesture. The seemingly opposed movements of cohesion and dispersion can be understood as a continuous movement. Deleuze and Guattari have formulated the model of the 'body without organs' to describe this double gesture of 'two-fold deterritorialisation'.[13] The motion of diffusion and fusion continuously redefines the boundaries between interior and exterior. Internal territories are intensively influenced from forces outside of their control while bodies extend their interiors outward to extend and reconfigure their territory. Deterritorialisation not only disperses interiors outward but simultaneously unifies a constantly shifting interior through the internalisation of external forces. These negotiations encompass both the laws of involution and evolution. Evolution is the external selection of internal mutations. *Involution* is the internal selection of mutations due to intensive alignments with external forces. Rather than deconstructing the organic whole of humanism this logic of continuous differentiation constructs a fluid semi-permeable boundary between interior and exterior. A provisional unity is established both through expansion and intensity. Such a model for the body is capable of describing the composition and stratification of unity while allowing the dispersal of those same characteristics through a continual process of differentiation.

Deleuze and Guattari's concept of *two-fold deterritorialisation* owes much to both Elias Canetti and René Thom as they both have suggested stable compositions of elements that remain

 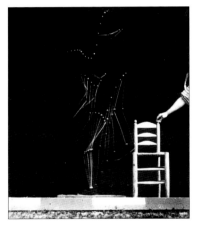

FROM ABOVE L TO R: Regnault, The Deviations of Nature (1775): 'Double child', used to illustrate Georges Bataille's text published in Documents (1930) (from the Cabinet des Medailles collection in Paris Bibliothéque Nationale). Smooth sponge(suberites) growing on a hermit crab's adopted shell. Egyptian sculptor's working drawing (papyrus). Differences among species and subspecies in ordinary and special avicularia of Metrarabdotos *bryozoans. Typical zooid module of bryozan structure. Chronophotograph: jump from a chair, 1884. Hypothetical morphospace defined by varying degrees of climb axis between the colony axis and the lateral angle branch systems, with constant branch spacing. These are the internal undifferentiated axes of growth apart from influences by currents and other forces. Marey's drawn analysis of the positions of a leg during running; Marey's drawn analysis of the positions of the front limb of a horse galloping with smoothing connective lines (both taken from chronophotographs). Marey's graphic notations of muscular shocks.*

open to influence through dynamic interactions and exchanges. Canetti's categories of *packs* (hunting, war, lamenting and increasing), *crowds* (open, closed, destructive, slow, baiting, flight, prohibition, reversal, feast and double) and *crowd crystals* (the unities that exist within crowds such as police and monks) all describe instances where multiple individuals enter into alliances from which new unities fuse and diffuse. These composite entities develop behaviour and traits that cannot be reduced to any one of the individual members but result from the differential alliances of a composite, aggregate organisation. Interiors and exteriors become folded into one another, yielding the continuous multiplicity of the pack-body, crowd-body or crowd-crystal-body. Canetti's psychoanalysis of crowds uncovers the emergence of composite body organisations, at the scale of the city, from free elements. Due to a crowd's desire for expansion and incorporation, its behaviour is continually, dynamically and turbulently transforming from dispersion and disappearance to coherence and stability. Crowds are organised by neither one body nor multiple free bodies but through bodily alliances that stabilise and disperse. The hundreds of thousands of perceptions that contribute to the organisation of the crowd are capable of both entrainment, to develop unity, and free movement, to produce dispersion. Similarly, Thom's concept of *retroactive smoothing*[14] in insect swarms describes the stabilisation of free elements after a territorial expansion. The elements of a swarm are given over to free motion where they are dispersed by external forces, only later to be reconstituted through a retroactive gesture that emerges from within and between the elements.

What is most startling about these pack, crowd, crystal and swarm bodies is that they interact with their environment intensively. Unlike a familiar contextualism or functionalism, which is based on the ability for form to passively result from contingencies and exigencies, an intensive sensibility turns external forces and contingencies to its own devices. By anticipating and reacting to external forces, supple and flexible provisional orders are able to incorporate vicissitudes and contingencies within their internal order. Supple bodies are *shaped* by an internal order capable of flexibly responding to vague external forces through *smooth retroactive gestures*.

Viscous bodies

Conventional architectural description lacks the clarity necessary for the measurement of the behaviours and characteristics of matter, as those effects are not static and cannot be fixed with proportional exactitude. As Luce Irigaray has argued in 'The Mechanics of Fluids'[15] this inattention to the dynamic and fluid is not accidental but a symptom of the 'precedence of the solid and static'.

The fluid model of viscosity is the condition where the cohesive characteristics of a body are determined by the external frictions, pressures and heat exerted upon it. Viscosity is a quality of being mutable or changeable in response to both favourable and unfavourable situations that occur by vicissitude. Vicissitudinous events are neither arbitrary nor predictable but are made possible by a confluence of internal motivations with external forces. For instance, when a seemingly accidental event occurs the victims immediately identify the forces contributing to the accident and begin to assign blame. It is inevitable however, that no single element can be made responsible for any accident as these events occur by vicissitude; particular influences at a particular time make the outcome of an accident possible. If any element participating in such an intricate network of local forces is altered the nature of the event will change. A viscous sensibility is dependent on both an intrication of local intensities and the exegetic pressure exerted on those elements by external contingencies. Neither the intrications nor the forces which put them into relation are predictable from within any single system. Connections by vicissitude develop identity through the incorporation of local adjacencies and their affiliations with external forces. In this sense, vicissitudinous mixtures become cohesive through a logic of viscosity. Irigaray defines the viscous as the model for relations of the *near and not the proper*.

Viscous fluids develop internal stability in proportion to the external pressures exerted upon them. Fluids behave with two types of viscidity: they exhibit both internal cohesion and adhesion to external elements as their viscosity increases. Viscous fluids begin to behave less like liquids and more like sticky solids as the pressures upon them intensify. Irigaray refers to these gelatinous forms as *near-solids*. Viscous forms are capable of yielding continually under stress so as not to shear, exhibiting both a *cohesive* stability in response to adjacent pressures and an *adhesive* stickiness to adjacent elements. The nature of pliant forms is that they are sticky and flexible. Things tend to adhere to them. As pliant forms are manipulated and deformed the things that stick to their surfaces become incorporated within their interiors. Forms of viscosity and pliability cannot be examined outside of the *vicissitudinous* connections and forces with which their deformation is intensively involved. Viscosity and vicissitude are characteristic to organisations that emerge through processes of differentiation.

Recently much attention has been focused on the potential development of a new kind of viscous machine. These gelatinous machines have been termed 'wet' and 'intelligent'. They are wet because they are fluid, supple, flexible and viscous in their development of varying degrees of stability, strength and coherence. They are intelligent be-

cause they exploit the vicissitudes of their surrounding environment for their own internal structuration.[16] They develop increasing and decreasing degrees of viscosity in response to external stimulus. The relationships between their viscosity and their interactions with their environment is not determined by any factor or operator but develops out of a confluence of multiple forces.

The gel-golf armature is an example of one such machine. It is a flexible armature that reacts to its environment through expansion and contraction based on the chemical content of the surrounding fluid in which it is immersed. When a ball with a specific chemical coating is dropped into the tank, the gel armature reacts by expanding and bending toward the ball, striking it with sufficient force to move it. It will continue to swing at the ball until it is pushed out of reach. Due to this chemical feedback with its environment this gelatinous matter is an *open* system. The gel is capable of responding to external forces and can therefore organise its environment through extensive gestures. Forces exerted on such an intensive body often instigate emergent gestures that are capable of reorganising the context which initiated them.

Deformation and curvilinearity are expressions of the dynamic, stable composition of bodies within a field of differential forces. Even the simple animal phylum of modular zooids[17] internally mutates through the internalisation of certain external influences. As zooid modules become locally connected to form large colonies – such as those of a seaweed – their individual organisations become specifically deformed. The more or less identical modules develop differing configurations, based on their alliances with one another, in response to exigencies. For example, as feeding must occur on the perimeter of the colony, and as the aggregate body increases its mass, sustenance is passed to the interior of the colony through specialised pores which develop only for this purpose. Long cilia mutate to clean the colony's surface and smaller, more powerful cilia develop to produce and funnel currents to increase the food supply to the interior of the colony. Reproductive functions are hypertrophied in specific zooids and atrophied in others as the colony begins to form specialised reproductive organs through alliances within particular sub-colonies of individuals. The modules differentiate into a more complex, particularised organism, due to an intensive relationship with the currents of the marine environment in which these colonies are immersed. The zooids are configured by their context and then begin to influence and reconfigure that context to maximise their own performance. An attention to the dynamic deformation of the module through local interstitial alliances and connections to evolving larger provisional unities can describe these forms of polymorphism.

Curvilinear Gestures

Gestures are always *intensively curvilinear*. Curvilinearity signifies the principled deformation of a line while organising many disparate elements continuously. Astrology provides perhaps the best example of an intensively curvilinear gesture. Any given constellation of disparate points or stars arrive in their respective positions through differential forces. An astrological gesture will unify those elements with a curvilinear line that both locates their particularities and places those particularities within a continuum. These gestures might take the form of a crab, ram, lion, fish, dipper, etc. What is more important than what these figures signify is that they are always *continuous*, always *curvilinear* and always *gestural*. Gestures, such as these, are highly principled flexible connective networks. The gesture maintains openness through an attention to the particular characteristics of the disparate elements which constitute it and give the continuous shape its particular curvilinear form. The abstract forces of their constituent, disparate elements and the retroactive unity by which those points are placed into a relation are expressed along a continuous line. There is no propriety to the gesture, yet the possibilities are partially determined by the contingent differences with which the gesture begins. The curvilinear gesture is capable of maintaining many different and particular influences within its provisional unity. The primary characteristics of the gesture are its provisional unification through a process of differentiation and the curvilinearity of its lines based on this same deformation and differentiation. The simultaneity of the one and the many in these models renders any gestural organisation a multiplicity, capable of dispersing into the constellation of the many, or calcifying into the singularity of the one. The gradual dispersal of constituent points in some gestures invites more open readings where the gradual condensation and alignment of elements leads to a greater degree of unity and closure. Gestures emerge from thousands of tiny perceptions; of cells, proteins, enzymes, hormones, and other base matter. Matter becomes connected forming organs, organs are collected to form bodies, bodies begin to articulate gestures in response to a constellation of forces resulting from differential interactions across molecular, cellular, organic and bodily scales.[18] Hunger, for instance, does not arise from any single organ's perception but rather occurs through a dynamic interaction of e-coli bacteria that construct a body of digestive perception, the impulses of the stomach and large and small intestines, hormones, glands, and the other visual, oral, auditory, and olfactory stimuli from outside the body. Hunger is a unifying gesture that renders thousands of tiny perceptions visible as an abstract expression. Gestures are rigorous, precise modes of organisation that render imperceptibly minute and multiple

desires as unified perceptions. Bodies are expressed, stabilised, organised and unified through the play of a multiplicity of tiny forces.

Architecture is one vector mingled with many other political, social, economic, institutional and cultural forces. Architecture is not capable of determining events but nonetheless it participates in the formation of urban bodies and populations. These urban bodies may be strictly determined or they may occur spontaneously. For instance, a more or less closed urban body is composed within the architectural space of a soccer or football stadium with the occurrence of a *wave*. This is one example of a building organising a unifying gesture across constituent elements. There is no single individual that determines the instant or location that a wave will begin, what the speed of the wave will be across the crowd, whether the wave will move in a clockwise or counter-clockwise direction around the stands, what percentage of the crowd will participate in the wave or what the duration of the wave will be. These events are determined by the proceedings of the game, the media and the constituent fans. Although the example of the wave is constrained within a closed architectural structure, it is still not reducible to the form of the object in which it is housed. No stadium is capable of determining or predicting with exactitude these urban gestures, although it is capable of organising the *thousands of tiny perceptions*[19] in such a way that a temporary unification is possible. The impulses that contribute to the production of the wave effect are differential and multiple, leading to a singular unifying gesture that temporarily renders the stadium and its occupants as a provisional body. The waving body may persist, even expanding as more of its elements are excited into a state of waving, and as the hundred thousand tiny impulses subsist so too does the provisional body dissipate. The composite body of the waving stadium does exhibit cognition at the scale of urbanism: it is excitable, it is prone to hunger, it can be angered, it is celebratory, it is responsive to images, it is capable of sustained attention and distraction from its internal motor (the game occurring at its centre). The intricate connection of tiny events, of the most base kind imaginable, along with the monolithic structure of the stadium and the game itself are necessary to the formation of the wave. Particular gestures are sponsored by particular forms: the wave is a closed gesture circulating within a unified architectural volume. The challenge for architecture is the design of urban spaces in which a multiplicity of gestures are possible. An alternative model of the body to that of the stadium, which is after all a closed holistic enclosure, is perhaps the beginning for such an architecture. Gestures, such as the wave, establish a system of circulation between the crowd singularity (the one) and free elements (the many). These gestures of unification and dispersal constitute and diffuse bodies continuously. The wave is a curvilinear gesture that circulates through the individual particles, within the monolithic structure, uniting disparate elements into a dynamic, temporal body.

Gestures as Abstract Expressions of Forces

Etienne-Jules Marey was interested in recording the movements, pulsations and flows of bodies directly as abstract gestures. As Francois Dagognet has argued:

> The whole of his work had consisted in showing what one could learn from a curve, which was not merely a simple 'reproduction'. It was from and with the curve that forces could initially be calculated. It was easy to obtain the mass of the body as well as the speed it was going (chronobiology); from this one could induce the force that had set it in motion, the work expended to produce this action. This trajectory always had to be questioned and interpreted. Not only were the slightest nicks and notches in the line due to certain factors, but they enabled the determination of resistances as well as impulses.[20]

The figure of an electrocardiogram reading of the heartbeat is not only a numeric representation but a gestural expression of an abstract flow that captures perceptions of excitability, anger, relaxation, truth, deception, etc. Likewise, Marey's connective lines between photographically arrested instances of motion were drawn retroactively to express the force and duration of a body, its mass, velocity, direction and gravity in a single gesture. The lines of frozen motion of his photographs are merely the instants through which motion circulates between intervals. The connective strokes drawn by Marey are highly differentiated lines that express temporal and corporeal forces. Most importantly, these lines organise manifold influences along a continuously differentiated line. The smoothing lines of Marey traverse intervals expressing a continuity that incorporates a constellation of disparate forces. These unifying figures begin to describe a dynamic fluid body as it is intensively influenced and organised by particular contingencies and movements. The curvilinearity of these abstract expressions results from the differential forces that those lines organise. These curvilinear gestures express a body in time, in motion, intensively involved with its context. To reduce these curvilinear gestures to ideal average lines would evacuate them of their particular content. Outside of the vagueness of particular influences bodies such as these do not exist.

The most important principle here is that flows occur across the intervals between bodies. There is no flow within a whole, only stasis. Networks of internal and external forces are resolved through these dynamic exchanges. An architecture of static bodies rejects all contiguous, contingent

forces, leaving the flows between bodies unattended. The insight of D'Arcy Thompson is that all bodies are always internally mutating in response to forces outside their influence. This principle of involution intensifies the relationships between bodies and disperses the interiority of an ideal body into a differential network. The body is reterritorialised in a two-fold manner as the interior of the body flows out and external contingencies flow in. Thompson posits perhaps the first geometric technique for the analyses of duration as it applies to the morphogenetic composition of form. Differential forces are the sources and material for discoveries, inventions and new dynamic stabilities. These forces are mapped by a deformable body geometry. D'Arcy Thompson shares a profound disinterest in the module, as did the Egyptians in Panofsky's analyses. Thompson locates discriminate characters in order to chart their reassembly, migration, development and mutation due to external pressures. Thompson uses the initial type as a mere provision for a dynamic system of transformation that occurs in connection with larger environmental forces. Thompson *intensively involves* external forces in the deformation of new morphological types. The flexible type is able to both indicate the general morphological structure of a species while indicating its discontinuous development through the internalisa-

tion of heretofore external forces within the system. For instance, the enlargement of the eye of a fish is represented by the flexing of a grid. This fluctuation, when compared to a previous position of the transformational type, establishes a relation between water depth and light intensity as those conditions are involved in the formal differences between fish. These events are not predictable or reducible to any fixed point but rather begin to describe a probable zone of co-present forces; both internal and external. The geometric effects of these deformations become a map of an intensive interaction between a disinterested environment and a discrete body, such that these two groups of forces become inextricably and intricately connected. The supple geometry of Thompson is capable of both bending under external forces and folding those forces internally. These transformations develop through *discontinuous involution* rather than *continuous evolution*. A deformable geometry[21] is capable of describing the flow of these forces by attending to the localised particular deviations of bodily matter. These curvilinear gestures are the abstract expressions of an open organisation or unity that arises from a dynamic network of differential forces. These gestures describe the continuous process of differentiation that both *fuses* matter into bodies and *diffuses* bodies into free matter.

Notes

1 For a discussion of the role of variation in the phenomenological reduction of particular bodies to ideal 'eidetic' bodies – in relation to the production of architectural types – see my 'Multiplicitous and Inorganic Bodies' in *Assemblage 19*, MIT Press, Cambridge, Mass, 1993, pp 32-49.

2 See Jacques Derrida's *Edmund Husserl's 'Origin of Geometry': An Introduction*, trans with a preface and afterword by John P Leavey Jr, University of Nebraska Press, Lincoln, 1989.

3 I have already developed a discussion of these geometries and their relationship to architecture in 'Probable Geometries: The Architecture of Writing in Bodies' in *aNY Magazine, no 0: Writing in Architecture*, ANY Co, New York, 1993, pp 44-49.

4 Mark Wigley, 'Postmodern Architecture: The Taste of Derrida', *Perspecta 23*, Rizzoli International Publications Inc, New York, 1987, p 160.

5 Mark Wigley, *Deconstructivist Architecture*, Museum of Modern Art, New York, 1988, p 80.

6 Michel Serres, *The Parasite*, trans Lawrence R Schehr, John Hopkins University Press, Baltimore, 1982, p 35.

7 Gilles Deleuze and Felix Guattari, *A Thousand Plateaus: Capitalism and Schizophrenia*, University of Minnesota Press, Minneapolis, 1987, p 10.

8 Friedrich Barth, *Insects and Flowers: The Biology of a Partnership*, trans MA Biederman-Thorson, Princeton University Press, Princeton, 1991, pp 237-249.

9 Georges Bataille, 'The Deviations of Nature' in *Visions of Excess: Selected Writings, 1927-1939*, ed, trans and introduction by Alan Stoekl, University of Minnesota Press, Minneapolis, 1985, pp 53-56.

10 Erwin Panofsky, *Meaning in the Visual Arts*, University of Chicago Press, Chicago, 1955, p 62.

11 Jeffrey Kipnis has recently escalated the distinction between collage – which he defines as discontinuous heterogeneity – and other practices of continuous heterogeneity in his 'Toward a New Architecture' in *Folding in Architecture, Architectural Design Special Issue no 103*, ed Greg Lynn, Academy Editions, London, 1993. This difference from and subsequent dismissal of collage strategies is the hinge on which Kipnis turns from the Post-Modern practices (including those of what has come to be called Deconstructivism) to more 'cohesive' architectural practices.

12 For an alternative discussion of continuous yet heterogeneous systems of organisation see my 'Architectural Curvilinearity: Folded, Supple and Pliant Architecture' in *Folding in Architecture*, op cit.

13 Elias Canetti, *Crowds and Power*, Farrar, Straus and Giroux, New York, 1984.

14 René Thom, *Structural Stability and Morphogenesis*, trans DH Fowler, Addison-Wesley, Reading, Mass, 1975.

15 'Yet one must know how to listen otherwise than in good form(s) to hear what it says. That it is continuous, compressible, dilatable, viscous, conductible, diffusible . . . that it is unending, potent and impotent owing to its resistance to the countable; that it enjoys and suffers from a greater sensitivity to pressures; that it changes – in volume or in force, for example – according to the degree of heat; that it is, in its physical reality, determined by friction between two infinitely neighbouring entities – dynamics of the near and not of the

proper, movements coming from the quasi contact between two unities hardly definable as such (in a coefficient of viscosity measured in poises, from Poiseuille, sic), and not energy of a finite system; that it allows itself to be easily traversed by flow by virtue of its conductivity to currents coming from other fluids or exerting pressure through the walls of a solid; that it mixes with bodies of a like state, sometimes dilutes itself in them in an almost homogeneous manner, which makes the distinction between the one and the other problematical; and furthermore that it is already diffuse "in itself", which disconcerts any attempt at static identification . . .' Luce Irigaray, *This Sex Which is Not One*, trans Catherine Porter with Carolyn Burke, Cornell University Press, Ithaca, 1985, p 111.

16 'Simple though it is, the gel looper exhibits the essential characteristics that set "soft" chemomechanical systems apart from mechanical devices made of more rigid materials. In contrast to conventional motors and pumps, gels are gentle and flexible, and their movement is more reminiscent of muscle than is that of metallic machines. This pliant motion is usually seen only in biological systems, such as the wings of birds, which reshape themselves continuously to maximise lift. Because gels are soft, they can manipulate delicate materials without damaging them. Even more important, however, gels are soft with repect to their environments. Machines made of metal or silicon operate as closed systems. They do not adapt to changes in their operating conditons unless a separate sensor system or a human operator is at the controls. Gels, in contrast, are thermodynamically "open": they exchange chemicals with the solvent surrounding them and alter their molecular state in the process of accomplishing work . . . these properties create self-sensing and self-regulating machines that respond intelligently to changes in their surroundings.' Yoshihito Osada & Simon B Ross-Murphy, 'Intelligent Gels', *Scientific American*, May 1993.

17 See Robert Woollacott and Russel Zimmer, eds *Biology of Bryozoans*, Academic Press, New York, 1977; *Bryozoans*, Hutchinson & Co, London, 1970; and especially Frank McKinney and Jeremy B Jackson's *Bryozoan Evolution*, University of Chicago Press, Chicago, 1989.

18 For Panofsky, the gesture was the first problem to be overcome by systems of proportion, as the gesture implied both particularity and temporality, where symmetry and proportion assume static fixity.

19 This discussion of 'thousands of tiny perceptions' in regard to the formation of singular perceptions (such as the desire that can be named hunger at a certain threshold) is elaborated by Gilles Deleuze in *The Fold: Leibniz and the Baroque*, University of Minnesota Press, Minneapolis, 1993.

20 Francois Dagognet, *A Passion for the Trace: Etienne-Jules Marey*, trans Robert Galeta with Jeanine Herman, Urzone, New York, 1992, p 62.

21 See my 'Multiplicitous and Inorganic Bodies', op cit.

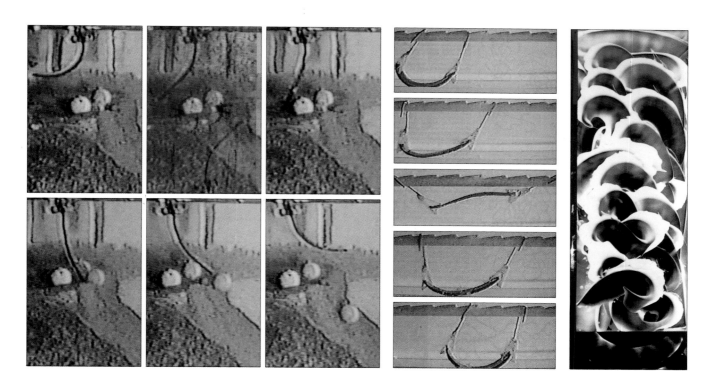

LEFT TO RIGHT: Gel golf demonstrates the ability of an intelligent gel to act on its surroundings. Gel looper device that moves by repeatedly curling and straightening itself as its surfactant molecules respond to the influence of an electric field with alternating polarity. David Reed, No 252, 1987, 274.32x91.44cm

MARK RAKATANSKY
THE GESTIC BODY OF ARCHITECTURE

Body?

Which body?

What attitude does architecture take towards bodies?

What gesture *does*, what gesture *can* architecture make in response to the gestures of bodies?

The gestures that conventional architecture tends to make towards bodies is to reduce the body to a series of standardised measures, proper behaviours, ergonomic formulations. In other words, architecture's gesture is to match, and thus spatially constitute, these already socially determined reductions of the body.

The gestures of architecture already precede the body, are already in place before any bodies interact with them, and thus architecture constitutes and manages those bodies (that eventually do interact with it) through socially-determined architectural configurations of walls, doors, tables, chairs, desks, filing cabinets, closets, whose purpose is to put into place socially determined 'proper' ways of working, waiting, eating, dressing, and so on. Conventional architecture attempts to mask this social determination of behaviours by giving its gestures the appearance of economy, naturalness, matter-of-factness. But, as Brecht noted, gestures are not matters-of-fact, rather they are always *directed* towards another, towards others:

The realm of attitudes adopted by the characters towards one another is what we call the realm of gest. Physical attitude, tone of voice and facial expression are all determined by a social gest: the characters are cursing, flattering, instructing one another, and so on. The attitudes which people adopt towards one another include even those attitudes which would appear to be quite private, such as the utterances of physical pain in illness, or of religious faith.[1]

That is what Brecht says about gestures, but what does the *Oxford Dictionary* say? It says:

Significant movement of limb or body; use of such movement as expression of feeling or as rhetorical device . . . (Fig.) step or move calculated to evoke response from another or to convey (esp. friendly) intention . . . L *gerere gest* – wield.[2]

To evoke response. Certainly. What sort of response may be a question – but as to the conveying of intentions, we know it is impossible, fortunately or unfortunately, in this piece of writing or any other, in these designs or any other, to count on the conveying of intentions in any exact or definitive manner. What might be conveyed are *some* of the attentions given within the work itself.

If the staff social worker at this adult day-care centre says: 'I think at first the [older participants] were not really certain what these objects were and how they related to the environment. This tends to be a cohort who looks at things from the utilitarian standpoint, and I think it was a very different mind-set when they started to realise, for example, that the rail in the hallway was much more than just a utilitarian object to steady oneself on . . . I think once they absorbed that this is more than just a handrail, they became very interested in it, almost proprietary towards it, because it is theirs, by nature of the inclusions', and if one of these older participants says about the coatroom: 'I can see that you were trying to think of every avenue of what a person does in there', then, yes, perhaps *some* responses have been provoked that are not irrelevant to *some* of our original intentions for this project.

But, of course, all it is really is steel, plexiglass, emulsion of paper, ink on acetate.

And all *this* is is ink on paper.

But then, that is all they ever are, all these kinds of things constructed rhetorically, because architecture (and writing) is always constructed rhetorically no matter how it is constructed, to provoke some response (no matter how benign), but – and here is the difference – in ways that either attempt to directly address its own (rhetorical and social) construction or not. Thus, in the end, in the finished work, there are no intentions left, only attentions. Attentions to ideas – in these examples, to the social and psychological gestures of bodies and architecture – and to their difficult and problematic but critical development into form.

Thus following Brecht (and the *Oxford Dictionary*), one might say that the gesture of architecture, like the gesture of the body, is already a rhetorical gesture towards another, is already a social gesture.

In other words, the social is not restricted to, and cannot be reduced to, selected programmes focused on selected groups of narrowly-designated 'users': the homeless, the

poor, the aged, the disabled. It is rather easy for architecture to appear under the sign of the social by selecting and constructing one of the aforementioned programmes in some diagrammatic manner (under the excuse of budgetary constraints), without ever addressing what is social within the programme or within the particular design. On the other hand, it is rather easy for 'high design' to avoid addressing issues of the social, never mind even attempting any of these programmes.

In other words, all architecture is social architecture.

But if the gestures of architecture are already social, their repetition as conventions requires that they be interrogated as such to reveal this condition. Brecht:

This means that the artist has to adopt a definite attitude . . . he cannot let it [the gesture] just speak only for itself, simply expressing it as the fact dictates.[3]

The drawing forth of what is social in the gesture, of the 'attitudes adopted by the characters towards one another', required, for Brecht, the turning of the gesture into the gest. A gest is, in John Willett's words,

at once gesture and gist, attitude and point: one aspect of the relation between two people, studied singly, cut to essentials and physically or verbally expressed.[4]

The term 'essentials' here refers to the framing of what in dynamical system theory would be designated as singularities,[5] not to some reduction of the complexity of the social and psychological field. Brecht:

These expressions of a gest are highly complicated and contradictory, so that they cannot be rendered by a single word and the actor must take care that in giving his image the necessary emphasis he does not lose anything, but emphasises the entire complex.[6]

And as it could be claimed that architectural elements act as actors – actors, that is, who also direct – the focus in Willett's definition on the relation between two people might be extended to refer to the relations between two entities (such as subject and self or subject and object or object and object).

Like the *tactical* operations suggested by Michel de Certeau,[7] a gestic approach finds as its site the conventional, the hegemonic form of the gesture, which it must interrogate, unfold, unpack, disengage from its hegemonic totality before reconfiguration, refolding, reconstructing. It finds social and psychological narratives already within the physical form of conventional gesture, in order first to reveal them, and then to operate on them.

The gest is never general. The gest is a specific gesture situated within the general field of the social. Thus, to articulate the specific is not to find it in contrast with the abstract, but to find that the specific is already a (localised) form of social abstraction, of psychological abstraction, which nevertheless is repeatedly actualised by the subject as a 'genuine' (non-abstract) activity. That a gesture is perceived by the subject as 'genuine' does not make it any less of a social and psychological abstraction, any less of a construction.

Thus, one localises an architectural event not to root it in some essential and proper place, some irreducible form of dwelling, but to find it enmeshed, enfolded, in a field of non-localised relations. To find – as in the *fort-da* 'game' of Freud's grandson: that repeated enunciation of the alternating absence (*fort*) and presence (*da*) of some small *object* that the child (in response to the departure of his mother) repeatedly tossed away and retrieved – that the 'here' (what is 'present') is not separate from, is not opposed to, but already infolded in, the 'there' (what is 'absent').[8]

In other words, the topological infolding of self and other, absence and presence, inside and outside, private and public is at work at every level of social and psychological inhabitation and might thus be engaged architecturally.

But let us consider for a moment an opposing *strategy*, a rejection of such an infolding of the specific and the abstract. A rejection of the specific, the local, the everyday, in favour of the abstract would require more than just a benign ignoring, as this is business-as-usual for most architecture. What would be required is a refusal, a radical refusal, a refusal in the end that would of course be impossible, but nevertheless might have more or less interesting consequences depending on the acknowledgement both of its attempt and of its failure. But it would require a refusal at more than just the macro scale (this is a common strategy, which then gets filled up at the micro scale with all the standard furniture, appliances, handrails, signage: all that which then mocks the efforts at 'difference' being made on the ceiling and the walls). The everyday always returns, in a return of the repressed, to capture the subject's attention at the place where one's attention always is: the everyday.

Thus, the architecture that ignores the everyday allows itself – sets itself up – to be ignored in the everyday, or you could say, to be ignored everyday.

But to ignore the wider, more abstract conditions in favour of the specific is to develop just another reductive form of instrumental 'problem-solving', and thus also to be ignored everyday. To reject the specific or the abstract in favour of the other is to miss the opportunity to play each off the other, to problematise each by the other.

But this is not about casual mixing. The abstract might be considered to be most productively located and interrogated within that place where it is least expected: the everyday, the concrete, the specific – as Ezra Pound suggested:

Don't use such an expression as 'dim lands of *peace*'. It dulls the image. It mixes an abstraction with the

concrete. It comes from the writer's not realising that the natural object is always the *adequate* symbol.[9] Everyday objects, so-called 'natural' objects: coatrooms, handrails, kitchens, closets, doors, walls are already *adequate* symbols for the exploration and interrogation of social and formal meaning, as they are already the objects around which these meanings circulate. But such an interrogation would require a 'representation that . . . allows us to recognise its subject, but at the same time makes it seem unfamiliar', in order to 'free socially-conditioned phenomena from that stamp of familiarity which protects them against our grasp today.'[10]

Thus as in writing, what is required is a re-configuration, a re-framing, to bring out these meanings, precisely because these objects are perceived as 'natural'. Brecht:

> The Bible's sentence 'Pluck out the eye that offends thee' is based on a gest – that of commending – but it is not entirely gestically expressed, namely that of explanation. Purely gestically expressed the sentence runs 'If thine eye offends thee, pluck it out' (and this is how it was put by Luther, who 'watched the people's mouth'). It can be seen from a glance that this way of putting it is far richer and cleaner from a gestic point of view. The first clause contains an assumption, and its peculiarity and specialness can be fully expressed by the tone of voice. Then there is a little pause of bewilderment, and only then the devastating proposal.[11]

Let me construct this another way. On the one hand, form and detail are of primary importance, but not for their own sake, as Brecht's collaborator Kurt Weill noted in his comments on gestic theatre: 'It is interested in material things *only up to the point* at which they furnish the frame of or the pretext for human relations.'[12] But, on the other hand, the conceptual basis of the work as it relates to human relations is only relevant to the extent that it, in Willett's words, 'can be conveyed in concrete terms', can be developed in form and detail, or in Martin Esslin's words: 'The inner life [of the characters] is irrelevant . . . *except in so far* as it is expressed in their outward attitudes and actions.'[13]

So there are no big symbols standing in for everyday events, just everyday events (even if, or rather precisely because, these events are already within the symbolic field), but *events*, that is, reconstructed in the (Foucaultian) sense characterised by John Rajchman: as moments

> of erosion, collapse, questioning, or problematisation of the very assumptions of the setting within which a drama may take place – occasioning the chance or possibility of another, different setting . . . like those events in a drama which take the drama itself as an event.[14]

According to Brecht:

The idea is that the spectator should be put in a position where he can make comparisons about everything that influences the way human beings behave. This means, from the aesthetic point of view, that the actor's social gest becomes particularly important.[15]

In positing this possibility of a gestic architecture, let me propose two orders of architectural gest.

The first order of architectural gest operates on a more global level (while still being actualised at the local level) by revealing that architectural elements are actors in this social and psychological drama of inhabitation, that in their acts and gestures of 'functional' accommodation these elements are, in fact, directing actors. This operation reveals and reconfigures gestic networks throughout the institution, thus providing opportunities for localised (second-order) gests. It is important to configure these localised events along a confluence of networks so that they become more than random, idiosyncratic gestures, so that they accrue in ways that refer to more general conditions.

Example One: In *Adult Day*, the general issue of support is operated on, is troped, through the exaggeration of a standard architectural element of support (the handrail), exaggerating what it – conventionally – is, as well as transforming it into both what it is conventionally related to (coat rod, physical therapy device) and into what it conventionally is not (bench, archive).

Example Two: In *A/Partments*, the general issue of being a part of and apart from, of public and private, of concealment and revealment, is operated on through the exaggeration of standard architectural elements of containment and ordination involving planes (shelves, counters, tables, seats) and volumes (cabinets, closets, thresholds, chairs). These related networks are drawn together, but in ways so that conventionally affiliated events are separated, and conventionally discrete events are affiliated.

The second order of architectural gest operates specifically on local singularities, local events. In fact, it needs these singularities to develop its own internal differences (of any significance) so as not to become just another totalising system; it needs, in other words, these singularities to problematise its own construction. It does so by actualising its accommodations in a directed (exaggerated) manner, by demonstrating its knowledge of 'human relations, of human behaviour, of human capacities . . . Consciously, suggestively, descriptively.'[16] This is necessary because conventional architecture already accommodates, in Brecht's phrase – 'the habits and usage of the body'.[17] but in a reductive, diagrammatic, and 'trance-like' fashion, without acknowledging that these accommodations are socially constructed, provisional, ideological.

To reconfigure that accommodation is not a matter of

constructing 'a better mousetrap', but of revealing the social gests that are already within conventional accommodation, of interrogating the instrumentalism of these gestures, practices, events, even if the result must itself be instrumental in some manner – cannot, as architecture, *not* be instrumental – but might in its own instrumentality examine, thematise, problematise this instrumentality.

The question then, for this second order of gest, is not whether you have addressed ('accommodated') the event, but *how* you have addressed the event, how you have addressed it such that in its architecturalisation *some* form of gest is revealed and, in addition, is troped, reconfigured.

For example, in *Adult Day*, it is not that we placed a mirror in the day-care centre coatroom (although it is surprising how few mirrors are present in coatrooms); it is *how* we placed it there. We could have just mounted it on the wall with cheap moulded plastic mounts or even developed some fancy wall-mounts in stainless steel. But in mounting the mirror-image of the present with the same clamping system that holds the photographic images of the past, we construct the photographs as other mirrorings, and your present image as another 'snapshot'. We attempted, that is, to architecturalise the social and psychological construction of the subject in this event as the gest of comparison of the self to the self, of the self to others. Duras says:

> But contrary to what . . . people still think today, I believe photographs promote forgetting . . . The fixed, flat, easily available countenance of a dead person or an infant in a photograph is only one image as against the million other images that exist in the mind . . . It's a confirmation of death. I don't know what use photography was put to in its early days, in the first half of the 19th century. I don't know what it meant to the individual in the midst of his solitude – whether he valued it because it enabled him to see the dead again or because it allowed him to see himself. The second, I'm sure. One's

always embarrassed or delighted by one's own photograph, but in either case also surprised. You're always more unreal to yourself than other people are. In life, even if you include the false perspective of the mirror, you're the person you see the least; and the best, composite image of yourself, the one you want to keep, is the specially prepared face that you try to summon up when you pose for your photograph.[18]

For example, in *A/Partments*, the doubling of representations of the 'private' subject (at the apartment doorway, now transformed to include a seat for sitting or holding packages, and a display case for 'personal objects') in the 'public' corridor is accompanied by a scopic doubling of the door viewer. The first viewer, moved from the door to the door frame (eroding the frame), links the inside of the apartment to the outside of the corridor through the conventional fish-eyed vision of (justifiable) fear; the second viewer, placed in the frame eye-level with the seat in the corridor, links the 'inside' of the seat to the outside of the corridor through a fish-eyed vision of (justifiable) pleasure. Thus, infolding, or revealing as already infolded: inside and outside, public and private, individual and community in the architectural gest of the threshold.

None of these examples, nor any of the other attempts in these projects to address the gests of everyday events, represent some definitive development of the gest of any of these events. There are any number of gestures in every event that might be reconfigured as gests.

Like here, for example. At the ending of this text.

Because if you are reading this right now, if your body is being accommodated by some architecture and if this journal is being accommodated by your body, then you know that I wrote this for you.

As a gesture to you.

You: my reader, editor, colleague, director, respondent, client, collaborator.

You: my user.

Notes

1 Bertolt Brecht, 'A Short Organum for the Theatre' in *Brecht on Theatre*, ed John Willett, Hill and Wang, New York, 1964, p 198.

2 *Oxford Concise Dictionary*, Oxford University Press, 1982, p 414.

3 Bertolt Brecht, 'On Gestic Music', *Brecht on Theatre*, op cit, p 105.

4 John Willett, *The Theatre of Bertolt Brecht*, Eyre Methuen, London, 1977, p 173. For other commentary on Brecht's concept of the gest, see Walter Benjamin, *Understanding Brecht*, Verso, London, 1983, pp 1-25; Roland Barthes, 'Diderot, Brecht, Eisenstein' in *Image-Music-Text*, Hill and Wang, New York, 1977, pp 69-78; and Gilles Deleuze, *Cinema 2: The Time-Image*, University of Minnesota Press, Minneapolis, 1989, pp 189-203, 315.

5 Sanford Kwinter, '*Quelli Che Partono* as a General Theory of Models', *Architecture, Space, Painting, Journal of Philosophy and the Visual Arts*, ed Andrew Benjamin, Academy, London, 1992, p 36: 'Topology . . . describes *transformational events* (deformations) that introduce real discontinuities into the evolution of the system itself. In topological manifolds the characteristics of a given mapping are not determined by the quantitative substrate space (the grid) below it, but rather the specific 'singularities' of the flow space of which it itself is a part. These singularities represent critical values or qualitative features that arise at different points within the system depending on what the system is doing at any given moment or place . . . In a general sense singularities designate points in any continuous process . . . where a merely quantitative or linear development suddenly results in the appearance of a 'quality' . . . A singularity in a complex flow of materials is what makes a rainbow

appear in a mist, magnetism arise in a slab of iron, or either ice crystals or conventional currents emerge in a pan of water.'

6 Bertolt Brecht, 'A Short Organum for the Theatre', op cit, p 198.

7 Michel de Certeau, *The Practice of Everyday Life*, University of California Press, Berkeley, 1984. A responsiveness to local conditions has been characterised by de Certeau as the realm of the *tactical* ('A tactic insinuates itself into the other's place, fragmentarily, without taking it over in its entirety, without being able to keep its distance . . . It must constantly manipulate events in order to turn them into "opportunities"') in contrast to the realm of the *strategic*, which attempts to posit itself as autonomous to local conditions. ('As in management, every "strategic" rationalisation seeks first of all to distinguish its "own" place, that is, the place of its own power and will, from an "environment". A Cartesian attitude, if you wish: it is an effort to delimit one's own place in a world bewitched by the invisible powers of the Other.')

8 Lacan, *The Four Fundamental Concepts of Psycho-Analysis*, Norton, New York, 1978, pp 62-63: 'The activity as a whole symbolises repetition, but not at all that of some need that might demand the return of the mother, and which would be expressed quite simply with a cry. It is the repetition of the mother's departure as cause of a *Spaltung* [splitting] in the subject – overcome by the alternating game, *fort-da*, which is a *here or there*, and whose aim, in its alternation, is simply that of being the *fort* of a *da*, and the *da* of a *fort*.'

9 Ezra Pound, 'A Retrospect' in *Literary Essays of Ezra Pound*, ed TS Eliot, New Directions, New York, 1968, p 5.

10 Bertolt Brecht, 'A Short Organum for the Theatre', op cit, p 192.

11 Bertolt Brecht, 'On Rhymeless Verse with Irregular Rhythms', *Brecht on Theatre*, op cit, p 117.

12 Kurt Weill, '*Gestus* in Music', *The Tulane Drama Review*, vol 6, no 1, autumn 1961, pp 28-29. The emphasis is mine.

13 Martin Esslin, *Brecht*, Methuen, London, 1984, p 123. The emphasis is mine.

14 John Rajchman, *Philosophical Events*, Columbia University Press, New York, 1991, pp viii-ix.

15 Bertolt Brecht, 'On the Use of Music in an Epic Theatre', *Brecht on Theatre*, op cit, p 86.

16 Bertolt Brecht, 'A Dialogue about Acting', *Brecht on Theatre*, op cit, p 26.

17 Bertolt Brecht, 'The Literarisation of the Theatre', *Brecht on Theatre*, op cit, p 45.

18 Marguerite Duras, *Practicalities*, Grove Weidenfeld, New York, 1990, p 89.

THE PROJECTS

Adult Day

Adult Day, a work-in-progress, was conceived as an investigation into the social and psychological space of older persons and, more specifically, as an attempt to enrich an existing adult day-care facility with an architectural intervention that would engage the lives and institutional setting of its inhabitants. The new handrail weaves its way throughout the facility, addressing issues of psychological and social, as well as physical, support – emphasising how support always involves autonomy and reciprocity, separation and connection. What is involved in the support of a handrail, a bench, a building, an individual, a family, a care-giving institution? And what support does each of these give, within and between themselves? The new handrail supports various constructions of the subject, including, among other things, photographs (past and present) and fragments of recorded interviews of the older individuals and the staff, as well as fragments from the institution's own documents. It is often the case in the institutional care of older adults that their past is privileged as the normative time of their lives, against the present, which is always considered as something less; thus throughout the installation time and memory have been examined through the simultaneity of past and present.

The symbol of the handrail was chosen as the main armature around which to construct the project precisely because the handrail is a ubiquitous symbol of gerontological and handicapped design. But it is a negative symbol, a symbol of defeat – a place you go to when you have to, when you have no choice.

The handrail works its way through the facility addressing these multiple issues of support and the construction of the subject as it turns into a bench, a physical therapy device, a photographic recorder, an archive, an audio system for interview fragments, a calendar, a coatroom rail, and a camera mount for a wheelchair-assisted individual.

Here are a few of the relations, behaviours, and capacities that the rail 'describes': standing, walking, looking, reading, exercising, sitting, sitting next to someone else, checking the calendar, checking one's (past or present) image, checking the time, checking one's coat.

And here are a few of the ways the subject of support, of autonomy and reciprocity, has been troped throughout the project – conceptually, spatially, tectonically:

In the Siting

The recently renovated condition of the site suggested a certain formal economy: thus, rather than multiply forms, we chose a 'singular' form that could itself multiply, developing reciprocal connections between various 'autonomous' forms (attractors) of support: rail, bench, shelf, calendar, archive,

photograph, coat. If the site strategy used in this project might be considered to be related to the dynamic system of the 'rhizome' (because of its interconnectivity, heterogeneity, multiplicity, discontinuity and acentrality), it should be understood as utilising rhizomal networks that are already present at the site, but that are unarticulated, hidden, or repressed – networks that our network first 'deterritorialises' and which then 'reterritorialises' our network. In other words, we did not import a predetermined hermetic network to impose on the site. We chose instead to respond to, and swerve from, existing networks, to reveal the strangeness of what is already familiar, both its canniness and its uncanniness.

Example One: When the rail encounters the lounge area (through the wall) it reconfigures the existing *props* in the space (seating, table, fish tank) and the events those props support (sitting, looking, talking, waiting).

Example Two: When the rail encounters the coatroom (part-way through and part-way out of the wall), it transforms from a handrail into a coatrail, connecting the absent subjects represented by the empty coats with the absent subjects represented in the photographs and text fragments. The new rail, in response to the existing convention of the chrome-plated coat-rod and attached wood shelf, simultaneously engulfs the rod and turns inside-out in order to turn into a plane in order thus to turn into a (cantilevered) shelf.

Between the Elements
Like music, the meaning of each element accrues in relation to each of the other elements and to the entire series. Each element is related to the greater community of elements, at macro and micro levels, tropically as well as formally. In several cases the relation between elements is tactically direct, activated through time and use.

Example One: The bench and the camera and archive rail. Photograph albums that pivot up from between the armrests of the bench will contain photographs taken by a Polaroid camera (timed to photograph at random intervals) located opposite the bench. Each day's photographs will be mounted on clips next to the camera, to be transferred at the end of the week to the armrest albums, where people sitting at the bench can look at photographs of people sitting at the bench looking at photographs, but *through time*, with all the contingencies of the 'un-posed' moment. At the year's end, these albums will be transferred back to the camera rail, to the dated archival slots indicating the future years waiting to be filled.

Example Two: A camera mount for a wheelchair-assisted older individual (paralysed on one side) who formally was active in photography. Through the prosthetic of the camera mount he will gain greater autonomy, at the same time as he takes on the task of acting as a prosthetic for the handrail,

gathering new photographs for the handrail as he chronicles the activities of the day centre.

At the Elements
Every event as it is constructed through an architecture is already its own representation. So then one might reveal it as such, construct it as such, in the gesture of its gesture, in the construct of its gesture (Brecht: 'The actor must not only sing but show a man singing.'). So that, *in use*, the subject's own gesture may be considered in relation to its representation, may be seen as already a construct. And as there is no event that is experienced as singular, each of the elements is involved with several events of support – with the various constructions and representations of these events, with their affiliative tensions. In other words, with various constructions of the subject.

Example One: In the coat room, the handrail support of subjects (the physical support of the mobile body and the photographic or textual representations of bodies) is connected to the support of the outermost layers (the coat, the hat) of subject and the events related to the presentation of these layers (the taking off and on of the coat and the hat, the preparation of the body and the clothes before the mirror).

Example Two: In the bench, the armrest photograph album is simultaneously what divides the bench into individual seats and what connects this act of sitting though the reciprocal event of looking at the album.

In the Detail
These issues of support are continued into the details. Each of the elements has been worked through recursive and topological elaborations of, in this case, tubular structure: scaling, bending, connecting, penetrating, sliding, rotating, clamping, holding, engulfing, turning inside-out. These terms are not restricted to specific shapes or materials – fluidity is not restricted to curves or to steel. The tectonic details transform as they engage with specific local physical and social conditions throughout the facility. In addition, these parts have been individuated, but in a manner that emphasises how they must be reciprocally joined together.

Example One: the clamping system more closely reflects the temporal hold and mediation that characterises human support (physical or otherwise) than would any standard and falsely fixed framing system. Support is always mediated, and whatever is held in these clamps' support will always be seen in relation to the mediation of the clamp. Whether one might suggest that the clamp holds the photograph as the hand holds the rail, or that the photograph is supported by the clamp as the subject is supported by the rail, the questions remain the same: what (or who) supports what (or who)? by what means? to what degree? to what end? for how long?

Coatroom rail. *The corridor rail turns into the coatroom and addresses the act of supporting the outer 'skin' or 'shelter' of one's 'coat', that is, supporting the object that is a symbol of returning to one's own home. There are at this centre a number of older individuals who return to the coatroom regularly throughout the day to make sure that their coats or hats are still present, that they still have the object that will allow them to return home. There is one particular individual, a certain Mr Vito V., who, if the staff are able to disengage his hat from his head, will return to the coatroom up to ten times a day to re-engage it. A series of hooks (connected to photo clamps) was designed for anyone who might want a special location for their coat. The hat-support was created for any of the older participants, but with Mr Vito in mind. The mirror sited under the hat-support allows one to check one's appearance upon arriving or departing; the mirror pivots to allow its use by standing or seated individuals. The plastic shelf sited under the mirror supports whatever might need to be supported while putting on or taking off one's coat or looking in the mirror.*

Bench. *From the myriad of possible ways of suggestively describing the event of two people sitting next to one another, we chose to focus on the border between, the dividing and connecting separatrix of the armrest, which we in turn divided and connected through the pivoting photograph album. The armrest is also extended past its 'normal' length and is tilted up to support the raised album and to support the raising and lowering body. Similarly, the wall scoops (another version of the flange, grommet and rail engulfments) were developed to address the border between a wheelchair and a 'normal' chair by taking up the difference in depth (from the wall to the seat back) between the two, thus siting the heads of each person in the same place: face to face.*

Example Two: Rods establish pin connections through all the individuated support parts of the handrail, and additionally provide the support for the photograph mounts.

Example Three: The photograph mounts turn into coat-hooks or hat supports or mounts for mirrors; the pronged support system of the rail rotates and adjusts to support the bench or the plexiglass shelf or the fish tanks; the rail turns inside-out to become a shelf.

A/Partments

We are, at the moment, in the middle of this design – for the development of interventions in the studio apartments and lounges in an existing fifty-unit building, recently acquired by a local community group for low-income housing for older persons – so my comments here will be brief. (For any dynamical troping to occur in a project, a thematics should be designated at the beginning of the project, but consequently this thematic should, by necessity, develop as the project develops.) I am including this preliminary material here in order to discourage a narrow reading of 'gesture' as referring solely to a gesture of the hand(rail).

Returning to my *Oxford Dictionary*, it is interesting to note that the etymological root of the building type most associated with collective inhabitation – the apartment 'house' – is 'apart from'. It would be easy to focus on this being-apart-from as an architectural condition (particularly given the double apartness of the 'user-group': low income and old age), but it is important to remember Brecht's concern that 'the expressions of a gest are highly complicated and contradictory', and thus it is important to register, within the design, that this form of inhabitation involves both being-a-part-of and being-apart-from. And to this weave, it may be possible to add (both in terms of the subject and the architecture) being-in-parts, as well as – if I may be allowed a slight acoustical swerve – being-in-compartments.

In other words, the thematic of the project is the infolding of a part of and apart from, inside and outside, public and private, individual and community.

While the general considerations summarised at the start of each of the sections on siting, elements and details in the previous project also pertain to this project, below are a few considerations that specifically pertain to this thematic:

In the Siting

If, to return yet again to my *Oxford Dictionary*, 'to contain' means to 'have or (to be able to) hold within itself' or to 'enclose, form boundary' or to 'be divisible by (number) without remainder' or to 'restrain, . . . prevent from moving or extending', then the site strategy used here attempts to resist such containments by elaborating extensions, reminders, leakages, driftings, infoldings: the kitchen and the closet is infolded with the main living area, the bathroom is infolded with the closet, the interior is infolded with the corridor.

Between Elements

Conventional cabinets 'enclose, form' boundaries, 'restrain . . . prevent from moving or extending', are 'able to hold within' themselves the things they hold 'without remainder.' Conventional cabinets are enclosed boxes divided internally by shelves. In this project, the planes of these volumes come apart (and are eroded in many cases to no more than a single vertical partition and a door). These 'volumes', now detached from the wall, establish tactical sitings at various locations and scales: attaching to shelves, supporting cantilevered counters, or filling in under the false springing of the existing arch.

The planes that are the shelves are no longer restrained from extending beyond the volume or even beyond the 'room' (passing through and around the walls). The plane that is the counter is no longer kept apart from cabinets and shelves, but instead folds up into, among other things: a back splash, a dish rack, and an open, folded, volume of shelves.

To the extent that it is still possible here to speak of one element as distinct from another, given this infolding of one thing into another, one area into another, then one might say each element makes the subject both a part of its particular 'here' (*da*), and at the same time leads the subject to that which is apart from 'here' to 'there' (*fort*), but thus also brings that 'there' to its 'here'. Boundaries are thus put into processes of erosion and reaffiliation.

This directed interweaving of shelves, counters, tables, seats, cabinets, closets and thresholds is thus developed by drawing together (making 'a-part-ofs') events that are conventionally apart, and by drawing apart events that are conventionally 'a-part-ofs', in other words, by reconfiguring these 'belongings' and 'separations', these 'heres' and 'theres'.

At the Elements

This interwoven network thus provides the context for localised interrogations of themes of the project, which in this case includes the apart-ness and the in-part-ness of the subject to its self at the site of the (gestures of the) body. Thus at each element there is an attempt to reveal a social and psychological gest in relation to a framing of a part of the body: for example, in the repetitive and tactilely intimate labour of the hands at the sink as reflected in the angled mirror-finished plane of the dish rack, in the containment of the face along with other objects in the cabinet as viewed through the opening in the kitchen wall (framed by the face-sized opening in the cabinet door), in the erosion of the door frame through the indentation of the fearful eye, in the

Camera Support and Archive. *The act of 'capturing' (representing) the event is combined with the display and archiving of these representations. Memory is constituted through the discontinuous and transformational framings of events and props, in institutional space, through time. Here the rail, in play with the bench, focuses on the cataloguing of institutional time and memory – and its representations: present time (daily and weekly), past time (the past year's photograph albums) and future time (the weekly and yearly dated slots waiting to be filled).*

comparative view of the face at 'normal' and enlarged scale in the double bathroom mirrors.

In the Detail
The horizontal planes are themselves set apart from the wall, and the vertical partitions are set apart from the horizontal planes (both in terms of placement and colour). But our constructional system also requires the reciprocal joining together of these horizontal and vertical planes, requires, in other words, the interweaving of that which is apart from and that which is a part of.

Adult Day *and* A/Partments *have been developed under the auspices of the Committee on Physical Thought at the School of Architecture at the University of Illinois at Chicago.*

Adult Day, *Adult Day-Care Center, Parkside Senior Services, Des Plaines, Illinois. Project Manager: Andrew Blocha. Project Team: Ted Buenz, Susan Melsop and Anne Thrush. Project Funding: the Retirement Research Foundation.*

A/Partments, *People's Housing, Chicago, Illinois. Project Manager: Gerardo Cerda. Project Team: Mary Beth Burns, Tim Gillet and Michael Terwillinger. Project Funding: the Rothschild Foundation.*

Funding for the preparation of this text, which is part of a larger work on forms of attention in architecture, has been provided by the Graham Foundation for Advanced Studies in the Fine Arts.

Plan and model of A/Partments

Helen Chadwick, Piss Flowers, *1991-92, 12 enamelled bronzes, installation,*
Angel Row Gallery, Nottingham

JACK BUTLER

BEFORE SEXUAL DIFFERENCE
Helen Chadwick's Piss Flowers

Early in the ninth week of life in the womb, the human embryo develops a surprisingly large proto-clitoris/proto-penis genital structure technically designated as the indifferent, neuter or common genitalia. 'Indifference' describes the state when the tiny, incomplete body of the embryo is not yet mature enough to express the chromosomal, genetic sex that was encoded at the moment of conception.[1] The indifferent genitals share both male and female characteristics. The phallic portion of the urogenital stalk suggests the future erectile penis, but on the ventral aspect it is deeply grooved in anticipation of the invagination of the female. The indifferent genital arises directly contiguous to the deeply rimmed anus and is capped with glans clitoridis/glans penis.[2]

An undifferentiated stage of genital development, common to both sexes, was a surprising personal discovery resulting from my research in the late 70s when I was commissioned by the Children's Hospital of Winnipeg Research Foundation (Canada) to construct models representing genital morphogenesis.[3] Genital development was both analysed and explicated sculpturally. A plasticine model of the initial indifferent genital structure was constructed and remodelled to represent successive stages of maturation. Each developmental stage was photographed.

My investigation of genital development before sexual difference is based on research enacted from both the position of visual art and biology. It combines the vocabularies of medical, political, art, institutional and psycho-sexual discourses together with my own subjectivity framed within the same representation. It does not attempt to be scientifically neutral or artistically auratic, since there is no neutral place to stand outside the chain of signification constructed by language, no objective position outside the field of representation.

This embryological/visual art research concluded that genital differentiation is preceded by an initial indifferent common genital structure. This structure is subjected to genetically encoded developmental strategies and is morphologically transformed by the plastic deployment of volume and voids (gastrulation, invagination) into sexually differentiated genitalia.

Beyond a few select areas of embryology and medicine, there is little awareness of this information. Yet, this news seems to be pregnant with significance during this time of crisis in sexual difference as it stands at the intersection of feminism, science, art and politics. Certain questions can be asked:

Sex/politics: Does the contemporary psychosexual position of women simply exchange a biological determinism for linguistic determinism?

Female/male: Does the embryological state of undifferentiation suggest the possibility of a collapse of gender into a bisexual and androgynous model?

Art/science: Could the body stand in the place of the limen between two historic solitudes? Can the body be represented as an ontologically transparent layer through which art and science are mutually visible.

On questioning the politics of sexualisation it seems evident that the genitals, as biologically defined in their difference, cannot support the burden of socialisation constructed by the phallocentric order. For example, embryological research cannot validate the current theoretical shift from a paradigm of biological determinism, where women are 'proven' to be biologically inferior, to a linguistic determinism where women are defined within the construction of language (which is male) as 'exclusion' and as 'lack'.[4]

Within the codes of visual art it is possible to construct a paradox, an oxymoron, multiple layers of meanings simultaneously available, transparent signifiers presenting contradictory aspects. The visual arts' equivocal nature can be used to question the space between art and science, focusing on another 'space between', the space between the 'sexes' (read 'genders'). Formations of fantasy or visual paradoxes such as the seemingly paradoxical indifferent genitalia or Helen Chadwick's paradoxical *Piss Flowers* gain direct access through fantasy to play with the 'real'.

Sexual undifferentiation approached through art or biology suggests a memory of wholeness, a pre-Oedipal union with the phallic mother. In this fantastical, preanalytical, prelanguage state, it is possible to imagine alternatives to Oedipal determination, to imagine a state where the 'real' eludes the 'symbolic', where the indifferent genital can serve as a metaphor for a collapse of gender from male and female singularities to a more complex, layered concept of sexuality, where the sexes become transparent and can be seen

one within the other. This sexual transparency produces an androgynous model that includes the pre-Oedipal undifferentiated sexuality common to the history of every individual and the precursor of the bisexuality that 'in the psychoanalytical view, is not the outrageous behavioural attribute of the few, but the psychic condition of us all.'[5]

Helen Chadwick's *Piss Flowers* are a metonymic representation of the body of the androgyne. The androgyne would represent, through both visual and psycho-social construction, the possession of both maternal and paternal phallus. In disavowing difference, both sexes regain their 'lost half' and the power that comes with it[6] – 'providing the woman with the penis she lacks could also evoke the possibility of the pregnant man.'[7]

I came upon Helen and her partner David pissing into the snow from the loading dock at the back of the visual arts building at the Banff Centre. Helen was directing this activity to melt complementary and ambiguous patterns, first by urinating in the centre of a metallic ring, and then having her collaborator encircle the initial demarcation. I later saw the plaster casts of the piss drawings. The casts had been retrieved as artefacts of Helen's playful game of art-and-the-politics-of-difference. The cast urine had become an iconography of gender, collapsing into an easy, ironic, androgynous play between two bodies who seem to be progressing towards a state *after* sexual difference.

Notes

This article first appeared in In Side Up, *published by the Walter Phillips Gallery, Banff, Canada,1991.*

1 In the classic textbook *Human Embryology*, fourth edition, by WJ Hamilton, JD Boyd and HW Mossman (Williams and Wilkins, Baltimore,1978), the authors articulate three distinct classes of sexual development: genetic chromosomal sex, gonadal sex and genital sex. They introduce the terms 'indifferent' and 'neuter' to designate the latter two somatic states of sexual development (pp 412,423). The authors state that 'Though basically their history is identical in male and female embryos, marked sexual differences become apparent as development proceeds' (p 413), and 'It should be noted, however, that, up to about the 50mm C.R. length stage, the external genitalia in the two sexes are essentially similar.' (p 415)

2 Keith L Moore, *The Developing Human, Clinically Oriented Embryology*, second edition, WB Saunders Co, Toronto,1977, p 231. 'Thus the type of sex chromosome complex established at fertilisation determines the type of the gonad that develops from the indifferent gonad. The gonads then determine the type of sexual differentiation that occurs in the genital ducts and external genitalia . . . The external genitalia also pass through a stage that is not distinguishable as male or female.'(p 240)

3 The living embryo within the womb, continuous with the life and body of the mother, can only be viewed by intrusive intra-uterine photography. The genitals are too small to be viewed by ultrasound, X-ray or computer-aided visualisations.

4 Jane Gallop, *The Daughter's Seduction, Feminism and Psychoanalysis*, Cornell University Press, Ithica,1981, p 22.

5 Francette Pacteau, 'The Impossible Referent: representations of the androgyne', in *Formations of Fantasy*, ed Victor Burgin, James Donald and Cora Kaplan, Methuen, New York,1986, p 63. Pacteau adds, 'Androgyny can be said to belong to the domain of the imaginary, where desire is unobstructed; gender identity to the domain of the symbolic, the law . . . The androgynous-looking figure presents me with an impossibility, that of the exposure of difference, the very difference which constructs me as subject.'(p 63)

6 *ibid*, p 64.

7 *ibid*, p 70.

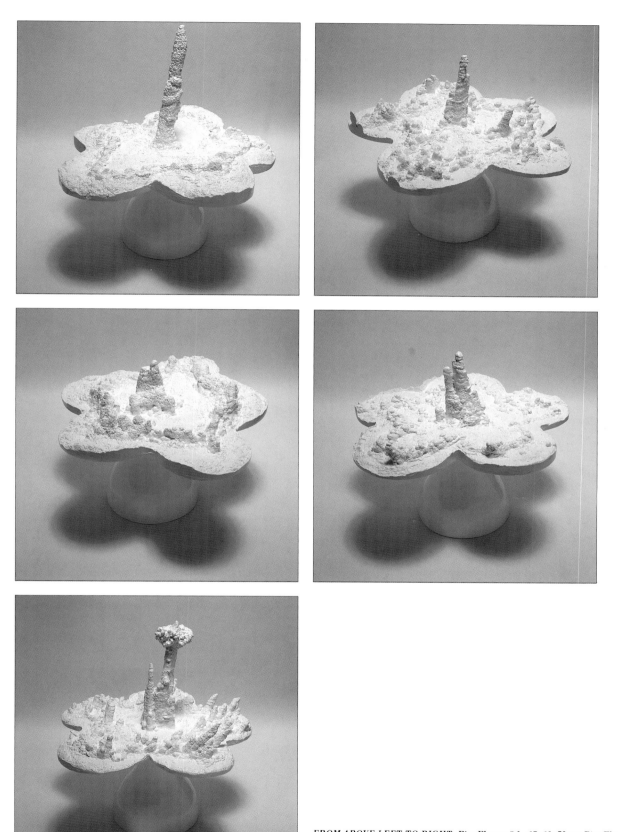

FROM ABOVE LEFT TO RIGHT: Piss Flower # 1, *67x62x71cm;* Piss Flower
3, *64x64x56cm;* Piss Flower # 5, *62x66x48cm;* Piss Flower # 10,
66x65x55cm; Piss Flower # 12, *62x62x68cm (all cellulose enamel on bronze)*

DANIEL KURJAKOVIC
FRAGMENTS
Remarks on the Aesthetic of Louise Sudell

Spaces I (the reflections)

I remember. (But I must immediately add that there is something hallucinogenic about this memory; perhaps one has to even call it a phantasmagoria reconstruction.) Last summer I found myself with the artist somewhere in the countryside. We found shelter in a building, not from our time. It was both splendid and dilapidated. One day: darkness slowly descending. The forest surrounding the house rapidly disappeared into the blackness of the night. Chains of cloud filled the sky. The sparse moonlight settled only on the crowns of the trees. We retired into the kitchen of the house to talk about this and that. A few candles gave off a milky light illuminating the middle of the room, in such a way that the room now appeared to be stretching back into infinity, whereas in daytime its exact size could be described. Empty and half-full bottles stood on the table. The reflections of the candle-light on them ricocheted onto the glasses where they dispersed like a kaleidoscope, constantly shifting in colour. Our faces (we were looking at each other through a glass) became distorted, appearing either longer or smaller. From time to time it seemed to me that the features of the person in front of me were dissolving, only to suddenly and unexpectedly materialise on the back of a glass. Our voices paved the way through the labyrinth of bottles and glasses. Here and there sounds were caught and partly deflected away by the curves and backs of the vessels. It seemed that the space in the room had folds into which the sequences and particles of our voices disappeared only to re-appear and solidify in a new form elsewhere. The day had retreated and the night (to use a bleached metaphor) had spread her wings. 'Oh,' said the artist suddenly. She pointed to the red liquid in the glass. I looked into it and after a while saw there a forest, softly lit by the moon, in which stood a house, not of our time, and in the kitchen of the house you could see the light of candles where two people were sitting in the glow of their tallow staring spellbound at the table, where glass vessels stood . . .

The Endless Series

It is strange how one paradoxically assumes that one is able to deduct characteristics of waking whilst reading the description of dreaming by the French philosopher Henry Bergson (1859-1941):

Faced with these unusual groupings of images which offer no plausible meaning, our intelligence (which by no means suspends all power of reasoning during sleep, as is claimed) seeks an explanation and wants to fill the gaps. It fills them by calling up other memories which often display the same distortions and inconsistencies as the previous ones and so require in their turn a new explanation – and so on indefinitely.[1]

An endless series. Whoever objects, saying that life is not a collection of unusual pictures, does not disqualify my suggestion that one can read Bergson's dream description as a paraphrase of waking. They can at the very most admit that they themselves have never experienced life as a collection of unusual pictures. Art can be this experience. A space where the other world becomes possible. Where reality and imagination, fact and fiction cross over.

The Unconscious (not/a prison)

A regret: the other side of our existence that withdraws from cerebral control – the evasive, the escaping – was given a place in the civilisation of the Occident. Psychoanalysis, as science, has named this other side as the sub-conscious. And by naming it so, has taken the edge off it, even emptied it. Where does the sub-conscious reside? What are its effects? How can we talk about it today? It is clear that there are other ways of thinking, other than the thinking ratio. But how should we give them their rightful place? How to fully expand on this thinking? How to develop this thinking? (Apart from that, we need to redefine and to question the place where thinking can happen in the order of the hierarchy of human behaviour; the hierarchy where the old power of thought is at the highest level . . .) Is it not so that many of these things that we do depend on processes which escape the notice of the primary control of the brain? Many of the things that we do depend on discrete processes mutual both to our body and our environment. Therefore: there is a thinking of the underground, of the – according to the old metaphor – night: implicit thinking. How do we want to interpret the fact that a large part of the cognitive work happens independently from the normative ideas of the rational, and of the logical, outside the reach of waking? An invention of a magical thinking, a returning to a wild thinking,

reminiscent of a mythological thinking? Let's leave these possibilities to themselves. But can we still call this 'thinking'? However, it does define us as humans, as acting people, as subjects. Subjects in two senses of the word: the suppressor and the suppressed. Double structure: activity and passivity. To be a subject, to be a human being means to suppress the world by thinking and to be suppressed as a body. To suppress? It is no coincidence that a war metaphor that puts up the opposite of culprit and victim, is more real than we usually credit a metaphor. Therefore, I pose the question: would it be possible to substitute them by throwing together 'to suppress' and 'to be suppressed'? If one could make this thinking a reality one would have to start anew: because the wish to know is also a desire. And the desire extends towards greed. Knowledge is never without object, goal and intention. A pure neutral knowledge does not exist (yet). It is always subservient to something or to somebody (the human). One could also say that knowledge is *a priori* instrumentalised. Knowledge also includes power; sometimes it becomes its instrument (to suppress other humans or, more generally, the other). Finally, we also deal here with – and luckily enough I can move away from extreme formulations – very basic things: greed, lust, vanity, jealousy, stupidity, injustice, desperation . . .

I start again: should one suggest a way to unravel thinking? To free it from the ropes of the rational and of the logical? Because through this the structures of bureaucracy and the modern state of the rules of laws simply doubles with fatal consequences. The one that brought to human society the orderly and cleaning light of names. But the light became fire. The modern world stands in it.

An image (Giotto's allegory of Envy): of a snake spitting its own poison out of its mouth into the eyes of the world. Then the world – staggering blindly forwards with a hand outstretched searching for help in an unknown future – is about to fall into an edgeless and supportless underground which, as always, has been part of the definition of the precipice of the world. For the last time: the precipice is indeed the subconscious. On the other hand, the precipice can also become a foundation for the underground. The pedestal that can be built on (the ego, the world). And – to finish this tiring accumulation of metaphors – only to walk out into the precipice, into the night, into the darkness enables us to return. To where? Back into this world, to us.

Rites of passage. It is an experience of transition, a transgression. Every meaning is connected to the experience and the meaning of this is the experience of ecstasy of the subject. Above all the subject goes out of itself in order to be able to get to itself. This experience is the sketch, out of which the phantasmagoria appears.

We perceive a thing in outline only; we perceive a sketch only of a thing; this outline calls up the complete . . . memory, which was already either unconscious or just a thought in form, takes advantage of this opportunity and comes forth. What we perceive is this sort of hallucination, encased and inserted into a real framework of reality'[2]

Whoever cannot depart from herself/himself can never come back to herself/himself. S/he stays outside of herself/himself. This is the really frightening strangeness. The prison.

The Fragment

The fragment is a part, a completely free-standing piece. It is a statement that we can read. But this statement, as complete and satisfactory as it may be, is also a reference for another statement. (A function that dangerously is fulfilled even better when the reading matter consists of gaps, rips.) The statement of the fragment is not only an expression of itself but also a reference for another statement, quite likely of a completely different way of speaking. The understanding that results from a fragment is never finalised. On the contrary. The fragment could say: read me, widen me through your reading. Increase me. Continue to think me! In that way the fragment discloses itself. In addition the gaps between each single fragment are not just empty. They are filled with emptiness. Only those who can read the emptiness can maybe understand. Not the text (the text has nothing to do with us, we are not bothered about it), but herself/himself.

The Skin's Writing, the Writing's Skin

The skin is a fabric that surrounds the body and consists of several layers. The history of the being is inscribed on it: accidents, wounds, scars, scratches make up the alphabet on which this writing is based. What is there to be read? It is the material shadows of time, the epidermal crystallisation of events that give rhythm to the human existence. It is the refrain of this alphabet: a rebound of waves (of the body) away from the cliffs (of the events). (And so the literal meaning.) The initial realm, on which the movements of the world leave their traces. A writing that could be continued endlessly if something did not happen in-between that gives it an end. And something does come in-between . . .

Each skin marks an absence. Of what does it consist? What is not here? What is there? The skin becomes a sign of presence. Of a living thing, of an individual? Or a bag full of innards, muscles and bones? Certainly, of a body. But where does the skin end and the body begin? I therefore have to ask: can one adopt the views of medicine, or to be more exact the prescriptions of anatomy, without a problem? They divide up the human body in order to name it. They dissect and 'invent' the organs, the organic monads: the heart, the kidneys, the veins and so on. The critical problem: how to

FROM ABOVE LEFT TO RIGHT: Louise Sudell, Wig stand *and* Personal Memory Intervention, *1993, suspended glass sheets trapping artist's bedsheet with real snakeskin; behind large glass panels;* Learned Memory Intervention, *1993, one way and full mirrored panels, projections of slices of the brain; in wooden walk-in booth;* Cultural Memory Intervention, *photograms of snakes and facial peels; between glass*

PAGE 84: Louise Sudell, Wig stand and wig of the artist's hair, shaving mirror, towel with artist's own facial peel, *1993, behind large glass panels*

create the body (think, design, let it begin). With what, or in which language? In which linguistic form? The language investigates and divides, orders and labels. Admittedly it makes the world recognisable. Recognisable in its own manner. It makes the world readable. In order to do so it also has to conceal. The writing writes, it tells us something by separating, it shows us something by cutting it into bits, it explains by replacing. The writing, each writing has a weight. Therefore the writing, that is lying on the world, makes a part of it disappear. This is what makes me formulate the following paradox: writing can make the world visible only if it makes it disappear.

It goes without saying that the body functions with the same logic. Its skin covers and is – this we learn from etymology – shell and hull. What makes up the writing of the skin? It is the process, by which the body has to cover, hide itself in order to be able to appear.

Spaces II (The Infinitesimal Moment)

We are still sitting in the same room. Somebody has lit a fire. The containers – cups, goblets and drinking glasses – seem to be trembling. Deep in thought we look into them. A voice says: 'Imagine, that we would be able to see a body. One moment it is lying still, and the next it is walking. The night sent the dream in advance to bring home the body which does not want to fall into the dream. It resists, it rears up. Slowly it slides from waking into the dream, from dreaming into waking – endlessly back and forth. Conflict. Until it does not know whether it is awake or dreaming. Dissolved thinking.'

I ask: 'When would be the moment of this dissolved thinking?' Possibly at the moment on the extreme edge of sleep, when the ego of the wakening, that wants to reappear, returns to the ego of the dream, that is still there and which holds it for at least a couple of moments and does not let it go. An infinitesimal, unending short moment.[3]

Maybe the human is in the state of transgression from one state to another. S/he closes the eyes and sees herself/himself walking as if in a dream through nameless spaces. S/he opens the eyes and as if blinded stumbles into the names of the world. The light has been caught in vessels, rebounding inside. 'And the body?' 'The body has turned itself inside out, in order to light the mind with its darkness. To impregnate it with its mucous substance.'

Utopia

Let's begin with the general: art is a form of concentration. A space of amalgamation, of grouping, of uniting, of layering and of superimposing. (Therein related to the theatrical.) What makes this concentration remarkable is its radiating intensity. It depends on density or strengths. I admit that this does not sound very decisive. So what can be said of

strengths, intensities? Where do they originate from? The originator – no, the compiler – is the artist. She orders the ensemble of signs, which she takes out of the multitude of worlds in which she lives. She stages. Or to be more exact: she puts images onto a stage. She assembles what we call tropics. (All those who know the beginning of Ovid's *Metamorphosis*, the allegory of genesis of the unformed nameless mass – chaos – hopefully understand what I am talking about.)

The etymology of the word tropics reveals that it means changes. Changes of direction. They have a place, a *topos*. Therefore they are also *topoi*. That is to say that they are sites of potential where one, according to one's ability, can build expressions, in order to reconstruct an opinion. And obviously there is a praxis bound to these places. This praxis may stay nameless, because it can change all the time. It connects the artist with the work, the work with the viewer. Ideally it connects the history of the individual (the artist) with history of the collective (the audience). It is about touching, communication, dialogue . . .

There is also another name for this concentration: contraction. But what is contracted? Contraction can only occur between things that are both strange and similar to each other. For example: the magical and scientific thinking, the 'in-sane' mind (paranoia, hysteria, delirium) and the intellect, the non-traditional and the logical, the dream and the waking, the mind and the body. In these contractions the borders, which surround the states of consciousness, disappear, and the names which surround things like coats, dissolve. Life becomes for a short moment a formless mass, chaos. This horror has to be endured. And – I continue in the some pathos – only out of this can a new world arise. Art can be the place, the *topos*, of this process. Yet in the future, art, in order to be that place, must be able to disappear, to dissolve, to leave its place, to leave its own image. Art becomes a non-place, *A-topos*, or again for the last time: Utopia.

Only if one (the same is valid for art) gives away one's image, can one reach it. Not until one loses one's image, can one make of oneself an image. (That is the experience of the mirror.)

Disenchantment

When Max Weber (1864-1920) created the catchword 'Disenchantment' at the beginning of this century, he meant (to paraphrase) the following: profane cultures arise out of the ruins of collapsed religious images of the Occident. The demise of religion is caught up by the autonomous arts and deviated through the moral and legal discourse. Capitalist enterprise is born. The wheels of the bureaucratic apparatus start turning: the social life of man starts to become abstract,

diverted by an immense administrative apparatus. The mythologies become neutralised, the reflection upon history takes its place. Through the demise of status, the individual is separated from its fixed image of status and left in a social space that is abstract. From now on the ego (the identity) can be created since it is no longer defined in advance. Can? No, must! The new freedom of the individual is, so to speak, an extended playground of possibilities which bring pressure upon the ego to decide for itself. This is a continual process in a new social framework. The ego's own existence comes to depend on it. Modern man is thus created: the subject, simultaneously suppressing and suppressed.

Our situation today corresponds to this paradox. Man is this contradiction, this uninjured disunity, this fragmented whole; man is in a dilemma. It is no metaphor if I claim that our skies are ripped open, worn out (the ozone). Our horizons are 'schizophrenic'.

Again a metaphor (that hopefully does not bother the reader any more): the world is the thing that forces us to act. And if we question whether what we have done is good, it shakes its head wildly and dismissively and says – yes! Or, to put it the other way around: it nods in agreement and says – no! Maybe one is too idealistic if one expects art to make clear this cultural and double-edged situation referring to the identity. To be an instrument that helps us to understand the paradox and/or to live with it.

Here I cannot make an analysis of the torn open skies. Simply this generalisation: science in fact tries to take apart the cosmos, putting it into compartments of discovery, to cut the world up into slices, to splinter the mind up into thin layers, to expose the big enigmas – man and world. By doing so it runs into new exciting worlds, constructing vibrant worlds, the supracosmos and the metamundas, and runs and runs – and outruns itself. It invents instruments of discovery and all too often follows a process of recognition where the instrument itself predicts the possible discoveries. This recognition not only manipulates but also has its own technical limits. Where one strives for demarcations, broadening, amplifications, one usually ends up only by handcrafting a cage of one's own imagination. Who does not know the simple and plausible story of the child that wanted to know what a flower was? The child began to take it apart: it tore off the leaves and examined them, plucked the blossom, split the stem, beheaded the plant – and after carefully doing this the child saw that nothing was left but halves, scraps, bits and fragments.

If one tries to make a diagram of human thinking, it is not enough to perceive a simple progression from one lower level to the next higher level – animistic, mythological, religious and finally scientific. This is not satisfactory: in principle there are no differences between these forms of thinking. There are only simply gradations between them. This sort of stepladder does not say anything about the nature of each type of thought, but blocks the way to seeing new nuances. Claim: our thinking today is an amalgamation of all these systems of thinking – and we can also presume that future thought will originate out of this disparate collection. How could we otherwise explain that conventional science 'finally leads only to the recognition of anomalies and crises'? It is no hypothesis that 'these are not solved and satisfied by [rational] reflection and [logical] interpretation, but by a relatively sudden and unstructured event.'[4] We could describe this event as 'intuition'. There are other names for it. In any case at such a moment a whole and finally inextricable bundle of experiences comes together, that has to do with the potency of logic and ratio only at its periphery.

Can art do something different? Can art be science, religion, mythology or magic? Can art understand the simultaneous nodding and shaking of the head of the world? Will man be able to deal with that? And how should art look today so as not to leave us in deep black despair in the face of the 'vanity of the world' and the absurdity of wars, but allow us to be here with calmness, composure and serenity?

Maybe art should be that monad, which splits up unity, that structured substance, that thing full of furrows (therefore skin and body), in which the world unfolds. That means: in which the world creates folds that show like shattered mirrors the paradox of existence glimmering or as something hardly recognisable between light and shadow. And if I try in a neck-breaking speech to say something, then – yes, I have to acknowledge that I, like the child with the flower, shall harvest scraps, however close I may move with my language full of metaphors towards my picture of the world. Therefore, here at the end of the text, once more there is silent pathos: an attempt that consists of nothing other than being silent, and waiting. In order to see art. In order to hear how the world grows, there where no perception and language can reach.

Notes

1 Henri Bergson, 'Le rêve' in *Mélanges* (ed André Robinet), Presses Universitaires de France, Paris, 1972, p 451.

2 *ibid*, p 455.

3 *ibid*, p 457.

4 Thomas Kuhn, *Die Struktur wissenschaftlicher Revolutionen*, Suhrkamp, Frankfurt am Main, 2 Auflage, 1976, pp 134-35.

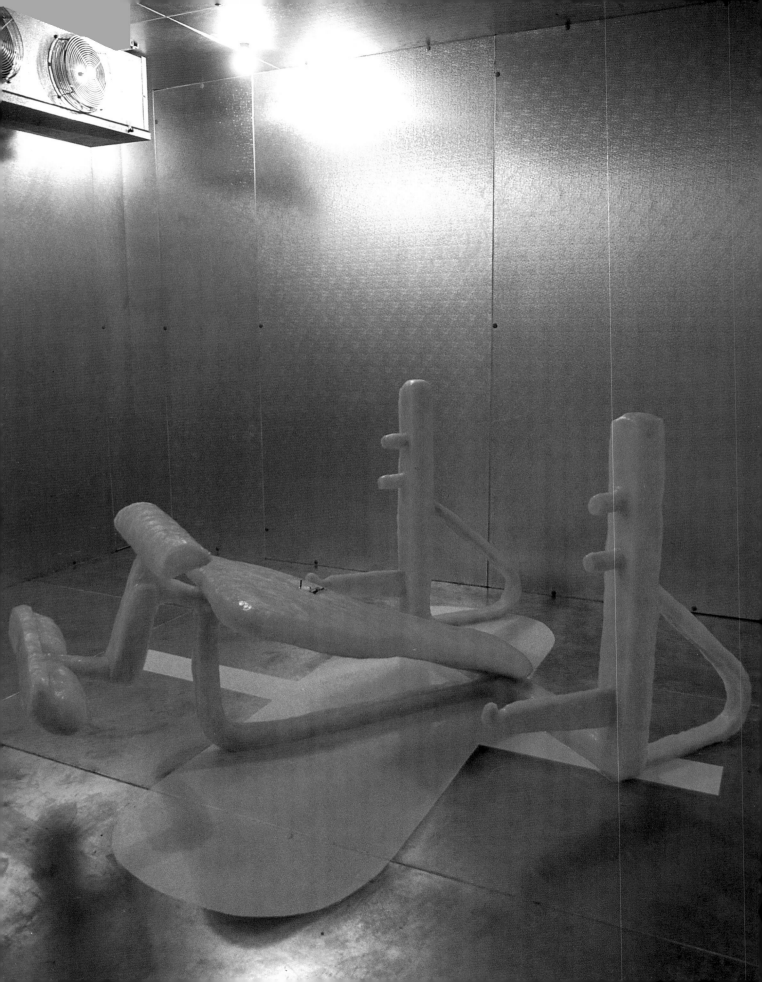

MICHAEL PETRY

IS ANYBODY AT HOME?
The Locus of Eros

'Everybody loves somebody sometime . . .', sung by Dean Martin in the 1960s, set off a chain reaction in my early childhood development. I started to pay more attention to the lyrics of popular songs and to understand innuendo and metaphor. My parents had given me an introductory lecture on sexual reproduction at the age of six. They showed me a medical encyclopaedia, similar to *Gray's Anatomy,* complete with pictures. Sections of the woman's abdomen were removed to show ovaries and uterus. Pictures of her labia and clitoris were shown closed and open like a skin butterfly. Her intestines were drawn in long black dotted lines, as were her liver, spleen, and other non-sexual organs. A cross-section showed the inside of a man's penis and testicles, his vas deferens, anus, and prostate gland. The picture showed his organs in a flaccid state and then in an erect position. The drawing even indicated the angle of erection for the average man as measured by Kinsey. What a lucky husband and wife, scientifically measuring all the 'naughty bits' of so many men and women; enough to get a statistical mean for men's erections and the lengths of erect clitorises.

But none of the drawings was as surprising as one depicting an erect penis inside a vagina, all in cross-section. I just couldn't make the mental translation of what it meant. The full frontal nude pictures of the sample man and woman seemed to have no corresponding parts capable of melding in such a way. I shook my head up and down as the information was proffered. Troilism, bisexuality, homosexuality, bestiality, necrophilia, and other sexual 'interests' were listed in the index. These sounded so interesting, but my mother would not explain these topics and shut the book.

It was left up to me as an adult to find these things out for myself. It all seemed so abstract to me then, and even more so now. I think all the boys and girls of my American generation hunted in their parents' closets for hidden books on marital bliss, *Portnoy's Complaint*, the sexual dictionary, and the ever-present hidden copies of Dad's *Playboy* magazines. I don't think it was just boys, but girls too, who wondered at Bambi, or Barbie. Characters we thought we knew from Walt Disney or Hasbro looked so different in colour photographic reproduction from their celluloid or plastic versions. Barbie did have breast projections, but she had no nipples, much less pubic hair, and as for her boyfriend Ken,

he did not even have a scrotum. We would make them 'make love' as in the diagrams. Nothing went in, no interlocking parts, and the only thrust came from our fumbling hands.

Can the thought of love ever match its simulation? Where was this body of the cross-sectioned pictures? Barbi Benton was going out with Hugh Heffner, so we knew where she was, but we still couldn't figure out how anything could be 'slipped to her' as her Richard Hamilton badge requested. Hugh seemed too tired to try. He was always pictured in his pyjamas. Didn't he ever go to work? This body quest continued to go unrewarded for a long time. The depictions, the simulations, the abstractions of it were all around us, yet the real bodies that my sisters and I inhabited were so different. Strip poker with the neighbourhood kids only confirmed the fact that basically we were all the same, and yet none of us was like the allusive drawings. Only my Aunt Martha looked like Ms Benton, and like Barbie. She talked about 'free love'. My mother complained that she practised what she preached, with four husbands and many lovers.

By this time I was taking art lessons at the local museum. Drawing from life was denied to anyone under 18. I took it to mean that even when I drew the mountains or the desert they were not alive, that the cups and flowers I was encouraged to copy were all dead. How I longed to partake in live art.

This only made the elusive body more mysterious. Where was it, what did it contain, what did it mean, why were adults the only ones privy to it? I can see Kiki Smith and Matthew Barney playing Ken and Barbie. I can see Robert Mapplethorpe alone in the toilet. I can see Candyass poring over *Sports Illustrated* magazines. I can see Charles Ray masturbating and worrying if he would go blind. I think all we wanted was some answers to a few basic questions. But no one had any answers for anyone else. We all reacted to the search for the mythic body in our own ways, as did youngsters in the tightlipped British domain or the children of the Third Reich. Our strategies proved to be quite diverse, and only now are we able to come to grips with what our quests might mean.

The seach for the body took place alongside the desire for Eros. If the body was hidden, Eros was in the ether, and we gladly breathed it in. Certainly, we saw lots of young teenagers in gym class, on the beach, by the swimming pool,

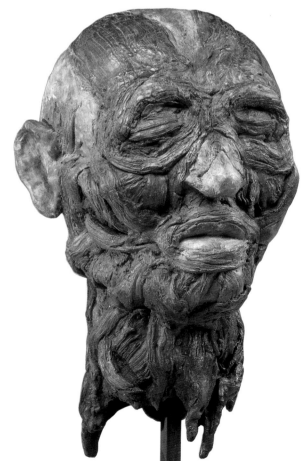

*FROM ABOVE: Mikey Cuddihy,
Iron Gates of Life: Close to Me,
1991, 244x183cm; Kiki Smith, Big
Head, 1992-93, bronze and steel,
52x22.9x25.4cm*

*PAGE 90: Matthew Barney,
Transexualis (detail), 1991, walk-in
cooler, formed and cast petroleum
jelly decline bench, human
chorionic gonadotropin, speculum,
2 video monitors, 2 video players, 2
video loops*

or, as we grew older, in the backseats of our parents' cars. But spilled semen on polyester flares can hardly be called erotic. This was just the quest for a fuck, the animal, the mating, the pairing, the unknown fulfilment of the cross-sections.

I thought I wanted love, but awoke to find Eros sitting on the corner of the bed.

The pleasures and pain of the flesh, the body as site are Matthew Barney's main concern. He is a very beautiful young man. He was a model and an American Football player. Matt was a fiction even before he consciously decided to become one. I looked on in physical awe of my sister's jock boy-friends. They, like Matt, were big and beefy, well-muscled and, I imagine, just as horny. Matt has simulated this cultural longing to sleep with the captain of the team, to take his power, to devour him like a cannibal and thus own him and not fear his spirit. Matt was a Jeffrey Dahmer pin-up boy without knowing it. I think that, when Matt recognised the full extent of his physical attraction, and the sway its erotic potential had for the viewer, he knew he was not only on to (or in) a good thing, but that it could provide him with a good body of work. So, he uses it. Boy, does he use it. Matt, like Acconci before him, dives into it wholeheartedly. Matt sticks all manner of things up every one of his pretty holes. Pearls and steel find their way into his anus, uretha, mouth, nostrils and ears. They are stretched and invaded while Matt is strapped to the ceiling of the gallery with mountain-climbing gear. Seen through the fictional eye of the video camera, Matt descends onto workout benches made from refrigerated petroleum jelly, or is chased about by Scottish guardsmen. He is the voyeur at his own orgy. These videos are seen by us in sporty environs. Prosthetic wrestling mats and football sledges lie discarded from the rigours of his performance. What are we to make of all this fictional body and real Eros? Can Barney have keyed into the ether, decoded it for us to participate in? Unlike Jeff Koons' sophomoric attempts to depict erotic visions of his sexual congress with his truly erotically sophisticated wife Cicciolina, Barney achieves erotic tension; not hoots of laughter.

Desire is the awful knowledge that we are but human.

This comparison is an important one to make, for while Cicciolina's fame derives from the complex use of her body as provocative agent (from porn to piss performances as an Italian Anarchist MP), Koons' comes from the commercialisa-tion of art. When advertising gets it wrong, or does not do its market research properly, big companies lose lots of cash, and Koons PLC certainly muffed it on this one. Sex can sell, but only in the realm of commerce; Eros rules in the domain of the aesthetic. Koons has yet to realise this, as his concern is not with the body, or Eros. Throughout the process, Cicciolina retains a dignified smirk, knowing so much more, looking like the indulgent parent, older sister, or seducer. Barney, too, retains his dignity even with his anus spread open by large speculums, because this is not a masturbatory exercise. This is an experiment into the depth and breadth of what it means to us to have and inhabit the physical shell. True introspec-tion leads him to insights in the physical condition of all viewer.

The body I desire cannot be anything but my own.

Kiki Smith seems to want to get under our skins or get us out of our skin. She relates to the meaning held in by the boundary of the flesh envelope. Matt digs deep, while Kiki finds gold where it is most obvious. She seems to have X-ray eyes that don't have time for the outer epidermis. Flayed human scale figures look as if they were really the live images of *Gray's Anatomy* or the cross-sections in three-dimensional stasis. They wait for us to turn our heads away so that they can get on with the action of living. Kiki's teaching aids for viewing ourselves confront the id on a visceral level. They kick us in Matt's groin. They simulate our fears of the messy bits of our own bodies, the bits that Matt can't successfully plug up, the bits that have a life of their own, like in the pictures of the mythic body. When we look into the eyes of our gods, we realise they have feet of clay and Eros is denied. Paradoxically, Eros is present by its absence in Kiki's manipulations of wax and colouring agents. But is her Eros the same as Matt's or mine or that of people of different cultures? Is Eros the same for men and women?

And what of Charley? Mr Ray simulates his own stimula-tion. His body turns to fibreglass as he fellates himself, layers of faux pubic hair fall out as he sodimises himself. The gaze of the camera is no further removed than that of the live observer who saw *Oh! Charley, Charley, Charley. . .* at the 1992 Documenta. Ray times eight. Ray as porno director in the new world of virtual reality, hypersex or hollow gesture? Ray posits the real, his own flesh, onto the ordered, the mechanically reproduced, the simulated. He pastes his own penis to the dotted line, or the three-dimensional model as in his *Male Mannequin*. He turns his flesh into plastic and makes ours crawl. All the tidiness we have grown to expect from the Hollywood version of sex and violence is exploded by a guy's flaccid dick. The body as truthful avenger, the organ as violator of paternalistic myth, flaccid meat as the pin to prick the male ego bubble. Ray's works are the cyberpunks who would soil the Greenbergian plane with their assertion that a dick is still a dick and not a paint brush. Barney is the

self-obsessed plastic surgeon looking inwards. Smith is the cathartic healer confined by the limitations of the flesh, and Ray having shed his skin like a caterpillar, emerges as the super-id to, respectively, id and the polymorphously perverse. These are the Duchampian children of Freud.

Where Science lives lust is at hand.

To stretch the Freudian analogy with callipers may be useful, if we acknowledge its paternalistic and gender constraints when mentioning artists who view the ego body. As a man I speak with a male voice and use its terminology as easily as I fit my own skin, so I have to be careful. I constantly ask myself questions about this male gaze. In an ongoing project with Mikey Cuddihy, we have come to the body in search of Eros through abstraction, the actual loss of the figure but not of self. Her work has always appeared to me to be highly erotic, while abstract, painterly and anti-rational. Descartes holds no pleasure for her, while I sometimes quiver at his elegance. The beauty of Mathematics sustains me almost spiritually: the gods of Euclid, Pythagoras, and Mandelbrot are pagans in her sensual realm. Mikey has different goddesses. What we share, what we both have, is Eros, the great *it*. We wonder if it, or anything, can be universal. Eros is evident in her works. It is the body that is absent or only reminiscent in the erased outlines and sensitive shapes. Large shapes that float on seas of soft worked colours, shapes that could envelop the field of the viewer, large but never womblike.

Mikey's works are Mikey scale. She 'labours' over them. They are created on the floor, close up, one on one. She attempts to rid herself of masculine distance. They are not created at arm's length. They are not rational. Men cannot see these works properly. They have a different voice and speak different languages. Kiki Smith's work cuts through words. Language is not necessary. The body speaks for itself and Eros is mute, but painting is a language with which men, and more notably women, must find a way to commune historically. Men have an advantage with this language. They made its rules. Men have left few codexes for women to translate from, so that when women find their own language, as in Cuddihy's *Gates of Life* series, men must do the catching up. Mikey is innately aware of the ego. Her consciousness is aware of its own corporeal possiblities and this is depicted in the beauty of the paint.

For beauty is the shadow of Eros as the disfigured is its reflection.

We do well to fear beauty, for it indicates that Eros, and all the disruption of the rational that ensues, is lurking about. The body cannot physically cope with the desires that desire engenders. Desire paradoxically places the body in a steady state of frustration for, once the desire is touched, it is no longer that which is desired, creating desire anew. Beauty has been exiled from the domain of art – it is too easy, too seductive, too possible to attain, so needed, so longed-for and yet so fleeting. As a man, I cannot say that I have experienced a female orgasm except second hand, and in close proximity; but, like the male orgasm, it was a mere second in the time of the universe, and yet so desirable that it suggested that Eros must reside somewhere, and might possibly be universal. However the aesthetic problems of beauty are too stellar an issue to be encompassed in this text.

So what is the language of Eros, the unspoken that does not need lips to speak, the Eros that exists *sans corpus* or *extra corpus* or perhaps has a parallel *corpus* that shadows the physical, that exists within the memory of the very atoms that make us physical? The notion that memory exists at all is the basis for Louise Sudell's investigations. Sudell posits that personal, learned, and cultural memory must be seen as one, a whole, divisible yet composite. Sudell delves deep into the ego, the conscious plane of existence in her installation works that use her memory as a basis for site. Her body is reduced to haircuttings, and facial peels; dead skin sloughed like a snake or a Smith sculpture, but clean, rational in overview, scientifically observed. It is the personal element that divorces all expectations of sterility from actuality. Sudell uses a male vocabulary to speak a female language. Cuddihy uses the symbols for male voice to speak an erotic esperanto. Whereas Sudell is British and has found freedom in work abroad, Cuddihy is an American who, in the misogynist culture and establishment of England, has located a hidden key within herself on hostile terrain.

Men feel free to touch the bellies of pregnant strangers.

The mysteries of the atomic flesh are those that have occupied my own work. How can we know anything other than that which we have individually marked out? Universality is a male concept seen through male eyes and measured with male bodies from the ancients to the present. It suits men as it upholds the status quo. The only possible notion of non-gender-specific (non-paternalistic) universality must be in the realm of Eros. It can be argued that it is either instinctive, as we cannot forget that we are animals, or non-intellectual, non-rational, non-empirical, for Eros strikes where it may at both sexes. The procreative urge of the lower-order animal forms, and in all plant forms, is such that they cannot help but attempt procreation. Only human beings are capable of consciously (as far as we know) suppressing the desire to see our own bodies as the best templates for the next generation of ourselves.

Michael Petry, The Chemistry of Love, *1992-93*

However, this desire to see our own organs attached to the dotted lines of the text book, or to the bodies of replicants or, even better, inside the bodies of others when we are dead (will *you* donate your kidneys?) argues the case that instinct is terribly strong. Only Eros can cross the genetic wires and burn them out in states of overloaded capacity. So for me, tubes and flasks, video monitors and discarded clothing, voices and technology, chemicals and ideas, these are the body, my body, my conceptual body, the body that I think must exist, the body I have argued for, the body that can know Eros and logic: another very male concept. I ask myself what the body is, other than a collection of salts and quarks, and whether these questions have any relevance to women who can have a body grow within their own with only minimal help from men.

Women listen to find out if they are saying too much while men speak to hear themselves.

A body within a body. What a crazy thought! It leads to notions of disease, parasites, and back again to parallel worlds. Do women worry about such things? Where is the dialogue? Is it enough for me to ask all the women I know for a response? Is not the act of asking the limiter, the non-Wittgensteinian *faux pas* at the erotic banquet of love? Where do my thoughts take me when I do not even know where my molecules have been? My works, like *Chaos Human Atomica: The Birth of the Parallel Universe*, attempt to address these issues, delve into the the body and return with a memory of past atomic combinations which retain a memory of their own. In short I posit that we can recall even the moment of the Big Bang, if only we can access the stored memory in the matter that makes up our physical bodies, as all matter was created at that moment and has existed in time since that point in one state or another. Instinctively, our protons know what to do. We do not consciously affect our electrons, and yet the neural network we call the brain is merely a great on/off switch triggered by electrical pulses. What if we could remember, what if we do? To create an aesthetic based on science is not to argue for predictive aesthetics, merely for one that mirrors the complex world in which we live.

Flight from Technology: The Sexuality of the Universe Part 2 continues another thread in my work. Where do the extremes of objectivity and subjectivity meet? Are they opposite faces on a coin meeting in an undefined fractal ground? Edges abutting but not overlapping, jostling for primacy. These works or *The Chemistry of Love* offer visual forms to analytical thoughts, and yet in their sheer physicality, they propel the participant into the all-too-real realm of Eros, the body, the experience of pleasure, mental and physical. The disorientation they offer the viewer can be exhilarating: science and art, objectivity and subjectivity, melding into a zone of pure observable experience. The lasting beauty of cosmic and elemental particulate science is its aesthetic lesson for us. Being that, it is impossible objectively to observe objects in a closed system – all the known and imaginable universes – as the act of observing alters that which is observed, and vice versa. The act of observation is further hampered by Heisenberg's Uncertainty Principle which states that a light particle can be measured as to its position or its velocity, but not both at the same time. As one measurement gets better the other gets worse. This means that (in quantum mechanics) it is impossible to predict the exact outcome of any unique measurement. A further complication is that light can act as a particle, a wave or, in a way, as both at the same time. We get either position or speed but not both, universal knowledge becomes incomplete, completely impossible, and the outcome is that artists and thinkers are rightly placed at the centre of the interpretation and understanding of the universe. The paradoxical beauty in my thoughts is that my body exists for me to question that physical assertion, while the experience of Eros displaces the locus once encountered.

The reflection in their mirror is my shadow.

The six artists I have discussed view the body in radically different ways as the potential for the making of art. Barney looks at the offal, Smith the epidermal, Ray the notion of it, Sudell the memory held within, Cuddihy the language, and I look at the possibility of it. Perhaps I am a doubting Thomas, for I too would stick my hand in the side of any god that demanded my worship at their altar. Eros seems the most friendly, if dangerous, and I have not shied away. The aesthetic voyager, the scientific novitiate, the sensual interrogator, yes, I have placed my hand in the flesh and I believe 'Everybody loves somebody sometime . . .'